MANFUL ASSERTIONS

'Manful assertions' – whether of verbal command, political power or physical violence – have formed the traditional subject matter of history. Yet few historians have thought to question the nature of masculinity itself.

Manful Assertions brings together current discussions in sexual politics with historical analysis to demonstrate that, far from being natural and monolithic, masculinity is a historical and cultural construct, with varied, competing and, above all, *changing* forms. Writing from a perspective in social history, the contributors draw on literature, cultural studies and sociology to explore the history and representations of masculinity from 1800 to the 1980s. Models of manliness discussed range from Thomas Carlyle and the nineteenth-century Man of Letters to Lawrence of Arabia and Imperial Man, and from the heroes of boys' stories in the inter-war years to the post-war Company Man.

Making men visible as gendered subjects within the accepted historical categories of family, business and labour, class and nation, *Manful Assertions* shows how – in the past as in the contemporary world – masculinities need to be understood as subjective identity, as social power and as cultural representation.

MANUEL ASSERTIONS

MANFUL ASSERTIONS

Masculinities in Britain since 1800

Edited by
Michael Roper and John Tosh

London and New York

First published 1991
by Routledge
11 New Fetter Lane, London EC4P 4EE

Simultaneously published in the USA and Canada
by Routledge
a division of Routledge, Chapman and Hall, Inc.
29 West 35th Street, New York, NY 10001

Typeset in 10/12pt Bembo by
Witwell Ltd, Southport
Printed and bound in Great Britain by
T J Press (Padstow) Ltd, Padstow, Cornwall

British Library Cataloguing in Publication Data
Manful assertions: masculinities in Britain since 1800.
1. Masculinity I. Roper, Michael II. Tosh, John 305.31

Library of Congress Cataloging in Publication Data
Manful assertions: masculinities in Britain since 1800/
edited by Michael Roper and John Tosh.
p. cm.
Includes bibliographical references and index.
1. Men–Great Britain–History. 2. Masculinity (Psychology)–Great Britain–
History. I. Roper, Michael. II. Tosh, John.
HQ1090.7.G7M35 1991
305.31'0941–dc20 90–49417
ISBN 0 415 05322 6
ISBN 0 415 05323 4pbk

CONTENTS

CONTENTS

PREFACE

This book brings together writers from several disciplines in pursuit of a common end. The history of masculinity in Britain is here approached from the vantage points of social history, sociology, literature and cultural studies. Our methods range from the analysis of texts to autobiography and oral history. But the book is more than a chance assembly of independent perspectives. All the contributors have been members of an informal study group on the history of masculinity which has been meeting monthly in north London since November 1988. In that time we have learned to see our subject as more than the property of any one discipline and to recognize its central importance to an effective politics of gender today.

The study group included others whose work is not represented here but who have greatly assisted this project: we particularly thank Lucy Bland, Joy Dixon, Catherine Hall, David Kuchta, Jonathan Rutherford and Dan Weinbren. We are also most grateful to Leonore Davidoff and Lyndal Roper for their comments and encouragement. Several of the contributions to this book began life as papers presented to History Workshop, and we would like to acknowledge the constructive criticism we received in this forum. Our hope is that the book will serve as a stimulus for further work on the history of masculinity both in History Workshop and elsewhere.

Michael Roper
John Tosh

ILLUSTRATIONS

NOTES ON CONTRIBUTORS

Kelly Boyd is currently completing her Ph.D. at Rutgers University on manliness in English boys' story papers betwen 1855 and 1940. She lives in London, but is a native of Tennessee.

Norma Clarke is the author of *Ambitious Heights, Writing, Friendship, Love: The Jewsbury Sisters, Felicia Hemans and Jane Carlyle* (Routledge, 1990). She is currently working on aspects of gender and literary culture in early nineteenth-century England. Her first novel for children is published by Faber & Faber this year.

Graham Dawson was a member of the Popular Memory Group at the Centre for Contemporary Cultural Studies in Birmingham from 1979 to 1985. He now teaches media and cultural studies at Brighton Polytechnic, and is completing research on war adventure narratives, masculinity and white English/British identity.

Peter M. Lewis is a freelance broadcaster, the author of several books on the media, and a lecturer in communication studies. While at Goldsmiths' College in the 1980s he was a member of the Gender Studies Workshop and the Masculinity Research Group. He is now a Visiting Fellow at City University.

Keith McClelland teaches part-time at the University of Reading and the Open University. He has published a number of articles on aspects of the nineteenth-century British working class and is on the editorial collective of *Gender & History*.

Michael Roper recently completed his Ph.D. at Essex University on masculinity and the evolution of British management since 1945. He has published in *Life Stories* and the *Journal of Australian Studies*, and he is a Research Fellow at the London Business School.

John Tosh teaches history at the Polytechnic of North London. In 1987–8 he was Visiting Associate Professor at the University of California, Davis. He is the author of *The Pursuit of History: Aims, Methods and New Directions in the Study of Modern History* (Longman, 2nd edition, 1991), and has also written on East African history.

Pamela J. Walker is from Toronto, Canada. She is completing a Ph.D. dissertation in history at Rutgers University on the Salvation Army in England, 1865–95. She is the recipient of a 1990–1 Charlotte Newcombe Fellowship.

1

INTRODUCTION
Historians and the politics of masculinity
Michael Roper and John Tosh

'Manful assertions' – whether of verbal command, political power or physical violence – have been the traditional stuff of history. Yet this truth is more often accepted than analysed. The context in which Thomas Carlyle used the phrase in the 1830s shows all too clearly that his readiness to applaud manly displays in others grew out of a deep insecurity about his own masculinity, which he later sought to purge through historical writings on such 'heroic' men as Oliver Cromwell and Frederick the Great.[1] Not for nothing is Carlyle so frequently hailed as a founding father of historical writing in Britain.[2] The historians who came after him echoed Carlyle's preoccupations, not only by excluding women from the public record, but by elevating the 'public' man as the object of study while entirely submerging his gender identity. Where they attempted to make masculinity natural and monolithic, this volume emphasizes its divergent, often competing and above all its *changing* forms. Where they buried their masculinity away in supposedly objective accounts of the past, we stress the ways in which masculinity underpins social life and cultural representation. And where they constantly emphasized the differences between women and men, boys and men, heroes and fops, we stress that masculinity has always been defined in *relation* to 'the other'.

Making men visible as gendered subjects has major implications for all the historian's established themes: for family, labour and business, class and national identities, religion, education, and – though we scarcely breach this bastion of professional conservatism – for institutional politics too. Our aim is to demonstrate that masculinity has a history: that it is subject to change and varied in its forms. The range of contributions to this volume is itself telling evidence of the historical diversity of masculinity. They deal in turn with the early nineteenth-century Man of Letters; the mid nineteenth-century

Professional Man and Respectable Working Man; Imperial Man and the Boy Hero in the inter-war period; and the post-war Public School Man and Company Man.

Through our work we hope to give historical substance to two key propositions: that masculinity (like femininity) is a *relational* construct, incomprehensible apart from the totality of gender relations; and that it is shaped in relation to men's social power. In making these claims we have two constituencies in mind: first, the historical profession which until now has been highly resistant to problematizing the masculinity of its male subjects; and second, the much more diverse body of people who are concerned with the contemporary politics of gender, but are frustrated by the lack of historical perspectives on masculinity. The problem at present is that on the one hand, historians have traced the history of precepts about 'manliness', but their discussions have lacked an adequate understanding of men's power over women as an organiz-ing principle of masculinity. On the other hand, some feminist approaches have viewed masculinity and male dominance as simple mirror images of each other. In the first part of this chapter we review the ways in which historians have discussed manliness, and the calls from gender studies for a more informed historical perspective on masculinity. Then we look at how historians and sociologists have theorized masculinity and its relationship to male dominance. Finally we offer our own conclusions about the historical themes which seem – at least on the basis of the contributions to this book – critical to the study of British masculinities.

HISTORIANS AND MASCULINITY

To the extent that historians have paid any attention to masculinity, they have deployed well-established historiographical tools. Much the most significant has been that branch of the history of ideas which deals with moral discourse. For most of the period with which this book is concerned – and certainly from the 1840s until the 1930s – the proper definition of 'manliness' as a code of conduct for men was a matter of keen interest to educators and social critics. Emphasis was variously placed on moral courage, sexual purity, athleticism and stoicism, by pundits who ranged from Thomas Arnold through Thomas Carlyle, Charles Kingsley and Thomas Hughes, to Robert Baden-Powell. Since this list includes some of the best-known literary figures of Victorian and Edwardian Britain, it is not surprising that their interpretations of

manliness have been closely studied, notably in Norman Vance's sensitive treatment of Hughes and Kingsley.[3] Special attention has also been given to the manly precepts which were upheld in all-male institutions of the period, notably the public schools, the Boys Brigade and the Boy Scouts. For example J. A. Mangan's study of the rise of athleticism analyses a key change in the ethos of the late Victorian public school.[4]

One important outcome of this recent work is that we now have a reasonably clear impression of a marked shift in the codes of manliness current among the governing and professional classes during the latter half of the nineteenth century – from the moral earnestness of the Evangelicals and Dr Arnold to the respect for muscle and might so prevalent at the close of the Victorian era. Moreover this shift has been carefully placed in relation to other key Victorian concerns such as churchmanship,[5] liberalism,[6] and imperialism.[7] Here at least is the germ of a gender perspective across a wide swathe of cultural and intellectual history, which addresses the diversity and mutability of masculinity over time.

Despite this promise, however, recent historical work on all-male institutions and on manliness leaves a great deal to be desired. The crucial problem is that women are almost entirely absent from these accounts, seemingly on the assumption that masculinity takes on a sharper focus when women are removed from the scene – as they may appear to be when men write about manhood or live together in schools and clubs. In the literature about Victorian public schools, for instance, there is scant acknowledgement that the typical schoolboy had been moulded by his mother or nanny for some years before he entered the school, and that feminine absence conditioned his emotional development during adolescence. In similar vein, historians of the scouting movement tend to be much more interested in Baden-Powell's stress on imperialism and class deference than his insistence that boys attending day schools be removed from the feminine atmosphere of home.[8] Current interpretations of Victorian manliness are marred by the same imbalance. It needs to be remembered not only that sexual purity was a major preoccupation for many proponents of manliness, but also that their doctrines were conditioned by their experience of (and views about) women – manifestly so in the case of Charles Kingsley.[9] There is a persistent British tradition of masculine autonomy in such writing which needs to be dismantled.

If women are largely absent from recent historical work on masculinity, it follows that little attention is given to the world of

3

family and domesticity. Yet any proper assessment of the historical significance of manliness surely requires that we treat it as more than simply a guide to men's conduct in work and public life. The proponents of manliness intended their teaching to influence men's behaviour in the home; indeed, it was commonly recognized that the foundations of manly conduct were laid within the family before formal schooling began.[10] The dual reference of manliness to both private and public spheres was implicit in David Newsome's pioneering work of thirty years ago;[11] but to follow up his insights required a systematic study of the place of men in families. Remarkably this task has until the last few years been all but ignored, with the result that the history of the family has been no less distorted than the history of masculinity.[12]

Removing women from the field of study also obscures the connections between masculinity and social power. When reading the recent work of historians, it is easy to forget that codes of manliness served as gender boundaries, or that attendance at public school was an apprenticeship for privilege over the weaker sex as well as the lower orders. It is certainly helpful to know the range of nineteenth- and early twentieth-century prescriptions for manliness, but this begs the question of how these differences should be interpreted. As Lynne Segal has recently emphasized, understanding what 'masculinity' is requires that we firmly locate the differences between men in the context of sexual politics: men's power over women, the power of older over younger men, and – during the last hundred years at least – the power of heterosexual over homosexual men.[13] Historians are in a potentially strong position to draw the kinds of connection which Segal recommends, since they study societies in motion from the vantage point of hindsight. It should not be necessary to spell out that the shifting spotlight on Reason, Feeling, Purity and Athleticism within 'manly' discourse before 1914 reflected not just the play of ideas, but a contested understanding of the sources of masculine power. Yet the history which places manliness in this gendered context has yet to be written; and more generally, the immense potential for historical insight into the politics of masculinity remains largely untapped.

SEXUAL POLITICS AND THE HISTORY OF MASCULINITY

While academic historians have been making tentative steps towards recognizing the gender of their principal subjects, others more cen-

trally concerned with the politics of masculinity have been calling for a new kind of history. The questions which we ask and the categories we employ in this book are strongly influenced by a range of politically aware writers, many of whom straddle the divide between academia and activism.

Several strands of sexual politics are involved here. First in the field, and still the most productive of scholarly work, is gay history. What seems particularly impressive in retrospect is how quickly gay historians moved away from discussing social attitudes *towards* homosexuality to re-create the historical experience of gay people themselves. Indeed the historical record revealed a veritable treasure house of positive images for gay men, which is one reason why they have attached such high priority to historical work. In the space of just five years (1977–82) three major studies appeared – by John Boswell, Alan Bray and Jeffrey Weeks – which documented the existence of gay sub-cultures in Western Europe during the eleventh and twelfth centuries, in London in the late seventeenth and early eighteenth centuries, and in England since the close of the nineteenth century.[14] Each of these works was characterized by a move away from a linear dynamic towards a careful contextualizing of homosexual experience in specific historical cultures, which revealed shifting patterns in the expression and organization of desire. 'There is', Bray affirms, 'no linear history of homosexuality to be written at all' – nor, we would add, of masculinity.[15]

To treat gay history in this fashion has wide-ranging and subversive implications. In Jeffrey Weeks's words, it 'propels us into a whirlwind of deconstruction'.[16] It suggests that the ranking of homosexuality and heterosexuality as fixed identities, far from being part of the 'natural' order, was consolidated only about a hundred years ago. And if the negative labelling and outright oppression of homosexual behaviour over the past millennium have been intermittent rather than continuous, what does this say about the self-image and self-doubting of the socially dominant forms of masculinity? For example, as several writers have pointed out, the medical and legal onslaught on homosexuality in Britain from the mid nineteenth century was part of the heavy price paid for the institutionalization of heterosexuality in the Victorian family.[17] The decisive contribution of gay history to date has been to dissolve the 'essence' of homosexuality – and by inference other sexual orientations too – and thus to undermine one of the central planks of 'commonsense' masculinity.

Heterosexual masculinity, of course, represents in large measure the

oppressive social order whose history gay writers wish to lay bare. But the men's movement during its most active phase in the late 1970s and early 1980s carried strong liberationist overtones too, because of the way in which it experienced the current norms of masculinity as oppressive. Most of these writers were middle-class heterosexual men, whose experience of personal life, often with feminist women, caused them to view their masculinity as a deforming of the true self. In the magazine *Achilles Heel* (1978–81) and in books like *The Sexuality of Men*,[18] they stressed men's estrangement from their emotional selves as the heavy price they pay for the privilege of living in a patriarchal society. In the recent words of Victor Seidler, 'If we live in a "man's world" it is not a world that has been built upon the needs and nourishment of men. Rather it is a social world of power and subordination in which men have been forced to compete if we want to benefit from our inherited masculinity.'[19] In such accounts gender is often represented more as an oppressive social structure 'out there' than as a set of relations which is reproduced psychically and socially in daily living.

A liberationist perspective was also evident in the men's movement attitude to history. The desire to recover a golden age in the past is clearly perceptible in Donald Bell's 1981 essay 'Up from Patriarchy', where Western pre-industrial society is seen in terms of 'a sharing of personal and productive life by men, women, and children'.[20] Like the women's movement, the men's movement set a premium on heroes from the past – in this case men who either challenged sexual stereotypes in their own lives or lent support to the women's cause, or both.[21] For many men at odds with the dominant constructions of masculinity today, the 'truly free man' of the past remains a beguiling myth.

But a concern with masculinity as experience and as potential for personal growth demands more of history than merely a 'good past'. To weigh the prospects for change requires a genuine historical perspective. Writers associated with the men's movement found themselves asking where the current deformed versions of masculinity came from and how integral they were to Western culture; like other radicals, they knew that before one sets about pulling something up by its roots it helps to know how deep those roots go. For Andrew Tolson the separation of work and home wrought by industrial capitalism in the nineteenth century is fundamental to the emotional economy of both working- and middle-class men today.[22] Seidler locates the decisive shift in the Enlightenment of the eighteenth century: when men learnt

to disparage their 'inclinations' and to act from the inner voice of reason, they became estranged from experience and invisible to themselves. Reason and Feeling were pulled asunder in a way which had baneful consequences for both men and women.[23] Like Tolson, Seidler is not a historian himself, but he is clear that history is indispensable to his project.

What we have labelled the 'men's movement approach' is not necessarily uncongenial to feminism. Much that feminists have written underscores the stress on the costs to men of patriarchy. As early as 1838 the American feminist Angelina Grimke remarked: 'The fallacious doctrine of male and female virtues has well nigh ruined all that is morally great and lovely in his character: he has been quite as deep a sufferer by it as woman, though mostly in different respects and by other processes'.[24] One hundred and fifty years later those sentiments are echoed by Cynthia Cockburn when she writes of men: 'our culture cruelly constrains them, in varying degree, to be the bearers of a gender identity that deforms and harms them as much as it damages women'.[25]

But the main tendency within feminism – including writers like Cockburn – has been very different. It has been rooted in the politics of women's liberation, and has seen men in the past, as now, not as victims of contradiction but as the upholders and beneficiaries of patriarchy. Much of the early work in women's history which began to appear in the 1970s was premised on this view of men but did little to explore it, preferring instead to focus on women's resistance to – and endurance of – men's oppression. But out of this gesture of solidarity with women of the past has grown a much more ambitious programme. To understand women's position now or in the past requires not only an engagement with the experience of the oppressed but an insight into the structures of domination.[26] Natalie Zemon Davis remarked as long ago as 1975 that historians of sexual difference should no more confine their attention to women than historians of class should study only the peasants or workers.[27] What is required is an understanding of the mutations of male dominance over time and their relation to other structures of social power, such as class, race, nation and creed. A programme of this kind is what is now usually meant by the history of gender. Without retreating in the least from the feminist insistence on the reality of women's oppression, this approach maintains that gender is a social system which at any time constructs the opportunities and experience of both men and women. It has the effect of problematizing both patriarchy and masculinity – and in historical terms, as we will

shortly demonstrate. This breadth of vision offers women's history the incidental but important prospect of transforming the mainstream historical tradition. The implications for the study of men are clear: as Jane Lewis puts it, 'Our understanding of the sex/gender system can never hope to be complete until we have a deliberate attempt to understand the total fabric of men's worlds and the construction of masculinity'.[28]

The calls for a historical approach to masculinity are at present almost deafening. In the journal *Gender and History* Gisela Bock looks for a history of men 'in gender-conscious and thus "male-specific" terms'.[29] The sociologists Tim Carrigan, Bob Connell and John Lee lament the 'embarrassing' condition of most men's history today;[30] John Bowen from literary studies describes historical work on masculinity as 'an urgent political task'.[31] The explanation for this unanimity is clear. Gay liberation, the men's movement and feminism all concur in affirming the social and cultural construction of masculinity, yet this tenet cannot be endlessly proclaimed without some solid demonstration of it in empirical work in time perspective. Moreover, the historical approach offers the best opportunity for exploring the meaning of gender as power: for seeing masculine and feminine identities not as distinct and separable constructs, but as parts of a political field whose relations are characterized by domination, subordination, collusion and resistance. There is a striking potential here for convergence with the interests of traditional historians. For they have always been pre-occupied with the location and exercise of power. It is high time that they recognized that men's power in history has resided in their masculinity, as well as in their material privilege and their manipulation of law and custom. But for this to happen, much more searching attention must be given to the politics of masculinity than all but a handful of historians have allowed until now.

PATRIARCHY, MASCULINITY AND MALE DOMINANCE

The terms 'masculinity' and 'patriarchy' are closely linked in a historical sense, since both were taken up by socialist and radical feminists during the late 1960s as part of the process of theorizing male dominance. As Joan Acker has observed, the concept of patriarchy emerged out of the need for 'correcting flawed social theory' which attributed male domination to nature or social necessity.[32] Patriarchy provided a way of drawing links between the different contexts in

which men's power operated: in the structure of ideas, relations and institutions. Lively debates soon developed around the question of whether male dominance was primarily located in the distinction between domestic and paid work, in sexuality, or in the state.[33]

For historians focusing on masculinity, the notion of patriarchy is important because of the primacy it gives to women's oppression, and because it provides a way of integrating the individual and structural dimensions of male dominance. For Sally Alexander and Barbara Taylor, writing in 1981, the significance of the concept lay in the way it revealed patterns of domination in public and private spheres. Patriarchy not only operated in public institutions like the state, military or politics, but also pervaded sexual identity. Drawing on the work of Juliet Mitchell, their 'defence of patriarchy' hinged on the belief that 'it allows us to confront not only the day-to-day social practices through which men exercise power over women, but also the mechanisms through which patterns of authority and submission become part of the sexed personality itself – "the father in our heads", so to speak'.[34] Patriarchy offered a means of explaining the persistence of male domination over time, and of laying bare its mechanisms at the level of the unconscious.[35]

As an umbrella term for describing men's domination of women, the concept of patriarchy has been criticized because it is ahistorical. In the early 1980s Sheila Rowbotham rejected it beyond its strict definition as 'father rule', on the grounds that it had strongly biological connotations, and because it seemed to suggest that male dominance was unitary and unchanging. As Rowbotham remarked, reliance on a patriarchal framework obscures the 'multiplicity of ways in which societies have defined gender' and is thus over-deterministic.[36] Subsequent interpretations, particularly in the area of women's employment, have countered this objection by showing that forms of male dominance do change over time.[37] From our perspective, however, the main limitation of patriarchal frameworks is that they are more adept at highlighting the changeability of public and institutional power structures than of masculinity. When the term 'masculinity' is used, it functions as a simple shorthand for the personal aspects of oppression by men. As Carrigan, Connell and Lee point out, such approaches regard 'masculinity as more or less unrelieved villainy and all men as agents of the patriarchy in more or less the same degree'.[38] Men are too easily seen as having a natural and undifferentiated proclivity for domination, because their subjective experiences are left unexplored. Accounts which concentrate on the psychic dimensions of patriarchy

have illuminated women's internalization of 'male' values, but have not shed light on masculinity as a gender identity, while accounts focused on public structures like the workplace or state have often assumed simplistic motives on the part of patriarchy's beneficiaries. At present there lies a vast 'no man's land' between history's Great Men and the disembodied structures of male power.

In Sylvia Walby's treatment of employment and gender relations in nineteenth- and twentieth-century Britain, for example, the strengths and weaknesses of 'patriarchal exclusionary practices' are charted very fully, but we discover little about the gender identities of the union officials or employers who enforced them.[39] Walby rightly criticizes historians for assuming that women simply vacated skilled jobs at the end of the First World War in unthinking accordance with the promptings of 'social custom'. However she goes on to depict men in a similarly one-dimensional way.[40] In the household, men act out of a desire for 'control over and exploitation of women', while in paid work the 'key feature' of patriarchal relations is 'closure of access by men against women'.[41] At work or home, men are simply agents of oppression. Masculinity is seen as unitary, fixed in time, and oppressive in equal degree. Without a more complete understanding of why men sought to control and exploit women, we risk returning to theories of an inherent male tendency towards domination.[42]

While we have chosen to retain the concept of patriarchy in this volume, we use it not as a shorthand for male dominance but to refer to the various forms of 'father-rule'. The German sociologist Max Weber defined patriarchy in a similar way, as social authority based on a family structure in which the oldest male presides over an extended family.[43] This kind of approach is useful because it raises the issue of power relations between men and how they relate to hierarchies of age, class, occupation and race. There is considerable dispute about whether the concept should extend at all to the generational aspect of relations between men. However, we would argue that issues concerning the transmission of power between men are closely connected to the reproduction of gender inequality.[44] Such a perspective helps explain why the accession to power in the workplace and political domain has so often been framed in terms of conflicts between father-figures and their dependants. For example Cynthia Cockburn has vividly illustrated the ways in which the 'craft control' by men in hot metal printing was reproduced through a gender hierarchy in which age and skill were interdependent.[45]

We have adopted an approach focused on masculinity because it

ultimately makes possible a more dynamic, more differentiated explanation of gender relations than patriarchy – at least in its narrower usage – can provide. Casting light on the mechanisms of men's social power requires that we explore more fully men's gender identities and the nature of their relations with each other. This involves taking up Alexander and Taylor's call for work on how 'patterns of authority and submission become part of the sexed personality', and concentrating on the experience and mentality of the oppressors as well as the oppressed.[46]

GENDER AS RELATIONAL

If we are to unravel the complex ties between power and identity, we have to look not only at how women's subordination has been constructed at various moments in history but in a much more all-embracing way at how gender inhabits social structures, practices and the imagination. Instead of trying to define boundaries between male dominance and categories of race or class, as much of the literature on patriarchy seeks to do, we explore how such categories are themselves fractured along gender lines.[47] As Joan Acker has recently pointed out, this kind of perspective reveals new dimensions to activities which had previously been thought of as having little to do with gender: in this volume, activities as diverse as journalism, business strategy, apprenticeship and definitions of skill; even the process of history writing itself.[48]

Admittedly, an approach focused on gender relations risks blurring what Acker has termed the 'critical-political sharpness' of patriarchy, because it widens the theoretical objective from the study of women's subordination.[49] But it does nevertheless offer the potential for radically recasting the mould of historical enquiry, because it sees gender as an organizing principle of social structures, institutions and practices. This is reflected in the contributions below, particularly those which deal with the relationship between masculinity and work. In his chapter on the respectable artisan, for example, Keith McClelland sets out a general context during the 1860s of hardening employment boundaries, as women were entirely excluded from some industries (mining for example) and limited to less skilled jobs in others. The growing predominance of working-class men in skilled trades went hand in hand with the construction of masculinity through rites of apprenticeship, and a notion that the purpose of wage labour

was the support of dependants in the home. So while at one level respectability might be viewed as an 'exclusionary principle', it must also be seen as the product of historically specific links between gender identity and the work culture. Michael Roper's study of the post-war generation of managers a century later indicates an entirely different kind of investment of masculinity in work, but with a similar outcome. While women continued to be excluded from better paid jobs, a lifetime's passion for technology rather than artisanal skill provided the exclusionary principle. Furthermore, while the artisan of the 1860s gained manly pride from his breadwinning wage, the post-war manager, assured of his means, expressed masculinity directly in product fetishism.

A closer look at the interface between identity and power relations also reveals that women's and men's attempts to exert pressure on prevailing notions of masculinity have had an impact – albeit limited – on sexual inequalities. Even in the late nineteenth century, ideologies of manliness did not go unchallenged. In her study of Salvationist men, Pamela Walker shows how women used the Army's ideas about Christian manliness to control men's behaviour. For men, conversion entailed renouncing the drinking and gambling which had often proved injurious to women. While Salvationist women gained power through membership of the Army, so too men felt that they had won a superior kind of manliness. In a very different way, Peter Lewis's autobiographical essay demonstrates that the beneficiaries of hegemonic masculinity may question the basis of their privileges, and like the Salvationist men, seek to renounce them. Having spent from infancy to his thirties in public schools as housemaster's son, pupil and teacher, Lewis is prompted to write by a recognition of how the institution constrained his adult relationships with women. In their conscious attempts to change themselves, heterosexual men may have shed more light on the personal constraints of masculinity in the domestic sphere, than on their power in society.[50] However partial and contradictory, and however prone to the ambiguities of transforming masculinity while maintaining traditional privileges, such attempts are nevertheless significant, as Lynne Segal notes, 'simply as evidence that men *can* change'.[51]

Adopting a relational approach to gender has important implications for the way we think about public and private life. Following the precedent set by men like Thomas Carlyle, historians have for too long separated public and private, writing about the public domain as if it were exclusively male, and confining women to the private and

domestic realms. 'Manliness' has been discussed as a facet of public school education or British authority in the Empire; but as we have already indicated, its relationship to women and to constructions of femininity has largely been ignored. The consequence is that both women's agency in the public sphere and the scope of men's private lives have tended to be denied. The work of Leonore Davidoff and Catherine Hall, on the other hand, has shown that ideologies about femininity were always implicit in the conduct of public affairs among the middle class, even at a time when the notion of separate spheres was approaching its zenith. They point out that the 'male' world of business functioned to support domesticity, which was the main prop of moral and religious life.[52]

This book also explores the construction of public and private domains along lines of gender. John Tosh points out below that historians of the nineteenth century have rarely noted any link between manliness and domesticity, keeping the paterfamilias and the public man in separate compartments. In his own account of the Benson family, as in Norma Clarke's study of Thomas Carlyle, it is clear that the wielding of authority over dependants in the home provided a foundation for men's public activities. In Edward Benson's case there seemed an inverse relationship between public prominence and domestic happiness: he felt great fondness for his sons, but they only remembered his heavy paternal hand. Both cases reveal the kinds of household labour which were necessary in order to sustain the Great Man's public eminence.

Understanding gender in relational terms is also important because, as a number of writers have pointed out, dominant or 'hegemonic' masculinities function by asserting their superiority over the 'other', whether that be gay men, younger men, women, or subordinated ethnic groups.[53] In institutions like the public school, manliness is defined through elaborate rituals in which supposedly feminine behaviour is ferreted out and lampooned. Hence Peter Lewis identifies a pattern common to *Tom Brown's Schooldays* and his own education a century later, that while women played a central role as workers and 'stand-in' mothers, their activities were continually dismissed as peripheral. While mummy, matron and the maids serviced the boys' physical and emotional needs, the achievement of manhood depended on a disparagement of the feminine without and within.[54]

Dominant ideologies of masculinity are also maintained through asserting their difference from – and superiority to – other races. This was especially true of Britain's long ascendancy over the Third World

from 1815 up to the mid twentieth century. British colonial rule was partly justified by a conception of English manhood as a civilizing force. 'Courage, independence, veracity', qualities which Thomas Babington Macaulay found so lacking among Bengalis in the 1830s, were precisely those then regarded as integral to manliness in Britain, and which it was the imperial mission to instil in lesser breeds.[55] At the same time, the imagining of black masculinity was shaped by the multiple repressions of the dominant form of masculinity in Britain at that time. The negative attributes of lasciviousness and idleness, which the colonizers commonly fastened on to both Indians and Africans, represented a projection of their own unacknowledged desires.[56]

In this book we take the exploration of masculinity and race one stage further. The chapters by Graham Dawson on Lawrence of Arabia and by Kelly Boyd on boys' story magazines relate to the years after 1914, when the Empire's symbolic role in affirming the values of metropolitan masculinity grew more important as Britain's material decline from its nineteenth-century apogee began to enter public consciousness. But the connection between masculinity and representations of the Empire was complicated by the inclusion of supposedly non-white masculine traits in depictions of English manhood. Boyd's magazine heroes had often grown up among natives in the wilds of Africa before being subjected to the discipline and civility of the English school; in this context the ideal boy hero harnessed an element of untamed savagery to polished manners. Dawson points out that depictions of Lawrence of Arabia as hero depended on a similarly delicate balancing act, incorporating aspects of Arab identity such as fighting prowess or geographical knowledge, while at the same time stressing the superiority of English culture and technology. Lawrence's 'Englishness' is enhanced by beating the Arabs at their own game. Dawson's analysis warns us against viewing masculinity in isolation from, or as the simple opposite of, subordinated identities, for the former may well gain enhanced potency by taking on the guise of the 'other'.[57]

So masculinity entails an interweaving of men's social power with a range of cultural representations, both dominant and subordinate. This is further complicated by the fact that it is the product both of lived experience and fantasy. As Dawson remarks below, masculine identities are 'lived out in the flesh, but fashioned in the imagination'. Social and psychic domains are closely woven: how men would like to be has obvious implications for the ways in which they act in everyday life. A common theme running through our contributions is the

14

conviction that men's behaviour – and ultimately their social power – cannot be fathomed merely in terms of externally derived social roles, but requires that we explore how cultural representations become part of subjective identity. Conversely, we look for ways in which fears, pleasures and desires may enter the social domain. Klaus Theweleit has used the letters, diaries and novels of the Nazi *Freikorps* in the late 1920s to propose a far-reaching psychoanalytic interpretation of German fascism, which explains the soldiers' behaviour as acted-out fantasy. But phenomena like fascism are not simply male fantasy run riot.[58] While masculinity entails psychic conflicts and desires which are sometimes played out in public arenas, the relationship between action and fantasy is diffuse and often paradoxical.

The recent literature on the experience of British soldiers during the First World War illustrates how contradictory the connections between the psychic and the social dimensions of masculinity may be. On the one hand, Elaine Showalter has located male hysteria or 'shell shock' in the context of a crisis in middle-class masculinity, as the 'strong, unreflective masculinity' of Edwardian society was put to impossible test by the realities of trench warfare.[59] On the other hand, inverting that analysis completely, Claire Tylee has argued that the war was 'maleness run riot'. It held a certain 'vile attraction' for male combatants, the repression of which gave rise to war neuroses.[60] Both interpretations have validity, but only once we recognize that desire, experience and 'hegemonic' masculinity rarely translate directly one to another. Thus while militarism can be viewed as rampant masculinity, and individual men may have experienced battle as erotic,[61] even the more privileged class of combatants were also war's victims.

In direct opposition to Theweleit then, the contributions to this book illustrate the fragility of masculinity at the psychic level rather than elaborating on its role as a foundation for men's social power. Indeed the very process of acquiring social dominance may be subjectively experienced as oppression. This tension between empowerment and experience is most apparent in Peter Lewis's account of his schooling in the post-war years. Other commentators have pointed out the critical role played by the public schools in shaping the sexual identities of British middle-class men. For example Andrew Tolson argues that public school precepts were 'internalised in an obsessive masculinity', which thrived on fantasies of sexual mastery while discouraging emotional expression.[62] But while Tolson seeks to understand the public school's contribution to a social order grounded in sexual domination by men, Lewis recalls the terrible loneliness of an environ-

ment where bodily gratification, fantasy and emotional expression were separated from one other. We see here the contradiction between a cultural institution which shaped the psyche for the purposes of social and political leadership, and the perception of its subjects that far from being empowered by the experience, were victims.

Similar rifts between power and identity are apparent all the way through this book, from the man of letters in the early nineteenth century to the company man of the 1950s. Thus Norma Clarke illustrates how Thomas Carlyle's neurotic insecurities about his masculinity led him from a search for one father-figure after another in his early twenties, to a mature confidence secured only through the displacement of his real father from the position of household head. With a similar eye to the interaction between social power and subjective experience in the domestic domain, John Tosh shows how Edward Benson's authority depended on projecting his needs for dependence on to his wife Mary, consigning her to the position of an eternal child-bride. The managers in Michael Roper's study also depended on women to service their activities at work, but they experienced that work in a very ambivalent way: much of their emotional energy was spent in fending off a younger generation of men who threatened to deny them the pleasures of 'hands-on' involvement in production. Diverse in their historical setting, at the same time these examples echo each other in demonstrating that instances of male dominance may also, at the psychic level, indicate the tenuousness of men's hold over power. Indeed, we might well conclude that the investment of masculinity in power is far from entirely beneficial either to men's psychic well-being or even the efficient perpetuation of their power.

MASCULINITY IN CRISIS?

Public discourses about manly behaviour and demeanour have perhaps never been so contentious as during the period covered by this book, reflecting the fact that the definition of masculinity is itself a site of struggle. The assertion of other forms of social power is often framed in terms of a discourse about manliness. In the mid nineteenth century this was patently true of class and religion. These key Victorian categories often found expression in sharply dichotomized notions about masculinity – Reason versus Feeling, Mind versus Body, and – in their construction of 'the other' – the Child versus the Feminine. Dr Arnold of Rugby, for example, equated manliness with intellectual

16

energy, moral purpose and sexual purity, attributes which were exemplified in the life of his follower, Edward Benson. Arnold's exact contemporary, Thomas Carlyle, asserted a much more aggressive notion of manliness, stressing the superiority of the will and a rugged independence over the Christian virtues. The juxtaposition of Arnold and Carlyle illustrates the variety of discourses about masculinity at a given time, but more importantly their uneasy and often unstable ordering in a gender hierarchy. Arnold's code of manliness came to epitomize the values of the governing elite in Britain after 1832. One way of understanding the shift in political culture during the era of the New Imperialism is to see it as the eventual triumph of Carlyle over Arnold. By the 1880s Carlyle could be saluted in retrospect as a prophet because, according to Catherine Hall's recent account, he had anticipated some of the key attributes of Imperial Man: the emphasis on face-to-face authority, the celebration of the will, and the unequivocal assertion of racial superiority.[63]

In understanding how masculinity has been a dynamic of history, this volatile and unstable quality is particularly important. Transitions from one 'dominant' masculinity to another did not only take place at the level of precept; an equally important question for historians is how they were experienced by individual men. One of the most precarious moments in the reproduction of masculinity is the transfer of power to the succeeding generation, whether it be within the family from father to son, via apprenticeship in the case of skilled workers, or by 'palace revolutions' in business. The key question is whether the 'sons' take on the older generation's gender identity without question, or whether they mount a challenge, and if so how. In Tosh's account, the sons of Edward Benson, in living out a 'Uranian' (homoerotic) lifestyle, were making a discreet but pointed protest against the domesticated masculinity of their father, and one that was echoed by many other upper-middle-class men between 1880 and 1914. Peter Lewis's memoir of growing up in a succession of all-male institutions during and after the Second World War is itself an inter-generational challenge.

In recent years the work of Nancy Chodorow has gained popularity among some feminists and writers in the 'men's movement' because she appears to offer a psychodynamic explanation for men's seemingly eternal anxiety about their gender. Gender identity, according to this view, is more problematic for men than women because of the difficulties faced by boys in freeing themselves from infant identification with the mother.[64] In the context of this volume however, we prefer to locate this insecurity not in the object relations of infancy, but

in the simple fact that the passage from boyhood to manhood has traditionally been so bound up with expectations of and fantasies about power, not only in the home but in the workplace, politics and sport. Despite the myths of omnipotent manhood which surround us, masculinity is never fully possessed, but must perpetually be achieved, asserted, and renegotiated. As the anthropologist Michelle Rosaldo has put it, 'A woman becomes a woman by following in her mother's footsteps, whereas there must be a break in a man's experience. For a boy to become an adult, he must prove himself – his masculinity – among his peers. And although all boys may succeed in reaching manhood, cultures treat this development as something that each individual has achieved.'[65]

Rosaldo's comments neatly capture the fact that the achievement of masculinity is tenuous because power itself is in a continual process of contestation and transformation. To fill this out in historical terms, it is clear for example from Keith McClelland's account that nineteenth-century trade apprenticeship involved a measure of solidarity between men in excluding women, but also competition between them for access to craft lore. The enmeshing of masculinity and work in this way also meant that unemployment might be experienced by the respectable artisan, 'not only as economic but also as psychic depression'.[66] Even among middle-class men, the goal of economic self-sufficiency and freedom from patronage was elusive. Mastery of one's fate was to an extent an illusion; the vagaries of the market saw to that. In the memorable complaint of a Norfolk seed-merchant who came close to ruin in the early nineteenth century, 'I may be a man one day and a mouse the next'.[67] The association of manhood with gainful employment was, therefore, also potentially undermining of masculine status. Kelly Boyd's analysis of boys' story papers between the Wars bears on a similar theme: it is no coincidence that the increasing portrayal of ordinary boys in heroic roles during the inter-war period took place at a time when the actual prospects for 'manful assertion' were dimmed by scarce apprenticeships and declining employment. When young men cannot find work, not only their income but their masculinity is threatened.

The idea of a 'crisis in masculinity' may be an invention of the 1980s.[68] But given that it expresses this kind of contradiction between experience and expectation, its relevance is clearly not confined to the present. Masculinity is always bound up with negotiations about power, and is therefore often experienced as tenuous. It is clear that there are periods when changed social conditions frustrate on a large

scale the individual achievement of masculinity, and at such times the social and political fall-out may be considerable. A crisis in masculinity is precisely what many male office clerks experienced in the late Victorian period, as they saw their somewhat ambivalent occupational status undermined still further by the recruitment of female clerks; it was men from just this kind of background who formed the mainstay of the Jingo crowd.[69] Equally, the growth of the Boy Scout movement after 1908 can be seen not only as a response to fears about physical degeneration but as a means whereby lower-middle-class boys and scout-masters alike could try to enhance their masculine status at a time when the home was increasingly perceived as a feminine preserve.[70]

The current concern to scrutinize masculinity – of which this book is one instance – may itself be interpreted as a symptom of masculinity in crisis. In this Introduction we have placed our themes in the context of feminist and feminist-inspired thinking. But there is no doubt that received notions of masculinity among middle-class professional men – particularly those on the Left – have been placed under severe strain during the past twenty years. A decade of Conservative government has seen their economic and social status steadily decline. The general devaluation of education and the 'nanny' state has resulted in the subordination of this generation to a new masculine discourse of efficiency, competition and the pursuit of profit. At the same time, women's higher public profile and their challenges to the division of labour within the home have forced this generation of men to keep questioning their behaviour and politics. The recent spate of publications about masculinity, therefore, is a consequence as much of men's need to take stock of their masculinity as of women's determination to include the study of men within a feminist critique. However it is not our purpose to analyse the current state of masculinity in Britain – whether in crisis or underpinning the transition to a new era of male supremacy. Our contention is simply that attempts to fathom the perplexities of present-day masculinities will founder unless they are securely based in a historical perspective. The range of our essays is intended to direct the reader towards shifts over time in men's gender identities and in the nature of power relations between men and women. Our primary aim is to demonstrate that masculinity has a history, and that this history entails a complex interweaving of power with both imagined and lived masculine identities. For in our assertion that both male dominance and masculinity have shifted over time lies the possibility that they will not always be entirely fused.

NOTES

1 See chapter 2, p. 38.
2 J. R. Hale, (ed.), *The Evolution of British Historiography*, London, Macmillan, 1967; John Kenyon, *The History Men*, London, Weidenfeld & Nicolson, 1983.
3 Norman Vance, *The Sinews of the Spirit: the Ideal of Christian Manliness in Victorian Literature and Religious Thought*, Cambridge, Cambridge University Press, 1985. See also Mark Girouard, *The Return to Camelot: Chivalry and the English Gentleman*, Hartford and London, Yale University Press, 1981; and J. A. Mangan and James Walvin (eds), *Manliness and Morality: Middle-class Masculinity in Britain and America, 1800–1940*, Manchester, Manchester University Press, 1987, especially chapters by Jeffrey Richards and J. A. Mangan.
4 J. A. Mangan, *Athleticism in the Victorian and Edwardian Public School: the Emergence and Consolidation of an Educational Ideology*, Cambridge, Cambridge University Press, 1981; John Springhall, *Youth, Empire and Society: British Youth Movements, 1883 to 1940*, London, Croom Helm, 1977; Michael Rosenthal, *The Character Factory: Baden-Powell and the Origins of the Boy Scout Movement*, London, Collins, 1986; Mangan and Walvin, *Manliness and Morality*, especially chapters by John Springhall, Jeffrey Richards, J. A. Mangan and Allen Warren.
5 David Newsome, *Godliness and Good Learning: Four Studies on a Victorian Ideal*, London, John Murray, 1961; Vance, *Sinews of the Spirit*.
6 Stefan Collini, '"Manly Fellows": Fawcett, Stephen and the Liberal Temper', and Boyd Hilton, 'Manliness, Masculinity and the Mid-Victorian Temperament', both in Lawrence Goldman (ed.), *The Blind Victorian: Henry Fawcett and British Liberalism*, Cambridge, Cambridge University Press, 1989.
7 John MacKenzie, 'The Imperial Pioneer and Hunter and the British Masculine Stereotype in Late Victorian and Edwardian Times', in Mangan and Walvin, *Manliness and Morality*; George L. Mosse, *Nationalism and Sexuality: Respectability and Abnormal Sexuality in Modern Europe*, New York, Howard Fertig, 1985.
8 See for example Rosenthal, *Character Factory*.
9 Susan Chitty, *The Beast and the Monk: a Life of Charles Kingsley*, London, Hodder & Stoughton, 1974; Peter Gay, *The Bourgeois Experience: From Victoria to Freud*, vol. 2, *The Tender Passion*, New York, Oxford University Press, 1986, pp. 297–312.
10 See below, chapter 3, p. 44.
11 Newsome, *Godliness and Good Learning*.
12 The position is much less bleak with the appearance of Leonore Davidoff and Catherine Hall, *Family Fortunes: Men and Women of the English Middle Class, 1780–1850*, London, Hutchinson, 1987; see also David Roberts, 'The Paterfamilias and the Victorian Governing Classes', in Anthony S. Wohl (ed.), *The Victorian Family*, London, Croom Helm, 1977. But these strictures still largely apply to the post-1914 period.
13 Lynne Segal, *Slow Motion: Changing Masculinities, Changing Men*, London, Virago, 1990, esp. p. 10.
14 John Boswell, *Christianity, Social Tolerance, and Homosexuality*, Chicago, Chicago University Press, 1980; Alan Bray, *Homosexuality in Renaissance England*, London, Gay Men's Press, 1982; Jeffrey Weeks, *Coming Out:*

Homosexual Politics in Britain from the Nineteenth Century to the Present, London, Quartet, 1977.

15 Bray, *Homosexuality*, p. 104.

16 Jeffrey Weeks, *Sexuality and Its Discontents*, London, Routledge, 1985, p. 6.

17 Jeffrey Weeks, *Sex, Politics and Society: The Regulation of Sexuality since 1800*, London, Longman, 1981, p. 107; John Marshall, 'Pansies, Perverts and Macho Men: Changing Conceptions of Male Homosexuality', in Kenneth Plummer (ed.), *The Making of the Modern Homosexual*, London, Hutchinson, 1981, pp. 137–8.

18 Andy Metcalf and Martin Humphries (eds), *The Sexuality of Men*, London, Pluto, 1985.

19 Victor J. Seidler, *Rediscovering Masculinity: Reason, Language and Sexuality*, London, Routledge, 1989, p. 21.

20 Donald Bell, 'Up from Patriarchy: Men's Role in Historical Perspective', in Robert A. Lewis (ed.), *Men In Difficult Times*, Englewood Cliffs, Prentice-Hall, 1981.

21 John Stuart Mill and Edward Carpenter spring to mind. Past heroes have more often been talked about than written about in the men's movement, but see Sylvia Strauss, *'Traitors to the Masculine Cause': the Men's Campaigns for Women's Rights*, Westport, Greenwood, 1983; and Sheila Rowbotham and Jeffrey Weeks, *Socialism and the New Life: the Personal and Sexual Politics of Edward Carpenter and Havelock Ellis*, London, Pluto, 1977.

22 Andrew Tolson, *The Limits of Masculinity*, London, Tavistock, 1977.

23 Seidler, *Rediscovering Masculinity*, pp. 14–21.

24 Quoted in Aileen S. Kraditor (ed.), *Up From the Pedestal*, New York, Quadrant, 1968, pp. 110–11.

25 Cynthia Cockburn, 'Masculinity, the Left and Feminism', in Rowena Chapman and Jonathan Rutherford (eds), *Male Order: Unwrapping Masculinity*, London, Lawrence & Wishart, 1988, pp. 316–17.

26 For assessments of this transition, see Jane Lewis, 'Women, Lost and Found: the Impact of Feminism on History', in Dale Spender (ed.), *Men's Studies Modified*, Oxford, Pergamon, 1981; Joan Scott, *Gender and the Politics of History*, New York, Columbia University Press, 1988; Carroll Smith Rosenberg, *Disorderly Conduct: Visions of Gender in Victorian America*, New York, Oxford University Press, 1986, chapter 1 ('Hearing Women's Words'); Gisela Bock, 'Women's History and Gender History: Aspects of an International Debate', *Gender and History*, vol. 1, no. 1 (1989), pp. 7–30.

27 Natalie Zemon Davis, ' "Women's History" in Transition: the European Case', *Feminist Studies*, vol. 3 (1975–6), p. 90.

28 Jane Lewis (ed.), *Labour and Love*, Oxford, Blackwell, 1986, editor's Introduction, p. 4.

29 Bock, 'Women's History and Gender History', p. 18.

30 Tim Carrigan, Bob Connell and John Lee, 'Hard and Heavy: Toward a New Sociology of Masculinity', in Michael Kaufman (ed.), *Beyond Patriarchy: Essays by Men on Pleasure, Power and Change*, Toronto, Oxford University Press, 1987.

31 John Bowen, in *Literature Teaching Politics 1985: Conference Papers*, Bristol, Bristol Polytechnic, 1985, p. 43.

32 Joan Acker, 'The Problem With Patriarchy', *Sociology*, vol. 23, no. 2 (May 1989), p. 235.

33 For example, some interpretations focus on male control over women's sexuality and fertility (M. Mackintosh, 'Reproduction and Property: a Critique of Meillassoux', *Capital and Class*, vol. 2 (1977)); others on women's labour power (see esp. Sylvia Walby, *Patriarchy at Work*, Cambridge, Polity, 1986), and yet others on men's institutional power in finance, politics, the military and police (particularly Kate Millet, *Sexual Politics*, London, Virago, [1970], 1977). For summaries of the various approaches, see Veronica Beechey, 'On Patriarchy', *Feminist Review*, no. 3 (1979), pp. 66–83; Sylvia Walby, *Patriarchy at Work*, chapters 2 and 3; and Harriet Bradley, *Men's Work, Women's Work: a Sociological History of the Sexual Division of Labour in Employment*, Cambridge, Polity, 1989, chapter 3.

34 Sally Alexander and Barbara Taylor, 'In Defence of "Patriarchy",' in R. Samuel (ed.), *People's History and Socialist Theory*, London, Routledge, 1981, p. 372.

35 While rejecting the term, Sheila Rowbotham nevertheless understood its appeal in similar terms: as a means of explaining the deep-seated nature of male dominance. Patriarchy had emerged from a 'realisation that we needed to resist not only the outer folds of power structures but their inner coils. For their hold over our lives through symbol, myth and archetype would not dissolve automatically with the other bondages, even in the fierce heat of revolution' (Sheila Rowbotham, 'The Trouble with "Patriarchy" ', in Samuel, *People's History*, p. 365).

36 Rowbotham, 'The Trouble with Patriarchy', p. 365. Her views are echoed by Bradley, *Men's Work, Women's Work*, p. 55.

37 See esp. Cockburn, *Brothers*, pp. 197–9; Walby, *Patriarchy at Work*.

38 Carrigan *et al.*, 'Hard and Heavy', p. 141.

39 Walby, *Patriarchy at Work*, p. 167.

40 Walby, *Patriarchy at Work*, pp. 166–7.

41 Walby, 'Theorising Patriarchy', *Sociology*, vol. 23, no. 2 (1989), pp. 216, 223.

42 In Walby's view the nature of work influences the intensity but not the character of masculinity: certain forms of work 'will provide its practitioners with a reinforcement of their masculinity'. She argues that men may have less or more of it depending on their work, whereas it is surely more important to discover how work itself might actively construct, and effect changes in, masculinity (Walby, 'Theorising Patriarchy', p. 227).

43 For a discussion of Weber's use of the term, see Malcolm Waters, 'Patriarchy and Viriarchy: an exploration and Reconstruction of Concepts of Masculine Domination', *Sociology*, vol. 23, no. 2 (1989), pp. 195–7.

44 Sylvia Walby entirely rejects the application of the term to the nature of power relations between men, arguing that it should pertain solely to men's domination of women. See Walby, *Sociology*, vol. 23, no. 2 (1989), p. 214.

45 Cynthia Cockburn, *Brothers: Male Dominance and Technological Change*, London, Pluto, 1983. See esp. chapter 2. Indeed, as Cockburn observes elsewhere, men themselves have sometimes been more conscious of the hierarchy by age than of gender dichotomies. 'Introduction: Forum, Formations of Masculinity', *Gender and History*, vol. 1, no. 2 (1989), pp. 161–2.

46 Alexander and Taylor, 'In Defence of Patriarchy', p. 372.
47 This theme is explored by Leonore Davidoff, ' "Adam Spoke First and Named the Orders of the World": Masculine and Feminine Domains in History and Sociology', in H. Corr and L. Jamieson (eds), *The Politics of Everyday Life: Continuity and Change in Work, Labour and the Family*, London, Macmillan, 1990.
48 Acker, 'The Problem with Patriarchy', p. 238.
49 Acker, 'The Problem with Patriarchy', p. 239.
50 R. W. Connell, *Gender and Power*, Cambridge, Polity, 1987, pp. 234–5, 276; Michael Roper, 'Introduction: Recent Books on Masculinity', *History Workshop Journal*, 29, (spring 1990), pp. 184–7; Segal, *Slow Motion*, p. 288.
51 Segal, *Slow Motion*, p. 290.
52 Davidoff and Hall, *Family Fortunes*, p. 225.
53 Segal, *Slow Motion*, pp. x–xi; Carrigan *et al.*, 'Hard and Heavy', pp. 174, 179.
54 Christine Heward makes a similar point about public school education in the inter-war period, by stressing that mothers were commonly perceived as a threat to their son's intellectual development (*Making a Man of Him: Parents and their Sons' Education at an English Public School*, London, Routledge, 1988, pp. 178–9).
55 Quoted in John Rosselli, 'The Self-Image of Effeteness: Physical Education and Nationalism in Nineteenth-Century Bengal', *Past & Present*, vol. 86 (1980), p. 122; see also Mrinahini Sinha, 'Gender and Imperialism: Colonial Policy and the Ideology of Moral Imperialism in Late Nineteenth-Century Bengal', in Michael S. Kimmel (ed.), *Changing Men: New Directions in Research on Men and Masculinity*, London, Sage, 1987, pp. 217–31.
56 See Catherine Hall, 'The Economy of Intellectual Prestige: Thomas Carlyle, John Stuart Mill, and the Case of Governor Eyre', *Cultural Critique*, vol. 12 (1989), esp. pp. 179–80; and more generally, Segal, *Slow Motion*, pp. 169–75.
57 In *Male Order*, both Rowena Chapman and Suzanne Moore discuss a similar phenomenon: the 'colonization' of the feminine by the 'new man'. See 'The Great Pretender: Variations on the New Man Theme', pp. 225–49; and 'Getting a Bit of the Other – the Pimps of Postmodernism', pp. 165–93.
58 K. Theweleit, *Male Fantasies: Women, Floods, Bodies, History*, Cambridge, Polity, 1987. Theweleit's analysis of the texts themselves is provocative and insightful, but he draws little distinction between fantasy and action.
59 Elaine Showalter, *The Female Malady: Women, Madness and English Culture 1830–1980*, London, Virago, 1987.
60 Claire Tylee, ' "Maleness Run riot" – the Great War and Women's Resistance to Militarism', *Women's Studies International Forum*, vol. 11, no. 3 (1988), pp. 203–4.
61 P. Fussell, *The Great War and Modern Memory*, Oxford, Oxford University Press, 1975, p. 270.
62 Tolson, *The Limits of Masculinity*, pp. 35–6, 84–5.
63 Hall, 'Economy of Intellectual Prestige'.
64 Nancy Chodorow, *The Reproduction of Mothering: Psychoanalysis and the Sociology of Gender*, Berkeley, University of California Press, 1978. See also the critique by Jennifer Somerville, 'The Sexuality of Men and the Sociology of Gender', *The Sociological Review*, vol. 37, no. 2 (May 1989). In so

far as Chodorow's controversial theory lends itself to historical application, it is worth stressing that her 'given' begs the critical question of whether exclusive maternal care has been a constant of Western culture: research on working-class communities in Britain since the mid eighteenth century suggests a much more varied picture, with several instances of a division of labour between a husband caring for children and a wife out at work (Margaret Hewitt, *Wives and Mothers in Victorian Industry*, London, Routledge, 1957; John Rule, *The Labouring Classes of Early Industrial England*, London, Longman, 1986, chapter 7).

65 Michelle Z. Rosaldo, 'Woman, Culture and Society: a Theoretical Overview', in M. Z. Rosaldo and L. Lamphere (eds), *Woman, Culture, and Society*, Stanford, Stanford University Press, 1974, p. 28.

66 Walker also notes below that intermittent employment undermined a working man's status as household head. See also Ellen Ross, ' "Fierce Questions and Taunts": Married Life in Working Class London, 1870–1914', *Feminist Studies*, vol. 8 (1982), pp. 575–602.

67 Davidoff and Hall, *Family Fortunes*, p. 229.

68 For discussions about contemporary 'crises' in masculinity, see Connell, *Gender and Power*, pp. 158–63; Arthur Brittan, *Masculinity and Power*, Oxford, Blackwell, 1989, pp. 25–35. See also Peter Filene, *Him/Her/Self: Sex Roles in Modern America*, 2nd edition, Baltimore, Johns Hopkins Press, 1986, p. 213.

69 Gregory Anderson, *Victorian Clerks*, Manchester, Manchester University Press, 1976, pp. 56–60; Richard N. Price, 'Society, Status and Jingoism: the Social Roots of Lower Middle Class Patriotism, 1870–1900', in Geoffrey Crossick (ed.), *The Lower Middle Class in Britain, 1870–1914*, London, Croom Helm, 1977.

70 This analysis is clearest in the American case: see Jeffrey P. Hantover, 'The Boy Scouts and the Validation of Masculinity', in Elizabeth and Joseph H. Pleck (eds), *The American Man*, Englewood Cliffs, Prentice Hall, 1980. On the British case, see Rosenthal, *The Character Factory*.

2

STRENUOUS IDLENESS
Thomas Carlyle and the man of letters as hero

Norma Clarke

On 1 January 1824, Thomas Carlyle sat down to write a New Year's Day letter to his younger brother, John. Thomas Carlyle was in Perthshire, earning £200 per annum as private tutor to the two sons of a wealthy Anglo-Indian family, the Bullers, while beginning to establish a name for himself as a writer. He hated teaching. His brother John was a student in Edinburgh, studying medicine, but hankering, like his brother, after a literary life. By such means as translations and encyclopaedic hackwork, Thomas Carlyle had begun to make literature pay. His income from literature was not enormous, but, combined with his generous salary as tutor, it was enough to finance his younger brother's medical studies.

In his letter, Thomas Carlyle mixed his usual dose of encouragement and exhortation for the hapless John, who was never to pursue medicine with any diligence. He urged him to persist in his studies, however repugnant he found them. The pursuit of knowlege, Thomas loftily reminded John, was in itself noble. There was, he observed, 'nothing more interesting than to see a young man striving with all his energies towards such an object, and controuling [sic] his desires for pleasure and his dissatisfaction under painful restraint, consenting to be unhappy for the present that he may be happy and honoured in the future'. Furthermore, even if John did, eventually, decide to devote himself to literature, a professional qualification would provide some security; was indeed, from the vantage-point of an elder brother whose only secure source of income was tutoring, an obvious and easily accomplished advantage:

> a man who is not born to some independency, if he means to devote himself to literature properly so called . . . *ought* to study some profession which as a first preliminary will enable him to live. It is galling and heartbreaking to live on the precarious

windfalls of literature: and the idea that one has not *time* for practicing [*sic*] an honest calling is stark delusion. I could have studied three professions in the time I have been forced (for want of one) to spend in strenuous idleness.[1]

In writing thus to his brother, Thomas Carlyle was also, quite clearly, writing about himself. The noble ideal he held up for John was the light he tried to cheer his own life by: present misery, when allied to distant but worthy ends, led to happiness and honour. Signs of struggle in a young man were 'interesting' because they suggested his innate quality. The opposite of struggle was surrender: a giving in to the life of ease or impulse, abandoning higher (but as yet ungraspable) good for lower (immediate) pleasure. For young men like themselves, of peasant stock, the happiness and honour they might hope to achieve by present restraint was the honour and happiness of rising by merit into those social classes with which they were becoming familiar as tutor and as student.

The phrase 'strenuous idleness' was one Thomas Carlyle had used a few years earlier, again when writing to John. In 1821 he had confessed that he felt 'shame' and 'misery . . . at this age to be gliding about in strenuous idleness, with no hand in the game of life, where I have yet so much to win, no outlet for the restless faculties'.[2]

Strenuous and restless Thomas Carlyle certainly was, but any reader of his letters of the period would be hard put to describe him as idle: the quantity of books that passed through his hands, the sheer volume of intellectual labour he engaged in, was daunting. But the two words, pulling in different directions, point to a conflict that may be understood in gendered terms. The words themselves are like gender signposts: 'strenuous' denoting a male world of validation through hard work; 'idleness' a female world of leisure, also applied in its biblical sense to mean worthless. Having begun, by 1824, to devote himself to 'literature properly so called', without the protection of a masculine profession, Carlyle felt the vulnerabilities he warned his brother against. Financial in the first instance, these vulnerabilities had other sources which were less easily spoken about: viz., the uncertainly gendered social identity which literature might bring with it.

It was plain from both contexts in which Carlyle employed the phrase 'strenuous idleness', that strenuousness did not succeed in vanquishing idleness. Rather, idleness undermined strenuousness, turning it into a marginalized form of 'gliding about', an unproductive self-torture. In failing to get a good grip on 'the game of life', Thomas Carlyle judged himself at risk of failing to be sufficiently manly.

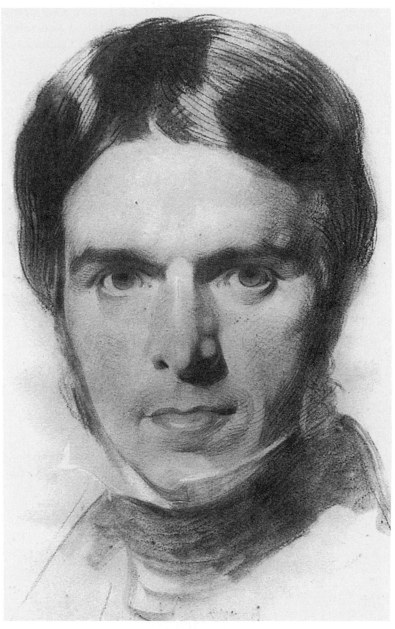

1 Portrait of Thomas Carlyle by Samuel Lawrence, 1838. (By kind permission of the National Trust Photographic Library)

He had drifted into the life of a private tutor after failing, for years, to settle into studying for a profession. The outstandingly promising eldest son of Scottish peasants, Carlyle had been sent at 14 – walking all the way – to Edinburgh, to be trained for the ministry. In the years of semi-independence that followed, he had painfully come to understand that he could not fulfil his parents' hopes. This was no small matter; they were devout, narrow Calvinists, and their son's loss of faith was a source of profound family anguish. It led to furious doctrinal quarrels at the time; was probably at the root of his mother's violent mental breakdown in 1816–17, which was so severe she had to be put 'under restraint away from home';[3] and it provoked a guilt and anxiety in Carlyle that dogged him for the rest of his days. Turning his back on the Church, he had rather half-heartedly attempted to study law; failing in this, he had begun to put together an income and a barely endurable existence out of the piecework of hack writing and tutoring. Neither of these pursuits rated as 'an honest calling'; each was rather a source of shame. They held in them no prospect of future status or security. On 1 January 1824, when he wrote to his brother, Thomas Carlyle was 28 years of age, deeply dissatisfied with his achievements to date, suffering badly from insomnia and dyspepsia, and in a state of chronic anxiety.

But the year that stretched ahead, the third year of employment as a private tutor, was to be a significant one. Two books were already in the press: Carlyle's translation of Goethe's *Wilhelm Meister*, and his own first full-length biographical and critical work, the *Life of Schiller*. No matter how 'galling and heartbreaking' he knew it to be, his hopes were nevertheless set by then on making a living through literature. He was encouraged in his convictions of personal genius by the Bullers and their middle-class and aristocratic connections. As tutor to the Buller boys he was treated with a respect and given a licence that would have made the average governess of the time green with envy, though he found his position insupportable. He was determined to leave, but in the meantime agreed to accompany the Bullers on an extended trip to London in the summer of 1824. It was his first experience of London and London was, of course, the acknowledged centre of literary life.

Carlyle came to London as a newly published young author, whose prospects were by no means yet clear to him. Throughout his stay, he was preoccupied with the need to shape possibilities for his future. He consciously looked about him for models. It was inevitable that he should light first on Coleridge, the man in whose intellectual footsteps he had long been treading. Marilyn Butler, in *Romantics, Rebels and*

Reactionaries (1981), identifies Coleridge as the first English representative of the man of letters: the professional intellectual, earning a living and a place by what he had to say in speech and writing.[4] In the 1820s such a figure, anxiously hauling himself apart from the Grub Street associations of his trade, had no name. But he had a ready audience; the practice of visiting in order to listen in homage and attentiveness was well-established. The visit might well be described as a pilgrimage, and if the great person lived on a hill, as Coleridge did at Highgate, it was so much the better.

Thomas Carlyle made the regulation visit to Coleridge in the summer of 1824. He came away deeply unimpressed. He reported back to brother John on the 'fat flabby incurvated personage' he had found the great literary man to be. Everything about Coleridge struck Carlyle as loose, floppy, unrigorous, collapsed; and in the physical shapelessness he read a moral failing:

> His cardinal sin is that he wants *will*; he has no resolution, he shrinks from pain or labour in any of its shapes. His very attitude bespeaks this: he never straightens his knee joints, he stoops with his fat ill shapen shoulders, and in walking he does not tread but shovel and slide – my father would call it *skluiffing*.[5]

The son, writing to his brother, reported on his first sight of the man who was, professionally speaking, his principal model, in terms that strongly suggested how instinctively he looked – at that moment – through the eyes of his own father. Shrinking from labour was not a characteristic James Carlyle, Thomas Carlyle's father, could tolerate; indeed, work provided for him the very definition of a man. In 1824, James Carlyle was still alive, having turned from his earlier occupation of stone mason to working a not very profitable farm. When he died, in 1832, his eldest son was once again in London. Thomas Carlyle reacted to the shock and grief of the news of his father's death by secluding himself for five days in order to write a memoir.[6] The writing was intended as therapy, a private effort by the son to come to terms with what his father's life had meant and what his own life meant in relation to it. In this memoir, Carlyle invested his father with the qualities of exemplary manliness. James Carlyle's 'great maxim of Philosophy' Thomas Carlyle recorded with love and pride, was that 'man was created to work, not to speculate, or feel, or dream'. The shovelling and sliding of dreams and feelings could not be incorporated into the postures real work demanded. With his 'strong Hand and strong Head', James Carlyle had spent his days building solid, useful, houses and

bridges. He was, his son wrote, 'a healthy man, he wanted *only* to get along with his Task'. He was not a writer like Coleridge, and he did not suffer from 'anxious impotence'; it could not be said of him as it could of Coleridge that 'he *would* do all with his heart, but he knows he dare not'. Coleridge's talk, aimless and without method, following wherever his 'lazy mind' might lead, was what Thomas Carlyle knew James Carlyle would have called 'clatter'. It was the sort of talk he would have had 'entire and open contempt for'. James Carlyle, skilled labourer, would have observed that it was idle and would have had nothing to do with it.[7]

If Thomas Carlyle looked at Coleridge through his father's eyes, it is equally true that he saw in Coleridge something of what he knew his father saw when *he* looked at his eldest son. The similarities were inescapable: Thomas Carlyle's method of seeking truth, deriving as it did from that same German transcendentalism that had so enthused Coleridge, led him to elevate intuition, contradiction and paradox over rule and rationality. It was to lead him, in his first really successful work, to produce a fictional psycho-biography, *Sartor Resartus*, that has been well described as 'a work of labyrinthine tortuosities', 'a somnabulist's creation, illustrating the power of dream and symbol'. *Sartor Resartus*, that 'circular odyssey . . . ironic in construction and tone', must have presented a peculiar challenge to James Carlyle when he sat down to read his son's book, given his profound conviction that working and dreaming were opposites.[8]

But Thomas Carlyle's response to Coleridge may also be seen in the light of his veneration for that other sage, the sage of Weimar, Johann von Goethe. On the day Carlyle wrote to tell John about the fat and flabby Coleridge, he had also sent his translation of Goethe's *Wilhelm Meister's Apprenticeship* to the great man. Finding in Goethe a spiritual and intellectual father, Carlyle, whose own father was of so forbidding and choleric a disposition that his children always approached him with great caution, dreamed that Goethe could also give him fatherly recognition of an emotional kind. In 1820, on reading *Faust* for the first time, he later told Goethe: 'I could not but fancy I might one day see you, and pour out before you, as before a father, the woes and wanderings of a heart whose mysteries you seemed so thoroughly to comprehend'.[9] Perhaps he had hoped that Coleridge would serve such a function. Carlyle's hopes on that score had certainly been raised by the experiences of his friend Edward Irving.

Thomas Carlyle's friendship with Edward Irving was, by his own account, the most profound and significant friendship of his life. Irving

taught him 'what the communion of man with man means'.[10] Though not childhood friends, Carlyle and Irving both came from Annan. They met as young men, recognizing in each other the powerful energies of ambition and talent. In a memoir of Irving, written many years after the latter's death, Carlyle recalled Irving's boast: ' "You will see now," he would say; "one day we two will shake hands across the brook, you as first in Literature, I as first in Divinity; – and people will say, "Both these fellows are from Annandale: where is Annandale?" ' [11]

To the young Carlyle, Irving was 'the faithful elder brother of my life in those years'.[12] Five years older than Thomas Carlyle, charismatic and sociable when the younger man was still surly and inwardly-bitten, Irving's brilliance as a preacher was early recognized. His sermons drew huge crowds. By 1824, the year of Carlyle's first visit to London, Irving had already settled there and was well established as the most fashionable orator of his day. Irving was also a disciple of that other orator, Coleridge, at whose feet he liked to sit displaying 'reverence' for his wisdom and 'apprehending the meaning of his rich and lofty discoursings' – a feat that was often well beyond finer minds.[13] The admiration between the two men was mutual: Coleridge declared that he saw the spirit of Luther revived in Irving.

Filial gratifications, of the sort Irving was able to enjoy at Coleridge's fireside, were denied Carlyle. To make matters worse, he was, in 1824, further deprived of his customary 'communion of man with man' with Irving. He stayed with him and his wife for part of his time in London, but the old days, when the two young men had been accustomed to stroll about and talk of 'religion and literature and men and things' were past. Into Irving's present life had burst not only a wife but a 'squealing brat'; and not only a squealing brat but a horde of religious enthusiasts who seemed to be forever milling about the Pentonville home. A disgruntled guest, Carlyle was increasingly enraged by the attention Irving paid to his son on the one hand and his followers on the other. Either or both always came before the claims of an old friend. Irving's eagerness to be holding his baby, his involvement in its development, struck Carlyle as pathetic; it was, he declared, 'piteous to behold' the way Irving 'dandles and fondles and dry nurses'. Carlyle resented being required to be interested in Irving's speculations on all aspects of '*Him*': 'the progressive development of *his* senses, . . . the state of his bowels, . . . his hours of rest, his pap-spoons and his *hippings*'. He sat restively while Irving sang to the baby. He had to endure having his own conversational gambits diverted by baby:

31

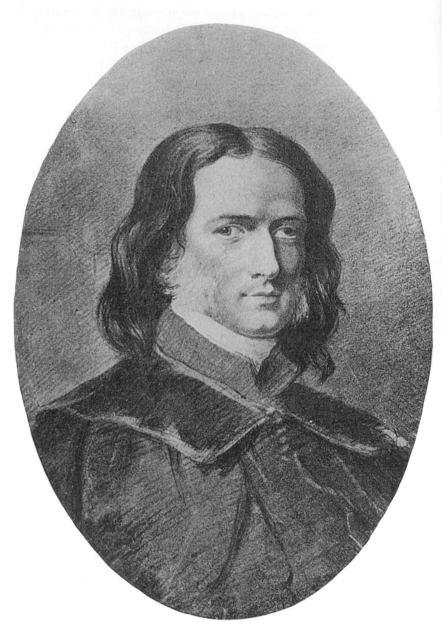

2 Portrait of Edward Irving, *c.* 1830. (By kind permission of the National Trust Photographic Library)

Irving's talk and thoughts return with a resistless biass [*sic*] to the same charming topic, start from where they please. Visit him at any time, you find him dry-nursing his offspring; speak to him, he directs your attention to the form of its nose, the manner of its waking and sleeping, and feeding and digesting.[14]

The anxious, hypochondriac, self-tormenting Thomas Carlyle was a man whose own thought and talk and letter-writing was notoriously full of scrupulously detailed accounts of his waking, sleeping, feeding and digesting. It is perhaps not surprising, therefore, that he experienced Irving's child as a rival. Deeper than that, however, was his sense of the grotesqueness of Irving's behaviour. It was bad enough to have to sit by while Irving involved himself in bathing the baby ('I declared the washing and dressing of "him" to be the wife's concern alone')[15] – a private and indoor activity; but Irving blithely behaved in the same way when out of doors. During a short stay at Dover that summer, the visual impact of the six-foot Irving holding his small baby was too much for Carlyle, who saw in it a monstrous overturning of the natural order:

> Oh that you saw the giant with his broad-brimmed hat, his sallow visage, and sable matted fleece of hair, carrying the little pepper-box of a creature, folded in his monstrous palms, along the beach; tick-ticking to it, and dandling it, and every time it stirs an eyelid, 'grinning horrible a ghastly smile,'* heedless of the crowds of petrified spectators, that turn round in long trains gazing in silent terror at the fatherly Leviathan![16]

(* from Milton, it is Death in *Paradise Lost*, 11, 846)

Irving, when challenged by his old friend and required to explain himself, revealed that there was in fact a coherent philosophy at work in his actions. By attending to his child's needs he was, he argued, 'exercising generosity and forgetting self'.[17] This female morality was not one Carlyle could readily identify with; and, frustratingly, he recorded no more about it beyond this passing remark – which he mocked.

Irving's 'terror'-inspiring behaviour, holding his baby and paying attention to it in public, was only one of the worrying symptoms of his decline. Connected with it was his attitude towards the more extreme emotional displays favoured by his religious followers. Instead of controlling their extravagant manifestations of religious enthusiasm, which included prophesying and speaking in tongues, Irving was

tolerant towards it. Irving's inability to see such developments as trends that required the exercise of firm masculine restraint perplexed Carlyle. Carlyle saw disaster ahead; and to the extent that Irving was banished from the Church of Scotland for his 'heresy', he was correct. But his own passionate disgust at the two related developments – baby and babbling cohorts – suggest them as points of peculiar sensitivity for Carlyle himself. He characterized Irving's followers as female, though the men were no less vociferous. Carlyle's repeated laments over 'poor' Irving in his letters from 1824 until Irving's death ten years later are couched in terms that evoke an upright man drawn into a female world of irrationality and ruined therein. This seems in any case to have been the general response to Irving's fall; those who, after his death, wrote loyal accounts of him were at pains to stress his manhood. One short pamphlet, published in 1853, was entitled: *Glimpses of Great Men: or, Biographic Thoughts of Moral Manhood*.[18] Irving's principal biographer, however, Washington Wilks, seems to have had more difficulty disentangling the coded signs of femaleness and maleness in his description of Irving: 'Black hair clustered in profusion over his lofty forehead, and descended in untaught curls upon his Herculean shoulders . . . On his lips there sat the firmness of a ruler, and trembled the sensibility of a poet.'[19]

Irving and Coleridge, the one a symbolic brother, the other a symbolic father, stood as omens to Carlyle, who saw something of himself in both of them. Irving's success marked out the path his fellow Scot might follow. Coleridge stood as the living symbol of what he aspired to become. Both men, in Carlyle's eyes, seemed to have equivocated with manly destiny. Neither offered the sure and certain convictions of manliness that his father lived by. Neither could figure as an appropriate model for a young man desperate for assurance about the path he was taking. They had travelled the path ahead of him. In Irving he saw how gifts of oratory might lead to ruin from too much clamour and praise; in Coleridge, how mysticism and trans-cendentalism, combined with indolence, could lead to a vapid, sunken self-engrossment.

Carlyle's record of his stay in London throughout 1824, as preserved in his copious letters, shows it to have been a year of crisis in which the future appeared to him as a looming struggle between forces that would undermine his manliness and influences that might enable him to retain it. He was already clear that the life of a private tutor could no longer be countenanced, principally because it deprived him of the ability to make his own decisions about life. The Bullers were as

indulgent as any employers could be; nevertheless, Mrs Buller's tendency to indecisiveness about such matters as where she proposed to settle – should it be Cornwall? Or Edinburgh? Or London? – drove him to distraction. To submit to such a life was to surrender the will, to take the first shambling steps towards shovelling and sliding through life. Literature was the only alternative; but his experiences of literary life in London, and his meetings with literary figures, compounded rather than resolved anxieties already raised by Irving and Coleridge. After meeting the Scottish poet, Thomas Campbell, for example, Carlyle judged him 'heartless', 'cold', 'conceited', found his talk 'small, contemptuous and shallow', and dismissed him as a 'literary dandy'. Escaping from Campbell's presence was like escaping some noxious influence: ' "Good heavens!" cried I, on coming out, "does literature then lead to this?" . . . The aspect of that man jarred the music of my mind for a whole day . . . he was my earliest favourite; I hoped to have found him different.'[20]

The sound of idols crashing can be heard over and over again. All around him Carlyle saw literary men who, far from fulfilling the noble aspirations of German idealism, were merely 'hacks that live by ink in this busy city'. And many barely even lived; they were failures: lazy drunkards, unable to support their families, vain, misguided, poverty-stricken, calumnious and debauched. The spectacle of such men and the possibility that he might dwindle into their likeness, was deeply unsettling:

> Good Heavens! I often inwardly exclaim, and is *this* the Literary World? This rascal rout, this dirty rabble, destitute not only of high feeling or knowledge or intellect, but even of common honesty? The very best of them are ill-natured weaklings: they are not red-blooded *men* at all; they are only *things* for writing 'articles'.[21]

Carlyle's disappointment with the literary world had its roots partly in what he perceived as its failure to offer a masculine vision equivalent in force to that which he had imbibed from his father. He was afraid, as were his parents and siblings, that he too might 'degenerate into the wretched thing which calls itself an Author in our Capitals'.[22] His almost hysterical admonishments of those he dismissed as magazine hacks – 'away! Be *men*, before attempting to be *writers*!' – brought with them a corresponding yearning for the certainties that fathers could provide.[23] On the one hand, he retained his faith in Goethe, the fatherly figure he had never met: 'I like him better than any living "man of

letters", for he is a *man*, not a *dwarf of letters'*; and on the other, he began
to be drawn towards the life his own father lived.[24] Instead of craving
fame as the 'miserable metre-ballad-mongers' did, he declared that he
would prefer, after all, to be 'a substantial peasant that eat my bread in
peace'.[25] Literature was not enough for a life: it was wine, but it could
not serve as a staple food.

By the end of 1824, driven by dyspepsia, disillusioned with literary
society, Carlyle was planning a retreat. The life that his father lived, a
life of daily physical labour far from the metropolis, rugged and earthy,
sustained by a loyal and hard-working family, seemed to offer the
possibility of masculine renewal. Constantly sick but with no obvious
ailment, Carlyle suffered from that 'feminine' complaint, the product
of insufficiently purposeful activity: overworked nerves. As he told
Jane Welsh, his future wife, who suffered comparable symptoms: 'This
must and shall be remedied: I must live in the country, and work with
my muscles more, and with my mind less'.[26] To his mother he wrote: 'I
will be a whole man, no longer a pining piping wretch, tho' I should
knap stones by the wayside for a living!'[27] And in an extraordinary
move, he proposed that his family should find a house for him in their
neighbourhood and that his mother and his sisters should leave their
farm at Mainhill and move in to take care of him.

His father's views about this scheme are not known, though Carlyle
knew that his father was displeased about his having given up tutoring.
The house, at Repentance Hill (also known as Hoddam Hill) was leased
in James Carlyle's name; but there is only one, slightly uncomfortable,
mention of him in all the endless letter-writing that was required for
this family project. It comes in the postscript to a letter from Thomas
Carlyle to his brother Alick – the only one of the brothers still working
on the land with his father, and the one destined to farm the new
property. Carlyle was at Birmingham, making his slow way home. His
mother, who had heard that knives were cheap in Birmingham, asked
her son to buy knives for the new house. He refused, claiming to be
useless at the kind of haggling shopping required. She could go to
Dumfries for them. Carlyle's letter is full of arrangements and plans.
The unquestioned centre of activities, he organized the family from a
distance, directing them into the appropriate positions to suit his needs.
His object, as he had plainly stated, was to be master of his own house,
creating a daily rhythm out of his writing needs rather than having to
fit those needs into the rhythm of his father's household. If he had any
stirrings of discomfort about these plans, they are only hinted at in this
letter. The discussion about knives and shopping ends with the

reflection: 'It is like a sort of marriage'; and the postscript reads: 'I hope my Father approves of all these farming schemes, and will not think of burthening himself farther with Mainhill and its plashy soil, when the lease has expired'.[28]

It seems extraordinary that such a major plan could go ahead without Carlyle knowing if his father agreed to it or not. Mainhill, his father's farm, was not a success; Carlyle's writing was bringing financial returns. From his position of strength as the major family wage earner, Carlyle proposed a scheme in which he offered his father house room having first, actually and symbolically, stolen away his place as head of the family. The given reason was his pressing need for circumstances in which he could write and retain health. With a farm worked by his brother, he could dig or write as he chose; with his mother and sisters in attendance, his shirts would be sewn and his meals cooked. These were not, in fact, services he had ever lacked. More significant and fundamental seems to have been the psychic need to feel himself a man, a role which required centrality, authority and the deference of others to his needs. The family willingness to play supporting roles was vital in sustaining Carlyle's belief in himself as man not dwarf.

This usurpation of his father's position in 1825 signified Carlyle's desire to reconcile two contradictory models of a masculine future: that represented by his father, a working peasant; and that represented by the lettered classes amongst whom he had found a place by virtue of his intellectual abilities. Disappointed in the latter, Carlyle returned to his father and thanked God that he had had 'from earliest years . . . the example of a real Man' continually before him, observing that 'it is only among what are called the *un*-educated classes (those educated by experience) that you can look for *a man*'.[29] His detailed account of the qualities of such a man may be found in the 1832 memoir of his father.

Unpublished until 1881 (after his own death), Thomas Carlyle's account of his father, James Carlyle, is a fascinating document. It is the work of a son who had achieved sufficient maturity and status to be able to take command of the relationship. In old age, Thomas Carlyle reports, his father had begun to look differently upon his eldest son. He had begun 'to respect me more; and, as it were, to look up to me for instruction, for protection (a relation unspeakably beautiful)'.[30]

James Carlyle became, by this means, approachable in a way he had not been before, a figure whose experiences and qualities could be shaped to fit the form his son desired. Such a form – paradoxically, considering the experiences of 1824 – was that embodied by literary

men. Musing on his father's peasant origins, Carlyle judged him to be 'among Scottish peasants what Samuel Johnson was among English authors'; discussing the quality of his father's untaught intellect, he compared him with Robert Burns: 'I know Robert Burns and I knew my Father; yet were you to ask me which had the greater natural faculty? I might perhaps actually pause before replying!'; describing his father's appearance, he noted that the head was 'noble . . . very large; the upper part of it strikingly like that of the Poet Goethe'.[31] These comparisons with acknowledged great literary men, men who had formed themselves and their experiences into artistic wholes that spoke widely to the minds and feelings of others, were made of a man who was at best indifferent to literature, at worst its sworn enemy. James Carlyle had no knowledge of Johnson, had not read Burns and was liable to dismiss all poetry and fiction as 'not only idle, but *false* and criminal'.[32]

Carlyle further clothed his father in vestments drawn from the mythicized figure of the natural man: gifted but undeveloped, rugged, abrupt, unpolished, with an uncorrupted, instinctive commitment towards the morally true. Such a man did not depend on the slippery potential of speech for his effectiveness, for speech at once implies persuasion and persuasion suggests values that might shift. James Carlyle's habitually taciturn manner served, for his son, as a sign of his emphatic moral certainty. But there are indications in Thomas Carlyle's *Reminiscences*, that the father had a more troubled, more ambivalent attitude towards his experiences than the son was prepared to countenance. In a significant passage, dealing with the years of his father's 'opening manhood', Carlyle describes his father working with other men, building houses, hunting for hare, participating in the small social events of the neighbourhood. The description strives towards a fond rosiness: cheerful workers, firelight glow as they gather round the hearth, 'merry meetings'. But all at once it collapses into the confession: 'Contentions occur'. His father's part in such contentions was decisive and violent; he was feared for his capacity and willingness to throw a huge man – a fellow peasant standing on a chair and speaking at a meeting – across a room. James Carlyle looked back on his violent days with 'sorrow', but his son had no such feelings. For him, such acts were not aggressive but defensive, they were 'manful assertions of man's rights against man that would infringe them'.[33]

Manful assertiveness was a commodity the son, not the father, felt the need of at that moment. James Carlyle cherished no pride in his former violent impetuousness. He did not look back on his ability to

throw a man across a room for assurances of his manhood. For Thomas Carlyle, however, contemplating a future in which he sought to construct a role for himself as far removed from the dribbling weak-kneed proser that was Coleridge, or the emasculated hacks living dwarf-like and dependent in city slums, the image of his father's direct assertion of might and right was a compelling one. So compelling that he rewrote the meaning his father himself put upon it.

By 1832, when he wrote the memoir of his father, just as in 1824 and in 1825, Thomas Carlyle still lacked what he considered a proper 'hand in the game of life'. Approaching forty, he was a man who had gained attention by his ability to comment on other men's books. It was to be another five years before *The French Revolution*, in 1837, propelled him into fame on his own account. Meanwhile, several attempts to achieve public office of some kind had come to nothing. His decisions, his acts, played no part in the movement of public events. All he could aspire to, as a writer, was influence. His daily life was home-based and sedentary. Like the women he lived with, his sphere was domestic, and his involvement with the wider world of affairs indirect. No matter how hard he worked, his achievement was always liable to seem nothing more than 'strenuous idleness'.

As Deirdre David observes in *Intellectual Women and Victorian Patriarchy* (1987), the thrusting mercantile middle classes of the nineteenth century tended to view the product intellectuals produced as of minimal value. In the popular perspective, intellectual life equalled 'unprofitably utilised leisure', the amateurish pursuit of knowledge for its own sake instead of economically profitable appropriation of knowledge.[34] As such, with some modifications, it was acceptable activity for middle-class women whose leisure was a significant sign of their husband's prosperity; but a young man unprofitably engaged was in danger of being drawn into feminine social roles. G. M. Young, looking back on the Victorian period from the 1950s, certainly thought that there had been a feminizing of intellectual work and a consequent (and regrettable) loss of virility. Their fathers he observed of the mid-Victorian public, had been better men.[35]

Given the prominent position Carlyle was later to occupy, as a powerful advocate of the importance of great men and as historian of such forcefully masculine figures as Cromwell and Frederick the Great, it is perhaps hard to appreciate the anxiety he felt in his early years as a writer. Age and attainment – which in his case meant elevation to the highest levels of cultural authority – did little to ease Carlyle's

anxieties because their roots were not to do with finance or status. His anxieties may be traced to class and gender dilemmas that were never resolved.

Gender and class operated on the young intellectual who was later to be among the most favoured and popular cultural patriarchs of the Victorian age, to produce specifically male anxieties about being a son and a brother; and, beyond the family, about becoming a figure whose innate powers should be recognized by his male peers in the form of commensurate social power. Carlyle's personal sense of failure to pursue an honest calling, one that was immediately recognizable as worthy of the eldest son of a God-fearing family, led him to construct a social role for himself that corresponded more to Calvinist notions of the priesthood than to contemporary expectations about writers. At the same time, a public that was increasingly, but painfully, turning from religion to science was ready to look on intellectuals as substitute vicars: counsellors, moral guides and wise sages. In this climate, Carlyle's anxiety about the manliness of his endeavours – as compared, for example, with those of his father – manifested itself in his intellectual attraction to men of force and war. His identification with the men of action he wrote about has been well noted; less well noted and more paradoxical is the way he created, out of the qualities of those he elevated into great heroes, a cultural role for aspiring male writers that was redolent with possibilities of power, comfort and gratification.

In a series of lectures, *On Heroes*, delivered in 1840 and published the following year, Carlyle introduced a novel category of hero. Along with the kings, priests, prophets and divines through whose agency history, as he understood it, happened, another social group claimed his respect: men of letters. To the astonishment of no small portion of his audience, Carlyle held up such notorious figures as Rousseau and Burns for their admiration. The man of letters, he declared, was now 'our most important modern person'. The function discharged by the man of letters was the highest function, one which he inherited from the priesthood: he was 'the light of the world'. Writers, those 'Spiritual Heroes', leapt the boundaries of class and social hierarchy to take their place at the very top of the tree: 'I say, of all Priesthoods, Aristocracies, Governing Classes at present extant in the world, there is no class comparable for importance to that Priesthood of the Writers of Books'.[36]

It was a radical and original response to the age-old problem of the privation, neglect and misery that habitually attended a struggling

writer's life; and a remarkable resolution of the dilemmas that had perplexed him in 1824 and subsequently.

But Carlyle's rewriting of the script would have fallen on deaf ears if his public had not been ready to hear his words. *On Heroes* was enormously popular. It was repeatedly reprinted, in large editions, throughout the century. It offered a society suffering religious doubt the opportunity to express religious feelings in a secular form. But its preoccupation with men of letters – even Mahomet and Odin are there, in part, because of their significant interventions in literature – gave something that was no less rapidly seized on: a construction of the literary worker that explicitly excluded women from the definition.

Although women writers had always had to face misogyny in its broad manifestations, the history of their participation in literature up to 1840 is a history of increasing acceptance by the cultural establishment. The early decades of the nineteenth century were a time of enormously increased opportunity for women writers. They worked in every field, not only as popular novelists and poets, but as travel writers, historians, biographers, essayists, journalists and reviewers. Men like Wordsworth felt no shame in admiring women like Helen Maria Williams; Keats respectfully plagiarized Mary Tighe; Byron praised Mrs Hemans.[37] None of them felt obliged to denigrate on gender terms writers whose work they judged of high quality; nor did they see such denigration as potentially profitable. After 1840 it *was* profitable for men (and women) to use the weapon of gender against women.

After 1840, women might write but just as they could not be priests, so they could not be men of letters. Their appropriate stance was a worshipful one and their appropriate activities reading and listening. The intensification of the servicing role among the wives of literary men of the nineteenth century reflects the vital part played by satellites in this creation of the man of letters. Alone, he might be a hack in a garret; with a devoted and admiring wife at the head of his following – signifying the wider public and at the same time instructing it in how to behave – the man of letters could be a hero. The wife's willingness to lay aside everything for his genius confirmed that the genius existed. With a study, a pipe, a smoking jacket and an oracular tendency, any writer, so long as he could attract an admiring host of reverentially ready ears and readier pens to write down his every word, could lay claim to a recognized social identity that carried prestige and respect. Such an identity bore no necessary relation to the quality of work produced.

That the man of letters was really a man is illustrated by John Gross's interesting study, *The Rise and Fall of the Man of Letters* (1969). Although focusing on journalists, reviewers, teachers and interpreters – areas of literary work in which women were present in strength – his discussion barely acknowledges a single woman writer.[38] This (for its own time) perfectly conventional approach to the literary and historical mapping of the nineteenth century would be unlikely to pass muster now; and it is generally recognized that adding a few female names is an inadequate response. The fact that many women in the nineteenth century pursued highly successful careers as writers – along with teaching, it was the only profession readily available to women – needs to be examined in relation to the social fiction that they did not.

The construction of the man of letters as a hero was, as Gross bluntly and bracingly observes, 'a fairly transparent exercise in self-glorification'.[39] But it had social as well as personal dimensions. It was an extreme response by one man to personal circumstances structured by social realities. Through the myth of the hero and the man of letters as hero, Carlyle sought to resolve tensions contained within the phrase 'strenuous idleness'. In doing so, he provided a society bent on defining all activity in gendered terms some very serviceable but highly questionable constructions.

NOTES

1 Charles Richard Sanders and Kenneth J. Fielding (eds), *The Collected Letters of Thomas and Jane Welsh Carlyle*, Duke–Edinburgh edition, Durham, NC, Duke University Press, 1970-, vol. 3, 1824–5, pp. 3–4.
2 ibid., vol. 1, 1812–21, p. 338.
3 For an account of Margaret Carlyle's breakdown, see Fred Kaplan, *Thomas Carlyle: a Biography*, Cambridge, Cambridge University Press, 1983, pp. 44–6.
4 Marilyn Butler, *Romantics, Rebels and Reactionaries: English Literature and its Background, 1760–1830*, Oxford, Oxford University Press, 1981, chapter 3, pp. 69–93, 'The Rise of the Man of Letters: Coleridge'.
5 Carlyle, *Collected Letters*, vol. 3, pp. 90–1.
6 The essay, 'James Carlyle', is the opening piece in a collection of memoirs published after Carlyle's death in 1881 under the title *Reminiscences*. Other essays in the collection include 'Jane Welsh Carlyle' and 'Edward Irving', both written in the months after Jane Carlyle's death in 1866. Thomas Carlyle, *Reminiscences*, edited by Charles Eliot Norton, London, Dent, 1972, pp. 1–34.
7 ibid., p. 5.
8 Camille R. La Bossiere, *The Victoria Fol Sage: Comparative Readings on Carlyle, Emerson, Melville and Conrad*, Lewisburg, Bucknell University Press, 1989, pp. 29, 33, 34.

9 Carlyle, *Collected Letters*, vol. 3, p. 87.

10 See *Froude's Life of Carlyle*, abridged and edited by John Clubbe, London, John Murray, 1979, p. 112.

11 Carlyle, *Reminiscences*, p. 230.

12 ibid.

13 Review of Mrs Oliphant's *Life of Edward Irving*, reprinted from *The New Englander* (July and October 1863) and separately printed, Edinburgh, Thomas Laurie, 1864, p. 42.

14 Carlyle, *Collected Letters*, vol. 3, pp. 195–6, 200.

15 ibid., p. 167.

16 ibid., p. 172. In *Paradise Lost*, II, 846, Milton depicts Death as 'grinning horrible a ghastly smile'.

17 ibid., p. 200.

18 A. J. Morris, *Glimpses of Great Men, or, Biographic Thoughts of Moral Manhood*, London, Ward, 1853.

19 Washington Wilks, *Edward Irving: an Ecclesiastical and Literary Biography*, London, 1854, p. 6.

20 Carlyle, *Collected Letters*, vol. 3, p. 85.

21 ibid., pp. 232–4.

22 ibid., p. 246.

23 ibid., p. 245.

24 ibid., p. 288.

25 ibid., p. 271.

26 ibid., p. 272.

27 ibid., p. 274.

28 ibid., pp. 293–5.

29 Carlyle, *Reminiscences*, p. 7.

30 ibid., p. 10.

31 ibid., pp. 7, 9, 13.

32 ibid., p. 9.

33 ibid., pp. 24–5.

34 Deirdre David, *Intellectual Women and Victorian Patriarchy*, London, Macmillan, 1987, p. 11.

35 G. M. Young, *Portrait of an Age*, Oxford, Oxford University Press, 1936, p. 187.

36 Thomas Carlyle, *On Heroes, Hero-Worship and the Heroic in History*, London, Chapman & Hall, 1894, p. 155.

37 Helen Maria Williams, 1761–1827, poet, historian and enthusiast for the French Revolution. Wordsworth's first printed poem was 'Sonnet on seeing Miss Helen Maria Williams Weep at a Tale of Distress', 1787. Mary Tighe, poet, 1772–1810. See Earle Vonard Weller (ed.), *Keats and Mary Tighe: the Poems of Mary Tighe with parallel passages from the work of John Keats*, New York, Century, 1928. Felicia Hemans, 1794–1835, poet. Byron took her long poem 'The Restoration of the Works of Art to Italy' with him when he left England in 1816. See Leslie A. Marchand (ed.), *Byron's Letters and Journals*, vol. 5, 1816–17, 'So Late into the Night', London, John Murray, 1976, p. 108.

38 John Gross, *The Rise and Fall of the Man of Letters: Aspects of English Literary Life since 1800*, London, Weidenfeld & Nicolson, 1969.

39 ibid., p. 34.

3

DOMESTICITY AND MANLINESS IN THE VICTORIAN MIDDLE CLASS
The family of Edward White Benson[1]

John Tosh

Home is the first and most important school of character. It is there that every human being receives his best moral training, or his worst; for it is there that he imbibes those principles of conduct which endure through manhood, and cease only with life.[2]

Samuel Smiles may have been labouring the obvious, as was his way, but recent historical writing has tended to lose sight of this nineteenth-century truism. Manliness and domesticity, two key concepts in the moral universe of the High Victorians, are not often discussed together. While the domestic world of nineteenth-century England is usually seen through women's eyes, manliness is treated as a code of behaviour which was fashioned at school for the public sphere, irrelevant to home and family. This is to view the Victorian age through late Victorian or Edwardian spectacles. In asserting the importance of upbringing as the foundation of manly character, Smiles was accurately reflecting a mid-Victorian faith in the efficacy of what he called 'home-power'.[3] The same is true of his equally emphatic statement that it is in the home that 'a man's real character . . . his manliness' is most surely displayed.[4] Thomas Hughes, author of *Tom Brown's Schooldays,* was of like mind.[5]

Didactic literature, then, was far from accepting or recommending a separation of middle-class men from the domestic sphere. But did this reflect actual experience? The Victorians, after all, had so much emotion invested in the idea of home that considerable allowance must be made for self-deception and wishful thinking in their statements on the subject. Until recently this was an impossible question to answer on the basis of properly documented historical work, given the prevailing tendency to treat paterfamilias and public man as two distinct beings.[6] But in 1987 Leonore Davidoff and Catherine Hall's *Family Fortunes: Men*

44

and Women of the English Middle Class, 1780–1850, marked a fresh departure. With a wealth of telling detail they explored the connections between domestic life and success in business and the professions during this period; masculine self-respect in their account depended not only on an exacting code of behaviour in public but on a properly ordered household, which in turn required of men a commitment to family life.[7]

In this chapter I offer an interpretation of the mid-Victorian period (*c.* 1850–80) which builds on Davidoff and Hall's treatment of the early nineteenth century. Rather than attempt an impressionistic general survey, I have focused instead on just one family, that of Edward White Benson, schoolmaster and bishop.[8] As a public-school headmaster in the 1860s and early 1870s, Benson was professionally involved in interpreting and teaching doctrines of manliness. At the same time his family life is richly documented in contemporary and autobiographical writings, so that his marriage and the upbringing of his sons emerge with some clarity. This material says much about the relationship between domesticity and manliness within a particularly influential segment of the Victorian middle class, but it also shows how the conditions of domesticity in one generation laid the basis for a shift in the contours of masculinity in the next – in this case in the lives of Benson's sons. The domestic sphere was not just an indispensable setting for the expression of manliness, as Samuel Smiles and Thomas Hughes declared; it was also the scene of powerful tensions pregnant with possibilities for change.

THE ARNOLDIAN OUTLOOK

Edward Benson became a powerful member of the academic and ecclesiastical elite of Victorian England. But he did not belong to this elite by birth. He was born in Birmingham in 1829. His father was an unbusinesslike chemical manufacturer, a strict Church of England Evangelical and a teetotaller; his mother was the daughter of a schoolteacher and had been brought up a Unitarian. When Benson was 13, his father died shortly after the failure of his white-lead works. His mother was able to keep her family of eight children going on an annuity, but when she died of typhus in 1850, Benson at the age of 21 assumed responsibility for his younger brothers and sisters: the total family income then stood at just over £100.

By this time Benson was an undergraduate at Cambridge. Only the generous patronage of a senior don enabled him to finish his studies with distinction, and be ordained. Within two years of his mother's

death he secured a comparatively well-paid teaching job at Rugby School. In 1859 he moved to his next post as the first headmaster of Wellington College, recently founded as the national memorial to the Iron Duke. By then Benson had done what was needed for his family dependants and was able – after several years of courtship – to marry his cousin, Mary Sidgwick. Six children were born during their time at Wellington: four sons and two daughters. Of these, Arthur (A. C. Benson), born in 1862, and Fred (E. F. Benson), born in 1867, will be frequently quoted here. Edward Benson left the school in 1873, on a ladder of preferment in the Church of England which was to lead within ten years to Canterbury. He died in office in 1896 while attending morning service with Mr Gladstone at Hawarden.[9]

This steep ascent from the son of a bankrupt to Primate of All England was made possible by Benson's ambition, his self-denial, his phenomenal industry and his attention to detail. He was recognizably cast in the mould of the 'new man' whose emergence at the beginning of the nineteenth century has been traced by Davidoff and Hall. They have shown how an expanding urban capitalism and the growth of Evangelical religion caused the desired masculine traits of the middle class to be defined in a new way, which stressed a punishing work ethic, independence from patronage or favour, piety and high-mindedness, sobriety and chastity, and dedication to family pursuits.[10] These qualities served both to promote success in business and to define a new middle-class character which could assert moral ascendancy over the landed aristocracy. It is a measure of the middle class's success in claiming the high moral ground that from the 1830s onwards the new code of manliness was increasingly evident in the public schools, which at that date catered largely for the sons of the gentry. Dr Thomas Arnold of Rugby was the headmaster who gained the greatest reputation for his efforts to raise the moral tone of these schools. His aim was to enable his pupils to cultivate their moral and intellectual powers to their full potential. To be 'manly' was to put away boyish pursuits, and to grow up straightforward, earnest, and pure. Restless energy, a driving sense of duty, and an absence of frivolity were the marks of the true Arnoldian.[11]

Dr Arnold certainly had no monopoly over public definitions of manliness, but he was nevertheless the single most influential educationalist in early Victorian England. Schools like Rugby not only served to civilize the squirearchy, as Arnold intended; they also opened up public school education to 'serious' middle-class parents who could now secure enhanced social status for their sons without consigning

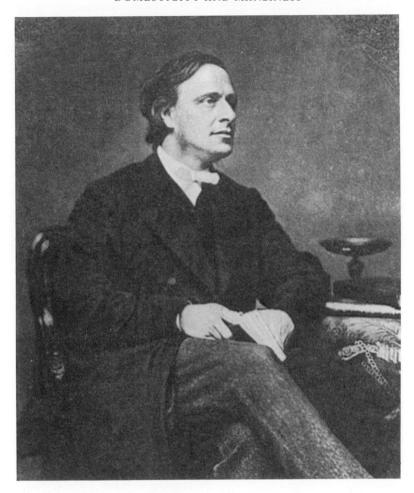

3 Edward White Benson, 1867. (Photograph reproduced from *The Life of Edward White Benson* by Arthur C. Benson, 1899, by kind permission of Macmillan)

them to a Godless jungle. The rapid expansion of the public schools around mid-century and the high standing of Arnold's educational philosophy combined to create a recognized career pattern through university, school, and bishopric. The resulting elite of scholar-churchmen – whom David Newsome has described with such empathy in *Godliness and Good Learning* – were men of considerable weight in the ruling circles of Victorian England.[12]

Although he was too young to have ever had personal contact with 'the Doctor', Edward Benson bore all the marks of an Arnoldian. The school he attended as a day boy in the 1840s, King Edward's Birmingham, had recently been reformed by a former colleague of Arnold's, James Prince Lee, whose memory Benson revered all his life;[13] and Rugby itself was still the school which Arnold had re-modelled when Benson taught there during the 1850s. Benson lived life at the same feverish pace as Arnold had done: he slept little and was seldom without a book in his hand. He shared Arnold's turbulent, passionate nature – though not his ability to relax and play. He brought the same moral intensity to the job of headmaster. 'Untruthfulness and indecency', the terms in which he identified the two most serious threats to the welfare of Wellington College, echoed Arnold's views exactly.[14] Benson's farewell sermon to the boys of Wellington College in 1873 eloquently bore witness to Arnold's conception of moral manliness:

> So shall your hearts beat strong with energy, yet be cool through self-restraint; and your work be wrought with diligence and rendered with cheerfulness; and your faces be bright with modesty, yet bold with frankness; and the grasp of your hands be firm and generous. For you will be men.[15]

MEN AND THE DOMESTIC SPHERE

Like Arnold, and like the 'new men' of the English middle class, Edward Benson set a high value on domesticity throughout his thirty-seven years of married life. Partly this was a matter of personal circumstances. Benson's position as an ordained priest and a headmaster severely limited his freedom to go out for evening entertainment; besides, Wellington College where he spent the first fourteen years of his marriage was situated on a desolate heath where the nearest settlement was the criminal lunatic asylum at Broadmoor. Although he was fortunate in the presence of two or three kindred spirits within a five-mile radius, his leisure time was spent mostly at home. But Benson was no involuntary prisoner in the home. 'The fact was', wrote Arthur Benson, 'my father was a very busy and active-minded man, who loved the domestic atmosphere. I think his idea of a delightful evening was that as many of us as possible should sit together reading, and asking intelligent questions.' When the family moved into new quarters in 1865, Benson gave minute attention to the decoration of the

nursery, pasting prints and pictures all over the walls. 'He loved family life' was Arthur's verdict, and it seems no less than the truth.[16]

It was of course possible in Victorian England for men to love family life and yet experience it in only very brief instalments. Indeed this is often taken to have been the norm in the middle class. According to the common view, the Industrial Revolution set in train the removal of most paid employment from the home and the laying out of semi-rural suburbs, far from the clatter of the factory and the counting-house. The middle-class man now seldom lived 'over the shop' as had been common in the eighteenth century; instead he travelled to work six days a week, largely ignorant of the household routine he left behind him. Only on Sundays did he spend time with his family, escorting them to church and taking the air with them in the park.[17] Several authors of conduct manuals addressed women who lived in households of this kind. Mrs Sarah Ellis is a well-known example. Her books, written between the 1830s and 1860s, assumed a domestic world populated by women, where men were in command but not much in evidence.[18] In the long term this would doubtless become the dominant middle-class family pattern, but it is important not to overestimate its hold on Victorian England. To be a domesticated man did not necessarily mean being a commuter savouring one's hard-won fireside moments. In 1851 a majority of middle-class families were still living at or close by their work premises.[19] Benson himself had been brought up in a house within the chemical works managed by his father.[20] As a headmaster and church dignitary, he always lived on top of his work in a tied house. A significant proportion of his long working hours was spent within the home itself, in his study.[21] This pattern is echoed in the lives of many Victorian professional men, for instance doctors.[22]

To emphasize the spatial distancing of work and home in nineteenth-century England therefore runs the risk of oversimplifying a complex picture. But it also obscures the point that the separation of spheres was centrally a matter of mental compartmentalization which did not necessarily depend on a physical gulf between work and home. Whether the husband worked at home or used it merely as a refuge, he had little to do with domestic labour or domestic management. This separation of function was universal, and it applied to men of advanced feminist opinions like everyone else: in the 1850s the extent of John Stuart Mill's participation in domestic chores during his marriage to Harriet Taylor was to make the tea when he returned home at 6 p.m.[23] In the Benson household at Wellington, the gulf between male and female spheres was symbolized by the door giving on to a flagged

49

passage which Fred (the third son) supposed led to kitchens and servants' bedrooms but which he never penetrated.[24] For Benson himself, meals taken with his family and evenings spent at the fireside were no less of a solace than they would have been had he daily commuted to a noisy and stressful place of business in town. He could enjoy the benefits and leave their material organization to others.

The notion of 'separate spheres' can also mislead in another sense. It may suggest a true complementarity in which each spouse was sovereign in his or her domain: the woman's sphere may have been confined, but it was at least fully hers. In *Family Fortunes*, Davidoff and Hall have shown how misleading this view is. Certainly Evangelical beliefs gave it little support. They quote the widely read Birmingham minister, John Angell James:

> Every family, when directed as it should be, has a sacred character, inasmuch as the head of it acts the part of both the prophet and the priest of his household, by instructing them in the knowledge, and leading them in the worship, of God; and, at the same time, he discharges the duty of a king, by supporting a system of order, subordination and discipline.[25]

Benson was no Evangelical, but by mid-century these sentiments had shed their earlier sectarian associations. The properly ordered household was widely taken by religious people of all persuasions to be a microcosm of the divinely ordered universe. Benson found in home the deference he required, as well as affection. His final authority there was unquestioned, reinforced as it was by his public roles of priest, headmaster and later bishop. Daily prayers and spiritual readings on Sundays highlighted his privileged understanding of God's will. His study served as a sanctum where, surrounded by the symbols of his priestly and educational power, he reprimanded his children and his wife, as well as errant schoolboys.[26] He was chief disciplinarian and jealous of his authority: Mary Benson recalled one occasion on which her questioning of his decision in front of the children earned a crushing rebuke in private, specifically because she had undermined his authority.[27] Benson also concerned himself minutely with the progress of his sons' education. When Martin (the eldest) was sent to boarding-school at the age of ten, his father set out to supervise the boy's studies by letter. Martin was urged to ever-greater efforts and treated to a weighty lecture whenever his frequent school reports suggested less than perfection in any area.[28] At a more mundane level, Benson made it clear that he was the overseer of household management, as well as the

authority in matters of discipline and schooling. He set the size of Mary's personal and housekeeping budgets, he carefully scrutinized the accounts, and he saw it as his duty to correct any negligence or extravagance on her part. Since Mary was quite inexperienced in managing a budget, and Edward carried from his impecunious start in life a horror of exceeding an allowance, they frequently quarrelled, especially in the early years of their marriage.[29] Along with the almost contemporary case of Leslie Stephen, Benson's hold on the family budget reminds us that all too often middle-class wives experienced the uncomfortable feeling of somebody looking over their shoulder whenever they gave an order to a tradesman or paid a servant. This burdensome accountability undermined the convention that the wife carried financial responsibility for the running of the household.[30]

Praesis ut prosis ('Take charge here that you may be of service') was the Latin phrase which Benson had inscribed over the entrance to the headmaster's house at Wellington.[31] Like probably most men of his class, he meant to be master in his own home, as well as outside it. If Benson was more effective than many, this was not just because of his masterful temperament but because his work lay right on the doorstep and he brought so much of it over the threshold. For middle-class men of the mid-nineteenth century, the association of domesticity with masculinity was not without its problems. As we have seen, Samuel Smiles echoed a widespread view when he maintained that home must be the prime arena for the display of manly character; but his readers knew that too great an attachment to home might breed unmanly dependence.[32] Those who carried out even part of their professional labours at home were particularly prone to demonstrate their power over the domestic sphere. Thomas Carlyle's ringing declaration to his future wife – 'I must not and I cannot live in a house of which I am not head' – is perhaps the best-known expression of this need for masculine assertion.[33] Edward Benson did not share Carlyle's doubts about the manliness of literary work, but his own professional life was sufficiently domesticated to require a forceful assertion of his will over the home and its inmates.[34]

HUSBAND AND WIFE

Edward and Mary Benson began their life together at a time when the prospects for a truly companionate middle-class marriage were thought by contemporaries to be better than ever. This was partly because

51

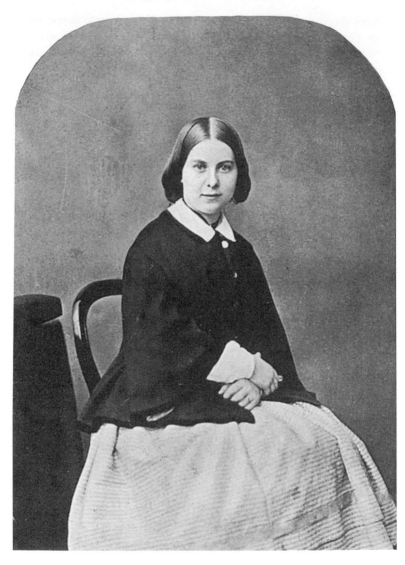

4 Mary Benson, 1860. (Photograph reproduced from *Mother* by E. F. Benson, 1925, by kind permission of Hodder & Stoughton)

husbands appeared to be so much more domesticated than they had been two generations previously. As John Stuart Mill put it in 1867,

The man no longer gives his spare hours to violent outdoor

exercises and boisterous conviviality with male associates; the two sexes now pass their lives together; the women of a man's family are his habitual society; the wife is his chief associate, his most confidential friend, and often his most trusted adviser.[35]

At the same time wives were becoming more and more emancipated from domestic labour. The 1860s have been identified as a critical decade in the transition from the Perfect Wife to the Perfect Lady, equipped with an array of specialist servants and free to become an attentive companion for her husband.[36] Benson was not a rich man. But his chosen career in education and the Church was well-paid by contemporary professional standards (his starting salary at Wellington was set at £800 per annum).[37] He could afford the full complement of servants, including a tried and trusted nurse for his children, and as a result Mary was spared many of the tasks which would have fallen to her grandmother. She was keenly aware of her obligation to be a fit companion to her husband and of how far short she fell of this ideal. 'Of large interests, of knowledge, of initiative there was scarcely any'[38] was how she put it forty years later. Mary was a highly intelligent woman – one of several whom Gladstone called 'the cleverest woman in Europe'[39] – but her education up to the age of eighteen had been very limited. Much of it had taken the form of tasks imposed by Edward himself during their long courtship (and his first years as a school-master) – in grammar, Latin, church architecture and so on.[40] In her leisure hours as a young wife Mary set herself a demanding programme of reading, and she learned German. But she felt that the gap remained; and it was compounded by a deep divergence in their attitudes to religion. Edward's Christian profession was, as Arthur put it, 'of a disciplinary and liturgical type' – intellectual and dogmatic.[41] Hers was a deeply personal, mystical faith, uncluttered by doctrine. When she experienced a period of spiritual crisis in 1875, she resolved it not by turning to Edward as her husband and priest but by sharing her troubles with a woman friend and examining her life at length in her diary.[42]

The gap in intellectual attainment between spouses in the Victorian middle class was most obviously the outcome of women's inferior access to formal education. This was the reason given by John Stuart Mill in *The Subjection of Women* for the dismal fact that marriage in practice was 'an unimproving and unstimulating companionship'.[43] But in the Bensons' case the gap must be seen in another light altogether – namely the twelve-year difference in their ages. Edward was close on thirty when he married in 1859, Mary just eighteen. This kind of age

gap was of course not uncommon in the Victorian middle class, given the difficulty many men had in assembling the means to support a wife at the required level of comfort.[44] Kitchener's mother was nineteen and his father thirty-nine on their wedding day in 1845; John Ruskin was ten years older than Effie Gray. According to a recent sample of the 1851 Census, 31 per cent of upper middle-class husbands were at least five years older than their wives.[45] What was more unusual about the Bensons – though more common than one might imagine – was that Edward told Mary of his wish to marry her when she was only twelve. The account he gave in his diary is worth quoting at length:

> Let me try to recall each circumstance: the arm-chair in which I sat, how she sat as usual on my knee, a little fair girl of twelve with her earnest look, and how I said that I wanted to speak to her of something serious, and then got quietly to the thing, and asked her if she thought it would ever come to pass that we should be married. Instantly, without a word, a rush of tears fell down her cheeks, and I really for the moment was afraid. I told her that it was often in my thoughts, and that I believed that I should never love anyone so much as I should love her if she grew up as it seemed likely. But that I thought her too young to make any promise, only I wished to say so much to her, and if she felt the same, she might promise years hence, but not now. She made no attempt to promise, and said nothing silly or childish, but affected me very much by quietly laying the ends of my handkerchief together and tying them in a knot, and quietly putting them into my hand.[46]

With that pledge, Mary's future was settled – in her mind as well as Edward's. For several years after their marriage, Edward continued to take Mary on his knee and to speak to her as if she were a child – particularly when he was finding fault with her. During one quarrel over expenditure in January 1864 he riled her by saying 'some people shrank from things of an unpleasant nature especially if they had fat chins'.[47] He called her by her childhood diminutive 'Minnie' all his life. After his death she turned her back on the name, preferring to be known as 'Ben'.[48] When she became a widow she realized, as she put it in her diary: 'He chose me deliberately, as a child who was very fond of him & whom he might educate'.[49] For the first fifteen years that had been the reality of their marriage. Edward Benson was not the only Victorian husband who sought to mould the woman of his choice to his own requirements; and as Davidoff has observed, men who approached

marriage in this way were in effect strongly reaffirming their middle-class masculine identity.[50]

Here was Victorian patriarchy at its most literal: to the rights and powers of the husband was added the authority of a father. Mary Benson feared Edward as one would a puissant father. Indeed it seems all too likely that she fully reciprocated Edward's perception of their relationship as one between father and child, since her own father (William Sidgwick) had died in the year she was born. Her diary of 1875 vividly recalls her fear as a girl. One entry in her distinctive staccato style reads: 'Lessons with Ed. – so dreaded – architecture and physical geography'. After their marriage she came to dread their periodic confrontations over the household accounts.[51] Motherhood was not enough to raise her self-esteem or give her some autonomy in her relations with Edward. She remained the child-wife. Not until after her religious crisis, at the age of 34, did she overcome her feelings of awe and fear towards him.[52]

In modern accounts of the Victorian family, the child-wife sits uneasily with the angel-mother – uneasily because it is clear that the mother ministered in this way to her husband as well as her children.[53] In 1863 Arthur Stanley, a scholar churchman like Benson, wrote to his financée: 'You must be my wings. I shall often flag and be dispirited; but you, now, as my dear mother formerly, must urge me, and bid me not despair when the world seems too heavy a burden to be struggled against.'[54] He was in his mid-forties at the time. Havelock Ellis, who was brought up during the 1860s and early 1870s, later wrote, 'To every man . . . the woman whom he loves is as the Earth was to her legendary son; he has but to fall down and kiss her breast and he is strong again'.[55] Benson would have recoiled from the carnal imagery, but the yearning was one he felt strongly. Two weeks before his marriage he wrote to Mary: 'Would you were here and that I could lay my head on your breast & be comforted'.[56] He often found the world no less heavy a burden to bear than did Dean Stanley. He was a man of high professional standards and almost neurotic anxiety, who could be reduced to tears by the frustrations of a headmaster's life.[57]

It is hardly surprising that the 18-year-old Mary felt inadequate for the task of comforter. She lacked the experience to understand Edward's troubles, and she was too much in awe of him: 'I have not yet deserved the privilege of being his comforter', she wrote early in her marriage. 'I never feel my own want of womanliness so much as when he is in trouble or ill.'[58] The turning-point seems to have been the most anguished moment in their marriage – the death of their 17-year-old

eldest son, Martin, in 1878. Mary's faith was more equal to the blow than Edward's. 'My dearest wife understood it all more quickly – better – more sweetly than I', he wrote one week later.[59] It was her resilience which gave Edward and the rest of the family the strength to come through the crisis. Mary's role for the remaining eighteen years of the marriage was now set. The memories of the younger sons, Arthur and Fred, were of their father's total reliance on her ability to soothe his irritation and relieve his black depressions.[60] The partnership became more harmonious because Mary was better able – like a mother – to intuit her husband's unarticulated emotional needs and to regulate the emotional equilibrium of the household. Benson's dependence on his wife was of course less visible than his patriarchal authority, not least because it was so much at variance with the ethos of manly independence. But it was no less real for that, and was surely the indispensable underpinning of his public posture of command and self-reliance. Child-wife Mary may have been, but after twenty years together, the atmosphere of their marriage was as much determined by the 'father's' dependence on the 'child'.

In this alternation of mastery and dependence the Bensons exemplified a paradox which lay at the heart of bourgeois marriage in mid nineteenth-century England. Edward Benson drawing his wife on to his knee one moment, and laying his head on her breast the next, reminds us that the child-wife and the angel-mother were not necessarily alternative forms of distortion in the relations between spouses. They could co-exist as two contradictory sides of men's expectations, and both stood in the way of true companionship. David Pugh in his book *Sons of Liberty: The Masculine Mind in Nineteenth-Century America* has dubbed the husband of that time a 'patriarchal child'. 'American men', he writes,

> unwittingly placed themselves in the dual and contradictory role of patriarch and eternal child, one the breadwinner, the other the grateful recipient of motherly attention. In both roles he was safe from the threats he saw in women: for the stern provider, they were helpless children; for the adult turned child, they were providers of another kind who would attend to his comforts without distracting him with unmotherly demands.[61]

As that last phrase suggests, the notion of the patriarchal child has important implications for understanding the place of sex in bourgeois marriage. Pugh lays particular stress on the husband's fear of genuine heterosexual relations as being tantamount to incest: whether as

'mother' or 'child', the wife represented a greater love than sexual desire, and to confuse the two would only defile her. Much work on middle-class marriage in England lends support to this view.[62] And so indeed does the case of Edward and Mary Benson, on a first reading at least. Benson had a passionate nature which he knew needed to be curbed. Like many other earnest young men of his time – like Lord Shaftesbury for example[63] – he sought an attachment to a pure woman who would hold him back from carnal temptation. That this was in his mind when he first opened his heart to Mary is clear from his diary for 1852.[64] Later, on the eve of their marriage, he told Mary, 'your sweetness and simple purity have been God's angels to me'.[65] Mary offered about the strongest bulwark against impurity that might be imagined. She was not only a child, but Edward's cousin, and – after the death of his favourite sister Harriet in 1850 – she probably became his surrogate sister too.[66] Their blood-tie was all the more explicit because Edward moved into Mrs Sidgwick's household and remained there under the same roof as Mary for five years, while he was teaching at Rugby (1853–8).

We need to be cautious, however, in assuming that an incestuous identification over several years necessarily drained the relationship of passion. In a great many cases the exact opposite was the truth, as is suggested by the frequency and success of Victorian cousin-marriage. At a time when the social contacts of middle-class children and adolescents were carefully restricted, family relationships often bore a high erotic charge. A passionate attachment between brother and sister was not uncommon, nor was it frowned upon. Cousins often attracted the same intensity of feeling, sometimes as a displacement of sibling love. Henry Coleridge said of his cousin Sara (daughter of the poet) in the 1820s that she had been 'almost my sister ere my wife'.[67] Edward Benson's passion for his young cousin-wife is not in any doubt. His letters to Mary in the two months before they married showed a rising excitement and an almost intolerable impatience as the long anticipated bliss drew near.[68] They are not the letters of a man whose desire had been killed by thoughts of child, cousin or sister.

Furthermore there is no evidence that Benson took a puritanical view of marital sex – in fact rather the reverse. In his public life he certainly took up sexual issues. But he did not take a stand on sexual restraint within marriage. His concern was rather focused on the need for purity among boys and young men amid the perils of masturbation and homosexuality.[69] Perhaps more to the point, during the years at Wellington Benson struck up a close friendship with Charles Kingsley,

rector of the nearby village of Eversley. Like Benson, Kingsley had no love for the Evangelicals. He preached the 'divineness of the whole manhood' and the hearty enjoyment of the body.[70] He roundly rejected the argument that too much indulgence in the marriage bed would lead a man to associate his wife with coarse and debased feelings. Kingsley's early novels had earned some notoriety for his robust attitude to heterosexual passion. At the same time, in private, he was using very explicit language in his love-letters to his fiancée.[71] I have no evidence that Benson and Kingsley discussed these matters, but it is inconceivable that a man of Benson's propriety would have maintained the friendship and permitted his young wife to visit Eversley rectory if he had radically disagreed with Kingsley's public views on marriage and sex. It should be added that Benson was not the only public-school headmaster to be influenced by Kingsley's views on this subject: Edward Thring of Uppingham was another.[72] For all his zeal in the cause of purity, Edward Benson was probably a man who accepted the place of sex in life, who had strong sexual needs, and who looked to marriage to fulfil them.

Mary's perception was inevitably very different. She was no Fanny Kingsley, able and willing to respond warmly to her husband's sensuality. This was not simply a matter of tender years and sexual ignorance. The root problem seems to have been her relation to Edward: she had no sexual feelings towards him. The only direct evidence we have of the Bensons' sexual life together is Mary's later recollection of their honeymoon in Paris. It makes pathetic, but also revealing reading: 'He restrained his passionate nature for 7 years and then got *me*! This unloving, childish, weak unstable child! . . . How I cried at Paris! poor lonely child, having lived in the present only, living in the present still. The nights! I can't think how I lived.' Mary's conclusion was that she had married without 'the real equal love' and 'that strong human passion' which Edward had. When she wrote her history of their relationship in 1875, again and again she reproached herself for her lack of love, her 'shallow heart'.[73] The fault was hardly hers. She had been pressed into an unofficial engagement at the age of 12 so that her genuinely affectionate feelings for Edward were stifled from the start by an oppressive sense of where her duty lay, of what she had promised, not what her inclination was. It seems all too likely that the trauma of the wedding night was never healed, and that her revulsion from marital sex remained. When Mary did discover her sensual side, Edward was excluded altogether. From about 1872 onwards she developed close attachments to a succession of women

friends. For the first time she spoke unaffectedly of love in her diary. Near the end of her marriage she fell in love with Lucy Tait, daughter of Benson's predecessor as Archbishop. Notwithstanding the guilt she felt for her 'carnal affection',[74] Mary found Lucy indispensable to her, and for most of her widowhood they shared a bed together.

Between Mary's emotional captivity as a child and the lesbian passion of her later years there cannot have been much room for a satisfying heterosexual relationship with Edward. But his strong libido was probably undiminished. Much of his difficult temperament bears all the marks of sexual frustration: the depressions, the neuralgia, the irritability, above all his legendary capacity for work. He was a man who spent as little time in bed as possible (five hours usually), and who found it extremely hard to rest or relax at other times. Domesticity exacted its toll, but it also diverted energies into channels which Edward found richly rewarding – a familiar enough contradiction in the case of men of masterful ambition and feverish activity. The cult of manly energy by which Thomas Arnold and his followers lived (or the cult of work in Carlyle's case) was closely linked to their code of sexual purity, and to the many obstacles which stood in the way of erotic fulfilment in marriage.

FATHER AND SONS

There is an appearance of familiarity about Victorian middle-class marriage, if only because a number of more or less plausible generalizations make for a recognizable area of debate. The same can scarcely be said for fatherhood. Hardly anything worth the name of a general survey exists, certainly not for the High Victorian period. The careful sifting of letters and diaries which E. Anthony Rotundo has done for the northern middle class in America[75] has simply not been attempted here, except for David Roberts's pioneering account of the aristocracy.[76]

In the absence of a proper study of the evidence, two notions about Victorian middle-class fathers seem to be current. The first stands on a literal interpretation of the 'separation of spheres'. The raising of children was essentially the mother's business; as her role became more self-consciously vocational, and suburban living became more widespread, the father receded to the margins – the provider and the arbiter on educational matters, maybe, but increasingly distanced from the daily interaction between the generations. This interpretation is particularly current in the United States, where Peter Filene speaks of

the 'default of fatherhood', and Rotundo has gone so far as to assert, 'the era of patriarchy had passed' by the mid nineteenth century.[77] In England as early as 1843 Mrs Ellis had commented regretfully on 'the almost double responsibility' towards children which devolved on modern mothers because of their husbands' negligence.[78] But this and other prescriptive writings were in part at least intended to nip an unwelcome trend in the bud; American material on the subject of the absent father was quoted in British magazines for this very reason, one suspects.[79] As American visitors to England noted, the fireside ideal held a much greater appeal for middle-class Englishmen than for their American counterparts[80] – probably on account of the stronger hold of Evangelicalism in England. A recent historian of the Bradford bourgeoisie has remarked that in the early Victorian era 'the role of the father in domestic intimacy and cohesion was almost as great as that of the mother'.[81] Nobody familiar with the autobiographies of the period could easily come to the conclusion that fathers had withdrawn from the field. Benson was certainly no retiring patriarch.

If we accept that up to a point fathers were an active presence in the home and go on to ask what face they presented to their children, we could invoke the second current notion – that father–child, and more especially father–son relations were characterized by oppression and revolt. Writers like Lee Krenis and Steven Mintz have shown how vital it seemed that children be taught deference and self-government in the home, at a time of social flux when other supports for these virtues like religion and apprenticeship appeared to be on the wane. For the middle class, instilling the approved character in sons seemed all the more vital as entry into the professions came to depend on hard work rather than patronage. In effect a great deal of the pessimism and anxiety with which the older generation viewed their social world was channelled into an intrusive and burdensome regime for children. As a result, according to this line of analysis, sons spent many years – sometimes a lifetime – seeking to free themselves from their upbringing, either through an overt challenge, or by religious argument, or through illness.[82]

Krenis and Mintz are clearly touching on a psychological theme of perennial importance whose relevance to the Victorians is indisputable. What Lawrence Stone has called the 'Victorian revival of patriarchy' is probably closer to the true state of father–son relations in England than Rotundo's 'end of patriarchy'.[83] But I question whether the theme of rebellion should be taken to be quite so predominant. It is after all largely derived from a handful of autobiographical writings – notably

Samuel Butler's *The Way of All Flesh* (1903) and Edmund Gosse's *Father and Son* (1907) – which owe their fame to the early twentieth-century fashion for the reminiscences of those who rebelled against Victorianism. In the case of the Bensons the theme of authority and rebellion is not specially illuminating unless one construes any and every departure from paternal precept as rebellion. The theme which sheds most light on the experience of the Benson sons is not authority v. autonomy, but the impact of a pronounced split in gender attributes between their parents. It is this which holds the clue to the unfolding of their masculinity.

Benson was a constant and imposing presence in the lives of his children. In the Benson household the children were not simply consigned to the care of servants, important though the family nurse, Beth, was in their lives. Benson was available to his children at regular times: they used to come and talk to him while he was shaving (presumably a guarantee that they would in fact be able to talk instead of merely listen), and in the evening he read to them and showed them pictures in his study; he was with them at meal-times and on walks on Sunday afternoons.[84] Benson's decision to send his four sons away to school at the age of 10 might appear the action of a father keen to keep his children at arm's length – as has often been suggested in the case of parents of his class.[85] But in fact Benson, like most professional men of his generation, sincerely believed that public school was indispensable for a sound moral and academic education: it was the premise on which his entire early career was based. He certainly did not put his sons out of mind while they were at school. He wrote to them frequently – perhaps too frequently, as we have seen. In fact Benson had an intense love for his children. No one reading his moving record of Martin Benson's short life could doubt that.[86] He kept every single letter that they ever wrote to him. At the age of 52 – when his youngest was 10 – he confessed to Mary how hard it was to contemplate the years ahead without little children.[87]

It was Benson's tragedy, and a tragedy for his children, that he could not show this love. They grew up not realizing the depth of his affection and were starved of intimacy with him. This was partly because they had a keen sense of their father's greatness. While he was at Wellington, Benson entertained people like the Prime Minister and the second Duke of Wellington, and the children were only too well aware that in the school their father's word was law. That sense of public eminence grew when Benson became a bishop in 1877. The Benson family is a striking instance of how the Victorian father's

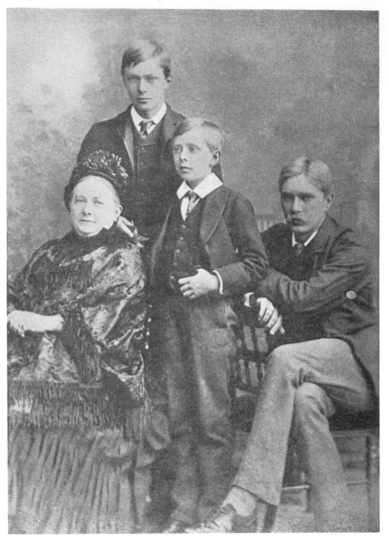

5 Mary Benson with her three surviving sons: E. F. Benson, R. H. Benson and
A. C. Benson, *c.* 1884. (Photograph reproduced from *Two Victorian Families* by
Betty Askwith, 1971, by kind permission of Chatto & Windus)

exclusive access to the public domain made him seem larger than life
within the home.

But the children's awe of their father went deeper. Essentially it
turned on the severity of his demeanour towards them. This did not

take the form of physical abuse. Although Benson was a notoriously harsh disciplinarian in the school, he did not beat his own children. But his displeasure was burdensome nonetheless, and it was displayed in what to the children seemed an arbitrary fashion, unfair and often unexpected. Even when Benson made an effort to be playful and boisterous with the children, reproof never seemed far away. Any moral laxity was corrected; innocent pleasures were killed by a word of disapproval; flippant remarks encountered stony silence. As Fred recalled, 'we sat on the edge of our chairs and were glad to be gone'.[88] After the Archbishop's death, when Fred and Arthur were able to read his letters and diaries, they realized the true extent of his love for them, and their sense of what they had lacked as children became all the more poignant. Fred wrote, 'That we should so have feared him, that we should so have made ourselves unnatural and formal with him, when all the time his love was streaming out towards us, makes a pathos so pitiful that I cannot bear to think of it.'[89] Arthur agreed: 'In those days he seemed to me more censorious than affectionate. How *can* children understand that they are loved, unless it is shown them plainly? Yet all my recollections of those days are of constant vigilance and self-repression, for fear Papa should be vexed.'[90]

This pattern of behaviour is worth dwelling on because it represented a departure from early nineteenth-century conventions. Accounts of middle-class families before 1850 are full of relaxed and approachable fathers – like Edward Irving showing off his babies to Thomas Carlyle, or William Wilberforce's 'simple unaffected joy in the company of his children'.[91] Dr Arnold himself, according to his first biographer, allowed his children the run of his study, and was gentle and playful (as well as firm) with them; as one of them later recalled, 'in all of us on the whole love cast out fear'[92] – exactly the opposite of the atmosphere in the Benson household.

In Benson's case the shift towards more formality and discipline is the more intriguing because he was a man of strong passions who did not hide his intense feelings for his wife, his friends, or even his professional colleagues. Why then did he not express his love for his children? The answer is that Benson's role as a father carried for him altogether different and far more solemn responsibilities than his roles as husband, friend or colleague. A high sense of duty was the key, as it had been in James Anthony Froude's upbringing. 'You will find', wrote Froude, 'many fathers – substantially kind and good fathers – whose single guide in all they do for their children is the highest, most imperious sense of duty. It is far rarer to find one who, in the little

private relations of common life, will throw them a kind word or a kind smile.'[93] Froude had in mind his own childhood in the 1820s, but the attitude he describes was more characteristic of the next generation. His description certainly fits Benson well enough.

Lee Krenis has suggested that fathers may have suppressed any expression of tenderness towards their sons in order to prepare them better for a harshly competitive and impersonal society.[94] In the more uncertain economic climate of the 1870s and 1880s the demands of the adult material world seemed all the more formidable. Benson was probably not immune from this worldly consideration, given the tenuous hold his own family had kept on the externals of respectability during his early years. But it was the moral training of his children which preyed upon him most. In this respect Benson reflected a widespread concern among educationalists and moralists of the day, which distinguished them from their early Victorian forebears. He was acutely aware of the inroads which biblical criticism and evolutionary science were making on the intellectual repute of the Christian faith; indeed his own brother-in-law and cousin, Henry Sidgwick, was a prominent agnostic. In an increasingly secular society the family carried an even more onerous responsibility than before to train morally responsible citizens. For someone as preoccupied with the moral welfare of the individual as Benson was, the withering away of the traditional supports for morality made every stage of the child's upbringing a critical battleground in the effort to internalize high moral standards, in the hope that he or she would survive with some moral credit in a world that too often condoned or rewarded sin. It was Benson's deeply held moral pessimism, combined with his onerous sense of accountability, which explained what Fred later called 'the watchfulness and responsibility of his love'.[95] Like many mid-Victorians he was not so much an absent, as an over-anxious father.

Benson's earnest vigilance was in complete contrast to his wife's attitude towards the children. Their temperaments were anyway very different. Where Edward was anxious, critical and over-serious, Mary was forgiving, not censorious by nature, and – with the children at least – relaxed and humorous. Although she was quite capable of reading them a moral lecture, she did so with a gentler tone than Edward,[96] and she did not harp on faults. Her sympathy and understanding were readily available. In Fred's words, 'She loved with a swift eagerness'.[97] Even when due allowance is made for the softened memories of middle-aged sons, the difference was pronounced, and it is confirmed by contemporary comment: Thomas Hughes, for example, regarded

the contrast between the mother's 'care and love' and the father's 'anxious affection' as an emotional fact of life.[98]

In a domestic regime of separate spheres where the mother stood for love and the father represented the discipline required for survival in the outside world, growing sons often experienced a gulf between the emotional characters of father and mother which made them all the more resentful of their fathers' authority.[99] Such a background features prominently in the lives of the family rebels of the period. In the well-known cases of Samuel Butler and Robert Louis Stevenson it led to bitter quarrels with the father when they grew up – and a countervailing desire to maintain warm and affectionate relations with the mother.[100] The sentimental idealization with which so many Victorians recalled their mothers reflects a real and poignant antithesis to the sterner code laid down by their fathers. What has been insufficiently stressed in writing on the English middle-class family is that this split in gender attributes led to a particularly brittle masculinity in the generation which grew up after 1860. For while boys all too easily identified with the stern and undemonstrative father, they learned to associate tenderness and affection exclusively with women – if not with the mother then the nurse or nanny. As a result boys came to distrust these feelings in themselves as unmanly, to an extent they would surely not have done if their fathers had been more openly affectionate.

THE FLIGHT FROM DOMESTICITY

This sharp division of gender attributes within the mid-Victorian family had far-reaching effects on the masculinity of the next generation. Along with the changing ethos of the public schools, it surely accounts for the extreme emotional reticence – the 'stiff upper lip' – which was so characteristic of middle-class men around the turn of the century.[101] One thinks here of Kitchener, born in 1850 the son of a martinet and of an adored mother who died when he was 14; reserved and sensitive all his life, he 'preferred to be misunderstood', as one colleague recalled, 'rather than to be suspected of human feeling'.[102] The character gap between the stern father and the loving mother made it extremely difficult for a growing boy to accommodate feelings of tenderness and affection in his masculine self-image. They belonged instead with his mother, and however powerful her influence and however great the son's devotion to her memory, they remained

feminine traits which he might yearn after and sentimentalize but could not express in his own demeanour.

Emotional reticence was not, however, a strongly marked feature of the three Benson sons who grew to maturity. They endeavoured to come to terms with their distorting character formation by a different path. As far as possible they pursued their lives in an all-male, homoerotic setting. All of them were apprenticed to this life at public school and Cambridge. Arthur remained the most closely wedded to it: his entire working life was spent first as a master at Eton, then as a Cambridge don. His diary as presented to us by David Newsome records a lengthy succession of romantic attachments to young men which makes sad reading because none of them lasted long, and because Arthur could disclose only a small part of his feelings; he seemed always to be 'on the edge of Paradise', he remarked at the age of 48.[103] Hugh, the youngest Benson son, took orders in the Anglican Church, lived as a monk for several years, and then entered the Roman Catholic Church in 1903. Fred as a society novelist led a life nearer to the mainstream. But in his twenties he had moved in the same circle as Oscar Wilde and Lord Alfred Douglas, and in his late forties he wrote a schoolboy love-story called *David Blaize* – his most deeply felt novel.[104]

The three Benson brothers all hovered on the fringes of the 'Uranian' group of writers which had such a distinctive voice in English literary culture between 1890 and 1930. Timothy D'Arch Smith emphasizes that the Uranians were for the most part not interested in homosexual relations between adults, but in the aesthetic and spiritual appeal of younger men and adolescent boys.[105] A sexually repressed upbringing such as the Bensons experienced, with its heavy emphasis on 'purity', created problems enough for adult men in expressing heterosexual love; it presented an even greater obstacle to a fully realized homosexual identity. But in a homoerotic ambience men like the Benson brothers could at least find a place – however attenuated in practice – for the warm personal relations which had been denied to them by their father. There is some resemblance here to Freud's classic homosexual childhood scenario of seductive mother and weak or absent father. But in these cases the father, far from being weak or absent, is palpably present and in command – only he is unapproachable.

The Uranian sensibility, which appealed so much to all three of the Benson brothers, represented in part a cautious assertion of an alternative sexuality, and as such it warrants a significant niche in the history of an emerging gay identity over the past century or so.[106] But the Uranians were also a symptom of a much wider phenomenon – the

refusal to marry and the flight from domesticity. The Benson family offers a striking illustration of this theme. As we have seen, Edward Benson's sense of himself and his place in the world had been intimately bound up with the domestic sphere. Except for four years at Cambridge, he lived in a domestic setting all his life – first under the parental roof, then in Mrs Sidgwick's house, and then from the age of 30 in his own household. In each of them he learnt to exercise authority – as a widow's eldest son, as the senior male in another widow's family, and as master and husband in his own house. His responsibility for his family was analogous to his pastoral care for his pupils and his flock. Although Benson certainly allocated much more time and effort to his professional duties, there is no doubt that work and family were both integral to his sense of personal worth. True manliness required good stewardship in both spheres.

None of Benson's sons followed that precept. After the age of twenty they never spent any extended periods under their mother's roof (unlike their one surviving sister, Maggie). Arthur, Fred and Hugh each cultivated a full social life away from home. Rather than recreate the conditions in which they had themselves been brought up, they chose to live in bachelor flats, schools, colleges and closed communities. The domestic world, with its feminine ambience, its combustible human chemistry and its inexorable routine, held no appeal for the Benson sons. Caught by the emotional world of the public school, they were unimpressed by the rewards held out by the office of paterfamilias. Without ever making an issue of it, they quietly signalled their own revolt against domesticity.

In so doing they conformed to a discernible trend at the end of the nineteenth century, for homoeroticism and homosexuality were only one facet of the flight from domesticity. Public concern about young middle-class men who possessed the means to marry but preferred to remain bachelors had first surfaced in the late 1860s, and it came to a head twenty years later.[107] By that time, many middle-class men were distancing themselves from home and hearth in the most literal way possible, by going overseas. The Empire beckoned young men in reaction against domesticity just as the Frontier did in the United States.[108] Emigration, the armed services and colonial administration all attracted plentiful recruits. Hugh Benson's first choice of career before he became a priest had been the Indian Civil Service. The Empire now also occupied an unprecedented place in the masculine imagination; in the work of popular writers like Kipling and Henty it had become an imaginative space where male comradeship and male hierarchies found

their full scope, free from feminine ties.[109] Almost all the popular paragons of imperial manliness at this time were men who either never married (Gordon, Kitchener, Rhodes) or else married very late (Baden-Powell, Lugard, Milner). The Boy Scout movement, aiming to take grammar school and Board school boys out of the home for character training, was in a way the apotheosis of the revolt against domesticity: as Baden-Powell explained in *Scouting for Boys* (1908), 'manliness can only be taught by men, and not by those who are half men, half old women'.[110] A similar revision of attitude was to be found in organized religion: by 1890 it was possible for a churchman publicly to condemn married clergy for 'an unmanly preference for English home life'.[111] Freedom from domesticity was a positive manly attribute in a way which had found little parallel among respectable professional men fifty years earlier.

The severance between manliness and domesticity was not the least of the cultural changes which came in the wake of the 'New Imperialism'. It may be that a popular sense of imperial mission, as that notion was understood in the late Victorian era, required a disparagement of home comforts. But there are grounds for supposing that the flight from domesticity was rooted in the first instance in the reaction of young middle-class men against domestic emotions and domestic constraints. The full ramifications of that reaction are by no means clear as yet, but the kind of family experience which the Benson sons looked back on was surely part of it.

NOTES

1 This chapter is a report on work in progress. An earlier version was presented at History Workshop's London seminar in October 1989. For comment and help of various kinds I am grateful to Leonore Davidoff, Iris Dove, David Newsome, and the other contributors to this book.
2 Samuel Smiles, *Character*, London, John Murray, 1871, p. 31.
3 Smiles, *Character*, title of chapter 2.
4 Smiles, *Character*, pp. 308–9.
5 Thomas Hughes, *Notes for Boys (and their Fathers) on Morals, Mind and Manners*, London, Elliot Stock, 1855, p. 90. Home is also a dynamic element in *Tom Brown's Schooldays* (1857), for all its repute as the archetypal public-school story: true manliness is made possible for Tom through the Christian home background of his friend George Arthur.
6 See above, Introduction, pp. 3–4.
7 Leonore Davidoff and Catherine Hall, *Family Fortunes: Men and Women of the English Middle Class, 1780–1850*, London, Hutchinson, 1987, passim.
8 The Benson family has figured in two fine studies by David Newsome:

Godliness and Good Learning: Four Studies on a Victorian Ideal, London, John Murray, 1961; and *On the Edge of Paradise: A. C. Benson the Diarist*, London, John Murray, 1980. There is also useful material on the marriage of Edward and Mary Benson in Betty Askwith, *Two Victorian Families*, London, Chatto & Windus, 1971. David Williams, *Genesis and Exodus: a Portrait of the Benson Family* (London, Hamish Hamilton, 1979) is a more popular account. M. Jeanne Peterson, *Family, Love and Work in the Lives of Victorian Gentlewomen* (Bloomington, Indiana University Press, 1989) treats the family life of an almost identical fraction of the Victorian middle class but offers a rather different interpretation.

9 A. C. Benson, *The Life of Edward White Benson*, London, Macmillan, 1899, 2 vols.

10 Davidoff and Hall, *Family Fortunes*, esp. pp. 108–13, 180–92.

11 A modern full-length study of Arnold and his impact is badly needed; but see T. W. Bamford, *Thomas Arnold*, London, Cresset Press, 1960.

12 Newsome, *Godliness and Good Learning*.

13 Newsome, *Godliness and Good Learning*, chapter 2.

14 David Newsome, *A History of Wellington College, 1859–1959*, London, John Murray, 1959, p. 109.

15 E. W. Benson, *Boy Life, Its Trial, Its Strength, Its Fulness, Sundays in Wellington College, 1859–1873*, London, Macmillan, 1874, p. 372.

16 A. C. Benson, *The Trefoil: Wellington College, Lincoln, and Truro*, London, John Murray, 1923, pp. 156–7. A. C. Benson, *Life of Benson*, vol. 1, p. 241; A. C. Benson, *Hugh: Memoir of a Brother*, London, Smith, Elder, 1915, p. 32.

17 This interpretation is most stressed in the United States; see John Demos *Past, Present and Personal: the Family and the Life Course in American History*, New York, Oxford University Press, 1986, pp. 41–67. But see also Donald H. Bell 'Up from Patriarchy: the Male Role in Historical Perspective', in Robert A. Lewis (ed.), *Men in Difficult Times*, Englewood Cliffs, Prentice Hall, 1981, pp. 306–23; and Jane Lewis, *Women in England, 1870–1939*, Brighton, Wheatsheaf, 1984, pp. 124–5.

18 Sarah Stickney Ellis, *The Mothers of England*, London, Fisher, 1843, and *The Wives of England*, London, Fisher, 1843.

19 Personal communication from Catherine Hall, with reference to her sample of the 1851 Census. See also Davidoff and Hall, *Family Fortunes*, pp. 231–2.

20 A. C. Benson, *Life of Benson*, vol. I, p. 23.

21 A. C. Benson, *Trefoil*, p. 47.

22 Zuzanna Shonfield, *The Precariously Privileged: a Professional Family in Victorian London*, Oxford, Oxford University Press, 1987; Peterson, *Family, Love and Work*, p. 175.

23 M. St J. Packe, *The Life of John Stuart Mill*, London, Secker & Warburg, p. 358.

24 E. F. Benson, *Our Family Affairs, 1867–1896*, London, Cassell, 1920, p. 21. In other middle-class families, easy access to kitchen and servants' quarters sometimes afforded children another perspective on both class and gender. See Leonore Davidoff, 'Class and Gender in Victorian England', in Judith L. Newton *et al.* (eds), *Sex and Class in Women's History*, London, Routledge, 1983, p. 26.

25 J. A. James, quoted in Davidoff and Hall, *Family Fortunes*, p. 109.
26 Mary Benson, diary, 24 January 1864, Bodleian Library, Benson Deposit [hereafter BD], 1/73.
27 Mary Benson, diary, undated entry, BD 1/73.
28 Newsome, *Godliness and Good Learning*, pp. 166–77.
29 Mary Benson, retrospective diary, 1875, BD 1/79, and diary, 16 January 1864, BD 1/73.
30 Noel Annan, *Leslie Stephen: the Godless Victorian*, London, Weidenfeld & Nicolson, 1984, p. 73. For a contrary emphasis on wives' financial autonomy, see Peterson, *Family, Love and Work*, pp. 124–5, 183–4.
31 Newsome, *Wellington College*, p. 173.
32 Smiles, *Character*, pp. 307–9.
33 Davidoff and Hall, *Family Fortunes*, p. 113.
34 Quoted and discussed in Norma Clarke, *Ambitious Heights: Writing, Friendship, Love – the Jewsbury Sisters, Felicia Hemans, and Jane Welsh Carlyle*, London, Routledge, 1990, pp. 41–2.
35 Speech in the House of Commons, 20 May 1867, quoted in J. A. and Olive Banks, *Feminism and Family Planning in Victorian England*, New York, Schocken, 1964, p. 73.
36 Banks and Banks, *Feminism and Family Planning*, pp. 62–74.
37 Newsome, *Wellington College*, p. 55.
38 Mary Benson, diary, 8 March 1898, BD 1/77.
39 E. F. Benson, *As We Were: a Victorian Peep-Show*, London, Longmans, 1930, p. 107.
40 E. W. Benson to Mary Sidgwick, 16 July 1855, BD 3/14.
41 A. C. Benson, *Trefoil*, p. 253.
42 Mary Benson, retrospective diary, 1875, BD 1/79; E. F. Benson, *Mother*, London, Hodder & Stoughton, 1925, pp. 22–3.
43 John Stuart Mill, *The Subjection of Women*, London, Virago, [1869], 1983, p. 176.
44 J. A. Banks, *Prosperity and Parenthood*, London, Routledge, 1954.
45 Davidoff and Hall, *Family Fortunes*, p. 323.
46 E. W. Benson, diary, quoted in E. F. Benson, *As We Were*, p. 64.
47 Mary Benson, diary, 16 January 1864, BD 1/73, and retrospective diary, 1875, BD 1/79.
48 Geoffrey Palmer and Noel Lloyd, *E. F. Benson As He Was*, Luton, Lennard, 1988, p. 60.
49 Mary Benson, diary, 8 March 1898, BD 1/77.
50 Davidoff, 'Class and Gender', p. 46.
51 Mary Benson, retrospective diary, 1875, BD 1/79.
52 E. F. Benson, *Mother*, pp. 25–7.
53 e.g. Eric Trudgill, *Madonnas and Magdalens*, London, Heinemann, 1976.
54 A. P. Stanley to his fiancée, 1863, quoted in Trudgill, *Madonnas*, p. 80.
55 Havelock Ellis, quoted in Edward Carpenter, *Selected Writings*, vol. I, London, Gay Men's Press, 1984, p. 116 (the passage is taken from *Love's Coming of Age*, 1896).
56 E. W. Benson to Mary Sidgwick, 7 June 1859, BD 3/15.
57 A. C. Benson, *Life of Benson*, vol. I, p. 207.
58 Mary Benson, diary, quoted in E. F. Benson, *Mother*, p. 14.

59 E. W. Benson, diary, February 1878, Trinity College Library, Cambridge.
60 A. C.Benson, *Life of Benson*, vol. I, p. 144; E. F. Benson, *Mother*, pp. 22, 28–9.
61 David G. Pugh, *Sons of Liberty: the Masculine Mind in Nineteenth-Century America*, Westport, Greenwood Press, 1983, pp. 83, 88.
62 e. g. Trudgill, *Madonnas*.
63 G. F. A. Best, *Shaftesbury*, London, New English Library, 1975, pp. 22–3.
64 E. W. Benson, diary, quoted in E. F. Benson, *As We Were*, pp. 60–1.
65 E. W. Benson to Mary Sidgwick, 2 May 1859, BD 3/15.
66 Mrs Sidgwick, Mary's mother, certainly became a surrogate mother to Edward. And on the eve of their wedding Edward told Mary that her hair was 'rich and full like my dear lost sister's'. E. W. Benson to Mary Sidgwick, 6 June 1859, BD 3/15.
67 Quoted in Nancy Fix Anderson, 'Cousin Marriage in Victorian England', *Journal of Family History*, vol. 11 (1986), pp. 285–301.
68 Letters from E. W. Benson to Mary Sidgwick, 1859, passim, BD 3/15.
69 Newsome, *Wellington College*, pp. 108–10, 166–70; Newsome, *Godliness and Good Learning*, pp. 44–5.
70 Charles Kingsley, *His Letters and Memories of His Life*, ed. F. Kingsley, London, Henry S. King, 1877, 2 vols, vol. 2, p. 186.
71 Peter Gay, *The Bourgeois Experience: Victoria to Freud*, vol. II, New York, Oxford University Press, 1986, pp. 297–311; Susan Chitty, *The Beast and the Monk: a Life of Charles Kingsley*, London, Hodder & Stoughton, 1974.
72 Edward Thring, 'The Charter of Life', in C. J. Vaughan (ed.), *The School of Life*, London, Rivingtons, 1885, pp. 86–7.
73 Mary Benson, retrospective diary, 1875, BD 1/79.
74 Mary Benson, diary, 1 October 1896, BD 1/77.
75 E. Anthony Rotundo, 'Manhood in America: the Northern Middle Class, 1770–1920', unpublished Ph.D. dissertation, Brandeis University, 1982. See also E.A. Rotundo, 'Patriarchs and Participants: a Historical Perspective on Fatherhood', in Michael Kaufman (ed.), *Beyond Patriarchy*, Toronto, Oxford University Press, 1987, pp. 64–80.
76 David Roberts, 'The Paterfamilias of the Victorian Governing Classes', in A. S. Wohl (ed.), *The Victorian Family*, London, Croom Helm, 1978.
77 Peter G. Filene, *Him/Her/Self: Sex Roles in Modern America*, 2nd edition, Baltimore, Johns Hopkins University Press, 1986, p. 78; Rotundo, 'Manhood in America', p. 222.
78 Sarah Ellis, quoted in Patricia Branca, *Silent Sisterhood*, London, Croom Helm, 1975, p. 111.
79 Barbara F. Leavy, 'Fathering and *The British Mother's Magazine,* 1845–1864', *Victorian Periodicals Review*, vol. 14, (1980), pp. 10–16.
80 See for example Ralph Waldo Emerson, *English Traits*, London, Routledge, 1856, pp. 62, 164.
81 Theodore S. Koditschek, *Class Formation and the Bradford Bourgeoisie*, unpublished Ph. D. dissertation, Princeton University, 1981, p. 528.
82 Lee Krenis, 'Authority and Rebellion in Victorian Autobiography', *Journal of British Studies*, vol. 18, 1978, pp. 107–30; Steven Mintz, *A Prison of Expectations: the Family in Victorian Culture*, New York, New York University Press, 1983.

83 Lawrence Stone, *The Family, Sex and Marriage in England, 1500–1800*, London, Weidenfeld & Nicolson, 1976, p. 665.

84 A. C. Benson, *Trefoil*, p. 42, and *Life of Benson*, vol. I, p. 243.

85 W. L. Burn, *The Age of Equipoise*, London, Allen & Unwin, 1964, p. 246; F. M. L. Thompson, *The Rise of Respectable Society: a Social History of Victorian Britain, 1830–1900*, London, Fontana, 1988, p. 152.

86 Extensive passages from E. W. Benson's life of his son are reproduced in Newsome, *Godliness and Good Learning*, chapter 3.

87 A. C. Benson, *Life of Benson*, vol. 1, p. 644.

88 E. F. Benson, *Our Family Affairs*, p. 39.

89 ibid., p. 104.

90 Quoted in Newsome, *On the Edge of Paradise*, p. 16.

91 For Irving, see Norma Clarke in this volume, p. 31. For Wilberforce, see David Newsome, *The Parting of Friends: a Study of the Wilberforces and Henry Manning*, London, John Murray, 1966, p. 35 (the quotation is from James Stephen).

92 A. P. Stanley, *the Life and Correspondence of Thomas Arnold*, 2 vols, London, Fellowes, 1844, vol. 1, pp. 211–13; Thomas Arnold (the younger), *Passages in a Wandering Life*, London, John Murray, 1900, p. 9.

93 [J. A. Froude], *Shadows of the Clouds*, London, John Ollivier, 1847, p. 25.

94 Krenis, 'Authority and Rebellion', p. 117.

95 E. F. Benson, *Our Family Affairs*, p. 103. My analysis here owes much to Mintz, *Prison of Expectations*, esp. pp. 28–35.

96 See the letter from Mary Benson to E. F. Benson, *c.* 1880, quoted in Palmer and Lloyd, *E. F.Benson*, p. 22.

97 E. F. Benson, *Our Family Affairs*, p. 105. See also A. C. Benson, *Trefoil*, pp. 273–5.

98 Hughes, *Notes for Boys*, p. 91.

99 Daughters were also of course deeply affected – and in turn influenced the emerging masculine identities of their brothers. A fuller study would certainly consider the role of the two Benson daughters, Nellie and Maggie.

100 Mintz, *Prison of Expectations*, pp. 59–101, 174–9.

101 On the role of the public schools in this shift in middle-class mores, see Newsome, *Godliness and Good Learning*, chapter 4, and J. R. de S. Honey, *Tom Brown's Universe: the Development of the Victorian Public School*, London, Millington, 1977.

102 Edward Cecil, *The Leisure of an Egyptian Official*, London, Hodder & Stoughton, 1921, p. 184.

103 Newsome, *On the Edge of Paradise*, p. 243.

104 Palmer and Lloyd, *E. F. Benson*, pp. 32, 49–52, 99–103.

105 Timothy d'Arch Smith, *Love in Earnest*, London, Routledge, 1970, pp. xix–xx, 7–8.

106 Jeffrey Weeks, *Coming Out: Homosexual Politics in Britain, From the Nineteenth Century to the Present*, London, Quartet, 1977, pp. 125–6.

107 Peter T. Cominos, 'Late Victorian Sexual Respectability and the Social System', *International Review of Social History*, vol. 8, 1963, pp. 18–48, 216–50.

108 Pugh, *Sons of Liberty*.

109 Preben Kaarsholm, 'Kipling and Masculinity', in Raphael Samuel (ed.), *Patriotism*, 3 vols, London, Routledge, 1989, vol. 3.
110 Robert Baden-Powell, *Scouting for Boys*, London, 1908, p. 266.
111 R. W. Church, quoted in Newsome, *Godliness and Good Learning*, p. 196.

4

MASCULINITY AND THE 'REPRESENTATIVE ARTISAN' IN BRITAIN, 1850–80

Keith McClelland

In discussions of British working-class life between about 1850 and the 1870s, most historians have agreed that there was a new tone and pattern evident after the crises of the 1830s and 1840s. The dominant figure in many accounts of this working class, as in so much contemporary social commentary and imagery, was that person whom Thomas Wright in 1873 took to be the typification of the working class as a whole – 'the working man'.[1] Many historians have followed Wright further in concentrating their attentions upon the 'representative artisan' as the working man *par excellence*. He was, thought Wright, someone who in times of anything like averagely brisk trade 'can command good work and good pay all the year round, has a comfortable home, saves money, provides through his benefit and trade clubs for the proverbial rainy day, is in his degree respected because self-respecting, and on the whole is a person rather to be envied than pitied'.[2] And such a man is often taken to be at the centre of key developments in the working class in the period: the establishment of a more secure and visible trade unionism, albeit one confined to a minority of workers; the expansion of the resources and members of friendly and co-operative societies and other means of collective security; the gaining of 'citizenship' by a significant minority of working-class men in 1867; the new legitimacy of the working class and its institutions in both civil society and the state.[3]

There have been considerable disagreements about how the changes in the post-1850 working class may be described, explained and evaluated, as there have been also about the relationship between those changes and the evolution of the whole society.[4] Yet whatever can be

This chapter is a revised version of an article which previously appeared in *Gender and History*, vol. 1, no. 2 (1989), pp. 164–77. We are grateful to Basil Blackwell Ltd for permission to reproduce the article.

learned from these, one of the most persistent absences in the historiography has been the realization that this was a *gendered* working class and that an adequate history won't be written until this is taken on. There has been important work by feminist historians and others on, among other things, post-Chartist politics, women's employment, marital, familial and sexual practices and beliefs, and the culture of respectability.[5] However, much mainstream working-class history or a more narrowly defined labour history of institutions like trade unions, remains, at best, marginally affected by much of this work.[6]

Part of the problem here can be one of sources. For instance, in work I have done on the development of the working class on Tyneside in north-east England, the search for material on women's history in newspapers, contemporary social description, government papers and other sources, has been a frustrating business: a few snippets here and there, the fragmentary reference, but mainly silence. So I could find little about their employment in the economy as a whole. Similarly, the amount of evidence available on women and cultural or political changes is scanty. In short, the sources themselves tended to push me into effectively marginalizing gender as a primary determinant of social identities and divisions. But the problem was also a conceptual one. I tended to assume that the 'issue of gender' was largely about women and that all I could do effectively was to register their absence from the kinds of public activities I was interested in, such as trades unionism or popular politics. What I was failing to take on was that the issue is about the gendering of men as well. And what I want to do in this chapter is to suggest some ways in which the articulation of class and gender among men such as Wright's 'representative artisan' might be approached.[7]

One of the important developments in labour history since the 1970s has been that a good deal more attention has been paid to the occupational structure of the working class, including the formation of occupational hierarchies, the structuring of social and technical divisions of labour, and the relationship between phases in the history of capitalism and the characteristics of the labour force. Much of this literature, at least as it has concerned this period, has focused primarily on working-class men and the antinomies that have been posited about them: the 'labour aristocracy' as against a rather heterogeneous non-aristocracy; artisans and labourers; the 'independent', 'intelligent' and 'respectable' as against those without these qualities.

However, each of these divisions needs to be seen in relation to the most fundamental of all within the working class – between men and

women. In the patterns of men's and women's employment in the long transition to industrial capitalism, there was evidently a concentration of women within certain areas of employment, a consequent exclusion of them from others, and an increasing concentration of men with jobs separated from the household.[8] The extension and consolidation of industrial capitalism from the 1840s undoubtedly reinforced this pattern. It is most obvious in the numbers of men and women employed and in the economic sectors in which they laboured. Although the crude figures of the census, especially in its published form, are fraught with problems – they ignore many types of employment, men's as well as women's, and are based on ideological assumptions about what 'occupations' were – they give some rough indication of probable proportions. Over the period 1851–81 probably some 85 per cent of men were 'occupied' while 35 per cent of women were. It is possible that there was a marginal increase in the proportion of women employed; it is certain that the great majority, perhaps about 80 per cent, were concentrated in domestic service, textile production and the clothing trades, in each of which they constituted a majority of the labour force. At the same time, there was some shift in the composition of female labour: a rise in the number of domestic servants; some increases in the proportion working in various forms of manufacturing, including textiles, clothing, food and drink preparation, and some others; a relative decline of outwork and some shift into the workshop and factory, although outwork and home-working remained extremely important in the Midlands and London particularly; and an increasing exclusion of women from regular employment in agriculture, transport and in mining work underground.[9]

Taken together with the changes in men's employment, there was a further strengthening of the gender gap in the period. For the most important areas of employment expansion in manufacturing were in the heterogeneous 'metal trades' (including engineering, shipbuilding, iron and steel), in which the opportunities for women's employment were generally few. There were also substantial increases in transport, especially on the railways, in building, in mining and also in clerical labour, largely at this stage the preserve of men. These trends not only reinforced the difference between the kinds of jobs men and women did; they also tended to widen the gap of skills and earnings: more men were moving into better- (and perhaps more regularly-) paid and higher skilled employment; women's position in generally low-paid, low-productivity, low-skilled jobs tended to be confirmed.

These facts are probably familiar enough. And crudely stated like

this they mask the vast areas of informal or irregular employment, as they also hide the forms of production without which no 'economy' could exist at all, but which lay beyond the categories of the market economy – the production and reproduction of 'material life' through the labour of childbirth, the nurturance of children, the preparation of food, the washing and repair of clothes . . .

It has often been emphasized by feminist historians that an understanding of women's oppression is impossible without grasping the connections between their position in the household and in the sexual division of labour within the society as a whole.[10] But making these connections has not been typical of much of the literature on male labour. The foundations of working-class men's position rested on their subjection to capital and competition within the labour market; but they also rested on the exclusion from or subordination of women within capitalist relations of production and the dependency of women within the household.

If this was so in general, the precise form of gender relations clearly varied a good deal in nineteenth-century Britain. Michael Savage has suggested that there were three broad types.[11] First, where very few women were in paid labour and the formal labour market was composed largely of men. Such was the case in Tyneside. Second, where there was little difference between the participation of men and women in either formal or household economies, as in the north-east Lancashire weaving districts. Third, where relatively large numbers of women were in paid employment, albeit low-paid and casualized, but were strongly segregated from men, as was the case in the extreme example of Dundee. While such regional variations clearly need a great deal more investigation, the central point here is that women's access to and experience of employment evidently differed from men's in that the demands of the household evidently had a greater determining weight than was the case for men.

One index of this is the extent to which the rhythms of women's employment cycle were shaped by the fortunes of a husband or father. Thus, for instance, Mayhew's volumes on London (or Booth's at the other end of the period), are replete with examples of women who, as wives or daughters, were working for pay when their husbands' or fathers' incomes were poor or non-existent. For example, the spread of sweating and the 'degradation' of the 'honourable' artisans in the London furniture trades meant that the wives and daughters of cabinet-makers would often be found at home or in garret workshops making clothes, trades in which the spread of sweating based on cheap and

super-exploited labour had become entrenched from the 1820s.[12] In the tailoring trades themselves, a journeyman tailor specializing in waist-coats told Mayhew that he was 'compelled' to get his wife to earn wages: 'I cannot afford now to let her remain idle . . . If I had a daughter I should be obliged to make her work as well . . .' The work that his wife was employed in was dressmaking, at which she earned 8 shillings a week compared with his 24. He made sure that she didn't work in the same branch of the trade as him for fear of further depressing it. But if he regarded her as being 'idle' when she didn't have employment, his anxiety was now about her 'over-exertion' for 'her work and her domestic and family duties altogether, are too much for her'.[13] Similarly, among the coalwhippers Mayhew reported that fourteen of eighty-six whom he interviewed at a meeting 'had wives or daughters who work at slop needlework, the husbands being unable to maintain the family by their own labour . . . All the wives and daughters would have worked if they could have got it.'[14]

There were considerable variations between industries, trades and regions as to *when* women worked. For instance, in the Leicester hosiery industry, examined by Nancy Gray Osterud, between 1851 and 1871 43 per cent of single women and 58 per cent of widows were engaged in paid labour, while 30 per cent of married women were. And here married women tended to stay in the labour force during their childbearing years and when the children were young, stopping employment only when the children were old enough to earn wages. As she says, such a pattern was only possible because of the 'domestic location and casual nature' of much women's work in Leicester's staple industries. But the pattern was by no means universal in the town. The wives of men in the artisan trades were much less likely to be employed than those in the hosiery and footwear industries.[15]

Men too experienced discontinuities of employment: the basic condition of *all* workers in the nineteenth century was insecurity due to structural and technological changes or cyclical fluctuations in the economy. But the determination of men's experiences of employment was weighted more towards their position in the formal labour market than was generally the case for women. Indeed, they might become dependent for part of the year on women, as in the case of the London bricklayers, plasterers and joiners who, thrown out of work in the winter, depended on their wives' earnings as ironers in a collar factory.[16] Unemployment, and dependence on wives and other members of the family, the state or charity, might be experienced, as now, not only as economic but also as psychic depression. We know far

too little about how men coped with this in the nineteenth century but there is little reason to doubt that, given the centrality of paid work to the construction of men's identities in capitalism, the loss of earnings and employment probably led to a sense of 'incompleteness' and shame as men and to a loss of dignity which could not be contemplated. Thomas Wood wrote that when his parents were 'suffering great want' in 1846 'father would have died and seen his children die before he would have paraded his wants, or, I believe, asked for help'.[17] Such feelings should not be treated casually. But there remains a central differentiating feature of men's experiences of employment which may be obvious but needs emphasis at this point: that no man would expect, or be expected, to leave work on marriage or at the birth of a child, seek employment because his wife's earnings were too low, or look for work that was reconcilable with his domestic 'duties'. No doubt these points are obvious, but they are central to men's experience of employment.

What should be obvious too is that the range and types of jobs available to men were clearly much greater than for women. If it is clear that women have generally been either excluded from whole occupations or restricted to low-paid and low-status jobs within particular trades, then there is no single factor, such as the exclusionary policies of trade unions, that will do for all cases.[18] The determination of gender differences in paid employment certainly includes employers' strategies, the relative weakness and strength of men and women in the labour market and households, the relative strength of workers' organizations, cultural presuppositions about what jobs men and women should be doing, and the transmission of knowledge and training necessary for particular kinds of jobs. The balance between these elements varied between different situations. Thus for instance, as Mary Freifeld has argued, the progressive exclusion of women from spinners' jobs in cotton had three main components: employers' strategies for cheapening labour-power which acted to the detriment of women as compared with men; second, a break in the transmission of skills from one generation of women to another; and, third, male trade union exclusionary policies, which probably played a secondary role in the initial exclusion of women, though they undoubtedly reinforced that exclusion from the 1850s onwards.[19] On the other hand, the relatively weak position of skilled women in the London bookbinding trades in the second half of the century probably owed most to the ability of the men to maintain powerful trade union organization in favourable market conditions.[20] And to take a third and rather different

case, the exclusion of women from the engineering and shipbuilding trades of Tyneside as they rapidly expanded after 1850 probably resulted from historical and cultural factors rather than immediate economic ones. There was no local tradition of women working in the metal trades and it probably never occurred to anyone – employers, working men or women – that anybody but men should be recruited to the new trades like boilermaking as they were established in the region.

Trades like boilermaking belong to that heterogeneous category of 'skilled labour'. Arguments about the nature and extent of 'skill' and its other side, de-skilling, continue.[21] While it would be facile to suppose that a very large number of jobs did not have a component of skill in that they included a technical ability that was not universally shared, this is not a sufficient definition of a 'skilled trade'. Further elements which are necessary include: the degree of technical ability; the restriction of the knowledge and practice of the skill to a select group of people; historically, the effective ability to maintain the technical components of the job (or key elements of it) together with a maintenance of the conditions of the trade in both production and market relations.

How the differentiation of skilled and unskilled labour occurred and the boundaries maintained were not solely determined by gender: but one can hardly talk of these matters as if gender was irrelevant as too many have tended to do,[22] not least because it is evident that by the second half of the nineteenth century the 'skilled trades' were overwhelmingly male. How this happened is a complex process and, again, there is no single explanation of the story. However, the point I want to emphasize here is that who got into skilled trades was partly determined by familial strategies and expectations of the 'careers' of boys and girls. Perhaps the most important thing that working-class parents could give their children was security, or at least some prospect of it. But for girls this might mean going into, say, domestic service before getting married; while for boys it would mean getting him into a regular and, preferably, apprenticed trade, as David Vincent has stressed in what is the best and most thorough examination of the issue.[23] For W. E. Adams in the 1840s, 'the choice of a trade was a serious question – perhaps more for my grandmother than for me, since she had to make herself responsible for a burdensome premium'. Unable to become an engraver or saddler, the boy's preferences, the family 'compromised' on him becoming a printer. Thomas Wood, born in Bingley in 1822, was the son of handloom weavers. He wanted to

become a weaver or a wool-comber but 'father would not hear of it, so I was put out to be a mechanic'.[24]

However, just who could get into a skilled trade remains shrouded in doubt. Geoffrey Crossick's figures for Kentish London suggest that the skilled trades appear to have recruited to a considerable degree from the skilled. Something like 42 per cent of men in engineering crafts had fathers in the same trade, while the figures for the boilermaking and shipbuilding crafts were 46 per cent and 64 per cent. However, I would hesitate to generalize from these figures as some have done.[25]

Getting a boy into a trade was a crucial route to security but it did not guarantee it. The serving of an apprenticeship was the best guarantee but even here it did not bring certainty of the future. In general, apprenticeship regulation was under considerable pressure from employers in the second half of the nineteenth century and some trades were unable to resist the encroachments on their privileges.[26]

But if a boy could be got into a trade, what he learned in it became a vital source of identity for him, in terms of the trade itself, the duties and obligations attached to it and in terms of gender. An adolescent would absorb the mysteries of the craft in learning his skills. He became the repository of collective knowledge about the trade and the medium through which it was transmitted from one generation of men to another. And in receiving training from the men he underwent a phase of 'unfreedom' or servitude which it was necessary to pass through if he were to emerge as a competent workman and which marked his passage from being one of the 'lads' to being a free and independent man.

While work and the work-group were places in which boys became workmen, they were also among the places in which codes of sexual behaviour might be consolidated and elaborated. Establishing the boundaries of 'legitimate' and respectable sexual behaviour and its other side, the transgressive, might take the form described by Charles Shaw in his account of mid nineteenth-century pottery workers. Here young men and women joined in transgressing the sexual rules of adults. While the adult throwers were away from the works, the young engaged in heavy drinking accompanied by 'jollification and devilry unnameable' with young women being persuaded to 'join in the indulgence'. Then 'the most lustful and villainous of the men', who were generally young, stayed at work all night; the 'decent' women fled, leaving the night to a 'revel of drink, lust and beastliness'.[27]

Other young men might engage in more respectable behaviour in which women functioned to establish the relationship between men. In

Thomas Wright's account, an apprentice might select a mate with whom to go for walks in the evenings or on Sundays and would talk to him of his girlfriend, even if she were fictitious. She was invented for the purposes of establishing that he was a 'proper' man: 'he will have learned that in order to be in any degree worthy of his age and generation he *must* have a girl – even if he has to invent one'.[28] And this demarcating of a 'proper' masculinity might also entail establishing that a boy was not 'queer', like Thomas Jordan, a Durham miner, who would not admit to being afraid to go down the pit with his father for fear of being thought such.[29] In adulthood too the work-group was often a source of male bonding, dependent upon excluding women. This might mean going to the pub with other men after work or it might take the form recalled in Flora Thompson's *Lark Rise to Candleford*. At dinner-time in the fields men might repeat 'what the women spoke of with shamed voices as "men's tales" which were probably "coarse rather than filthy" and appear to have chiefly concerned a lavish enumeration of those parts of the human body then known as "the unmentionables" '.[30]

If work was a place in which men's identities were partly constructed, the defence of the job and the trade was central to the sustenance of their moral economy. 'We are men and will be treated as such' declared the Friendly Society of Iron Founders in 1870,[31] and the capacity to maintain their position as independent men was the indispensable function of collective organization, primarily and increasingly importantly, of the formal trade union. Yet when they talked of independence what was meant by it?

In one aspect to be an independent man was to be not a slave, a condition which continued to be counterposed to the 'free born Englishman'. And what this entailed was, as Prothero has suggested, that a man was free to sell his labour-power; that he could maintain himself without recourse to charity; that he would have some degree of freedom in the regulation of his trade; and that collective organization was required to fulfil these conditions. In these aspects a man's independence was vital to the defence of his 'property in his labour'.[32]

But this needs qualification. It was not so much the ability to maintain himself as to be able to maintain himself and his dependants, something which entailed a collective as well as individual moral responsibility to do this on behalf of all members of the trade. Thus when the Iron Founders attacked overtime they said (in 1869) that the man doing it 'may fairly be said to be starving other men's families'.[33] In other words, bargaining strategies in paid employment were bound

up with the need to sustain not just the trade but the family economy of the members of it, a key element in the moral cosmology of trade unionists.

Not all men could enjoy such independence: the degraded artisan was not independent; and even those men who might be in a position to sustain their independence were aware that it rested on a precarious foundation. A shipwright on Tyneside declared in a dispute with the employers in 1851 that the men must hold together and refuse to 'submit to be treated as they have been . . . If they do, they will unman themselves very much'.[34] Further, some men were not independent because of the very nature of their occupations. 'A Working Man', writing in 1879, drew a distinction between those labourers who were 'attached' to skilled workers, and those who were 'unattached' and, therefore, 'more free'.[35] However, on another level, these 'independent' labourers were liable to fall into utter dependency on charity in the event of a crisis in the casual trades such as dock work.

Independence was not confined to men: the factory women of Lancashire had long been attacked by moralists for their 'independence', although the terms of this attack were always bound up with the notion of their being sexually threatening in a way in which independent men were not. On the contrary, the independent and respectable man was usually assumed to be a paragon of sexual virtue. There were also the women who, while not necessarily enjoying full independence, were themselves responsible for dependants. These would obviously include children but also could include relatives living off their earnings and household labour. This might happen where a husband had died or where he had ceased to be the chief wage-earner because of sickness, disability or unemployment. However, even where women had paid labour and were not immediately dependent upon a husband or father they were not necessarily independent. The most obvious example here are the domestic servants for whom service was not, and could not be, the 'servitude' of a probationary apprentice – a condition to be passed through as a merely temporary passage of a life – but a restricted and 'unfree' existence of dependency within another's household.

Yet what came to have dominance in the working class, and in discourses about it, was that distinctly masculine form and meaning of 'independence' in which a man aimed to attain or preserve a state in which he would be able to maintain dependants within the home. Speaking to north-eastern miners in 1873, Lloyd Jones brought together the themes of independence within the workshop and within the home:

What did every man in the country require in reference to his labours and his life? He wanted first the independence of the workshop, and he wanted to be able to pursue his work in such a manner and under such a condition that it should not be a degradation to him in his eyes. He wished to be independent in following his ordinary daily occupation; and they must bear in mind that the chief portion of a man's life was spent in the workshop. After he left the workshop he required to be comfortable in his own home. He wanted those comforts, which ought to belong to every man that had to labour to secure them, and he wanted in addition to secure the comfort and happiness of those who are depending on the fruits of his labour, and on his love for their welfare.[36]

These aspirations to masculine independence, and the attainment of respectability, were not new in this period. But what I think *was* new was the prominence and visibility of them in the culture. It is also possible – indeed, likely – that the capacity of some men to sustain independence and dependants was enhanced at this time, primarily for economic reasons but also because of the building of the institutions of collective social defence and a modicum of security – the co-ops, friendly societies and trade unions that became the central class institutions.

But *how* this happened is a complex question. In the first place, the sustenance of respectability and, where possible, independence, was partly conditional upon preserving the status and conditions of employment of men; but the realization was critically dependent upon the willingness and ability of women to maintain the household in respectable forms, as Ellen Ross has shown. And as she has persuasively argued, the strategies for survival among the labouring poor and working class of London included, among other things, maintaining good relations with neighbours – the point at which respectability was most visible and the domain in which women were paramount.[37]

Secondly, in the construction of 'hegemony' from the 1840s both state agencies and moral reforming ones within civil society proposed a range of solutions to the moral, social and political crisis of the 1830s and 1840s. And if one examines some of the key social policy issues of the period – the anxieties over the consequences of the factory system for the family (in, for example, Peter Gaskell's writings); the restriction of female and child labour in mines and factories; the state of the urban poor and the physical conditions of the city; the relief of poverty;

the policing of the industrial and urban communities – and the renewed political debates about the working-class franchise in the 1860s, there was persistent concern with not only regulating the poor and working classes as classes but also as men and women.[38] Although too complicated to examine in full here, it is evident that the building of a broad 'consensus' depended vitally on the attempted isolation and elevation of the respectable and independent working man as a key figure in the resolution of social and political instability. In part this was determined by the re-drawing of the boundaries of the public sphere of the working class so as effectively to cast working-class women into a position where they were almost hermetically sealed off from the possibilities of acting politically. Much of the basic set of relations here had been set in place by the early 1840s through working-class political movements themselves. As Sally Alexander has argued:

> Whatever their intentions, the Chartists by deleting women, the factory reformers by submitting to the principle of the protection of women and every working-class custom, insofar as it refused an equal status to women within the class, placed women in a different relationship to the state than men. Women fell under the protection of their fathers, husbands or Parliament and were denied an independent political subjectivity.[39]

This demarcation was reinforced, by the 1860s, through the assiduous cultivation of the respectable and independent working man by both his own spokesmen, including those in political reform associations and trade union representations to inquiries such as the Royal Commission on Trade Unions of 1867–9, and those of the ruling class who looked to him as a rational, intelligent figure able to be entrusted with the vote.

The 1867 Reform Act was an attempt to fix, as citizens, the respectable working men within the pale of the constitution. They were set in place by contrasting them in the political debates with their antithesis – the 'polluting' and dangerous residuum of the poor, the thieves, the prostitutes; but they were also fixed in the contemporary cultural arguments by positing them as the bearers of not only sober, self-help institutions like savings banks but also 'proper' relations between the sexes.

One may glimpse this in the question of drink. What was threatening about it was not just its dissolute consequences for work practices, important as this was. What was also, and crucially, at stake was the building of a model family and a society in which the different class and political interests of men would be transcended by the project of

making them into better human beings. Thus the Newcastle Temperance Society declared that the field of activity of organizations like their own was

> the home circle, enlightening and enforcing the duties of the parent, cherishing and directing the affections of the child – fostering the virtues which make the fireside happy; whilst the wider operations interfere with no man's politics, and intermeddle with no man's creed. The principles of this great movement address men as men, independent of sectional views or relative positions; and whatever concerns man in the undiminished entirety of his individuality, or in his varied relationships to society, it presents its assurances that it will make him a wiser man and a better citizen.[40]

And within the home, wives were expected to cultivate domestic skills and to manage family finances, a practice which, as Catherine Hall has remarked, appears to have been both widespread and to have been one of the differentiating distinctions between working- and middle-class homes.[41]

Yet if the family was at the centre of the discourses about what respectable working-class life ought to be like, what appears to have been happening was the development of a more rigid separation of domestic and public spheres within the working class and the increasing internalization of this as a desirable change by working people themselves. There was no single type of cultural form or institution available to the working class in the period but some of the key options were indicated in a fascinating, albeit moralistic and prescriptive tale, recounted of 'an artisan at his club' by a Newcastle journalist in 1869.

The story began with the end of the working day: 'thousands of the sons of industry' tramp home; they take their tea, perhaps play with their children for a little while, have a few words of chat with their wives, and then begin to doze in front of the fire. But it is too early to go to bed, and, besides, the wife has to get the children to bed and has 'more than one hand's turn of washing to finish'. So what is our artisan to do with his evening? The options all involve him going out on his own. He may go for a walk; or a man like him might go to this Methodist meeting – but this one is not religious; he might go to his trade union branch meeting were there a strike or other dispute on; were he teetotal – though he is not – he could go to his 'lifeboat rescue'; were he a drinker, of even moderate kind, he might go to the pub – but this may cost him three-halfpence and, more important, it 'might cost

him his soul'. In the event he goes to his Workingman's Club and does so to read the newspapers. And here he might take part in a range of activities – from playing games to debating current social or political issues, from a little melodrama or burlesque to smoking and gossiping with his fellow members.[42]

The maintenance of a culture of respectability and independence, with its model family and separation between the worlds of men and women, had always to be defended against descent into the rough and the unrespectable. And in the maintenance of that, women's cultivation of the home was evidently crucial. In this story of the artisan we are invited to see his wife as essentially a nurturant other, as the constructor of a place in which her husband might be humanized after the burdens of his labour and as the sustainer of the place which he might leave for the re-creation of himself in the company of other men. That is, the story assumes that women were essentially adjuncts to the lives of men. And indeed, there appear to have been few conscious challenges in this period to the assumption that the man's position, centrally at work itself, was the fulcrum upon which the home and the culture as a whole turned. When 'An ironworker's wife' denounced the employers during an 1866 strike on Tyneside, she did so in terms which identified herself as a member of a class in which the men were pivotal. Thus she wrote: 'We are told that we ought to live in good houses, clothe and educate our children properly; and yet at every opportunity the masters have, they come down upon us for a reduction.'[43]

By 'us' she meant the men at work and the family economies they sustained. This consciousness of men's dominance appears to have been pervasive. But to what extent this was really the case is one of the issues to be tackled in further work.

ACKNOWLEDGEMENT

I am grateful to John Tosh and Michael Roper for help with the revisions. For criticism, advice and encouragement in preparing the original I remain especially grateful to Leonore Davidoff, Catherine Hall, Angela John and Christine Robinson; and to audiences at Essex University, Leicester Polytechnic, the Institute of Historical Research, London, and an Open University Summer School, Bath.

NOTES

1 The Journeyman Engineer [Thomas Wright], *Our New Masters*, London, Strahan, 1873, p. 2.

2 Thomas Wright, 'Our Craftsmen', *The Nineteenth Century*, vol. 20, 1886, p. 551.

3 General accounts of the working class in the period which stress these kinds of developments include Trygve Tholfsen, *Working Class Radicalism in Mid-Victorian England*, London, Croom Helm, 1976.

4 A helpful way into these debates is through the literature on the 'labour aristocracy': see, among many others, R. Gray, *The Aristocracy of Labour in Nineteenth-century Britain c 1850–1914*, London, Macmillan, 1981. A recent work of general social history which has much of interest on these questions is F. M. L. Thompson, *The Rise of Respectable Society: a Social History of Victorian Britain, 1830–1900*, London, Fontana, 1988.

5 See, among others, Dorothy Thompson, 'Women and Nineteenth-Century Radical Politics' in Juliet Mitchell and Ann Oakley (eds), *The Rights and Wrongs of Women*, Harmondsworth, Penguin, 1976 and her 'Women, Work and Politics in Nineteenth-Century England: the Problem of Authority', in Jane Rendall (ed.), *Equal or Different*, Oxford, Blackwell, 1987; Barbara Taylor, *Eve and the New Jerusalem*, London, Virago, 1983, esp. chapter 9; Angela John, *By the Sweat of their Brow*, London, Routledge, 1984; Angela John (ed.), *Unequal Opportunities*, Oxford, Blackwell, 1986; Elizabeth Roberts, *Women's Work 1840–1940*, London, Macmillan, 1988; Jane Lewis (ed.), *Labour and Love*, Oxford, Blackwell, 1986; John Gillis, *For Better, For Worse: British Marriages, 1600 to the Present*, Oxford, Oxford University Press, 1985; Judith Walkowitz, *Prostitution and Victorian Society*, Cambridge, Cambridge University Press, 1980, Ellen Ross, ' "Not the Sort that would Sit on the Doorstep": Respectability in Pre-World War I London Neighbourhoods', *International Labor and Working Class History*, vol. 27 (1985), pp. 39–59.

6 For instance, Richard Price, *Labour in British Society*, London, Croom Helm, 1986, reflects many of the concerns of contemporary labour historians, albeit in an idiosyncratic manner, but it contains virtually no discussion of women or of gender relations.

7 As work in progress rather than settled conclusions, this chapter is intended to provoke thought rather than be a summary of detailed research. Parts of it draw on a previously published paper, 'Time to Work, Time to Live', in Patrick Joyce (ed.), *The Historical Meanings of Work*, Cambridge, Cambridge University Press, 1987.

8 L. Tilly and J. Scott, *Women, Work and Family*, New York, Holt, Rinehart & Winston, 1978 remains the best general analysis.

9 There was some increase in the numbers of women working at the pit-head: see John, *By the Sweat of their Brow*, pp. 70–6 for estimates of the numbers of women in mining, 1850–90.

10 The literature on this is very large. Among recent discussions, Sylvia Walby, *Patriarchy at Work*, Cambridge, Polity Press, 1986, helpfully surveys much of the literature and offers her own theory.

11 Michael Savage, *The Dynamics of Working-Class Politics*, Cambridge, Cambridge University Press, 1987, pp. 51–6.

12 For the furniture trades see Henry Mayhew, *London Labour and the London Poor*, 4 vols, London, 1861, vol. 3, pp. 221–31; for women's employment in London see especially Sally Alexander, 'Women's Work in Nineteenth-

Century London: a Study of the Years 1820–1850', in Mitchell and Oakley (eds), *The Rights and Wrongs of Women*.

13 Mayhew, *London Labour*, vol. 2, pp. 314–15.

14 Mayhew, *London Labour*, vol. 3, p. 239.

15 See Nancy Gray Osterud, 'Gender Divisions and the Organization of Work in the Leicester Hosiery Industry', in John (ed.), *Unequal Opportunities*.

16 Gareth Stedman Jones, *Outcast London*, Oxford, Clarendon Press, 1971, p. 84.

17 Thomas Wood's autobiography in John Burnett (ed.), *Useful Toil*, London, Allen Lane, 1974, pp. 311–12. In the depression of the 1930s Walter Greenwood was to write of unemployment that it 'got you slowly, with the slippered stealth of an unsuspected, malignant disease' while one of his contemporaries evoked the shame he felt on becoming dependent on his wife's earnings and the dole: 'I felt a burden on her'; their family life disintegrated as they bickered over money and, eventually, she and their son (who was also earning) 'told me to get out, as I was living on them': Walter Greenwood, *Love on the Dole* [1933], repr. Harmondsworth, Penguin, 1969, p. 169; H. L. Beales and R. S. Lambert (eds), *Memoirs of the Unemployed*, London, Gollancz, 1934, pp. 73–4.

18 Walby, *Patriarchy at Work*, chapter 4 discusses the range of 'Theories of Women and Paid Work'. For a discussion of trade union policies see Sonya O. Rose, 'Gender Antagonism and Class Conflict: Exclusionary strategies of Male Trade Unionists in Nineteenth-Century Britain', *Social History*, vol. 13, (1988), pp. 191–208.

19 Mary Freifeld, 'Technological Change and the "Self-acting" Mule: a Study of Skill and the Sexual Division of Labour', *Social History*, vol. 11, (1986), pp. 319–43.

20 Felicity Hunt, 'Opportunities Lost and Gained: Mechanization and Women's Work in the London Bookbinding and Printing trades', in John (ed.), *Unequal Opportunities*.

21 See, among others, Charles More, *Skill and the English Working Class, 1870–1914*, London, Croom Helm, 1980; Anne Philips and Barbara Taylor, 'Sex and Skill: Notes towards a Feminist Economics', *Feminist Review*, vol. 6, (1980); S. Wood (ed.), *The Degradation of Work?*, London, Hutchinson, 1982; R. Harrison and J. Zeitlin (eds), *Divisions of Labour*, Brighton, Harvester Press, 1985; John (ed.), *Unequal Opportunities*, John, esp. Introduction and essays in Part I.

22 For example, Charles More's work on skill – in many respects an excellent book – totally ignores the question.

23 David Vincent, *Bread, Knowledge and Freedom*, London, Methuen, 1982, chapter 4. Unfortunately, this study is confined to the first half of the century and has next to nothing to say about girls; but see Carol Dyehouse, *Girls Growing up in Late Victorian and Edwardian England*, London, Routledge, 1981.

24 W. E. Adams, *Memoirs of a Social Atom* [1903], repr. New York, Augustus M. Kelley, 1967, p. 81; Thomas Wood's autobiography, in Burnett (ed.), *Useful Toil*, p. 307.

25 Geoffrey Crossick, *An Artisan Elite in Victorian Society*, London, Croom Helm, 1978, chapter 6 for these figures and their context; Roger Penn has

argued that there was little particularly significant inter-marriage between the families of the skilled in Rochdale between 1856 and 1914: see *Skilled Workers in the Class Structure*, Cambridge, Cambridge University Press, 1984, chapters 10–12; Crossick's figures have been generalized by John Gillis to suggest that 'the skilled were . . . recruiting exclusively from their own ranks', *For Better, For Worse*, p. 247, which is not warranted by the evidence available. Other work on these issues includes John Foster, *Class Struggle and the Industrial Revolution*, London, Weidenfeld & Nicolson, 1974, esp. pp. 125–31 and Appendix 2; Brian Preston, *Occupations of Fathers and Sons in Mid-Victorian England*, University of Reading, Reading Geographical Papers, no. 56, 1977, who suggests on the basis of census data for six towns in 1871 that between 40 per cent and 50 per cent of sons followed their fathers into the same occupations. However, he defines 'occupation' so broadly – he really means the same industries – that it would be necessary to rework the figures.

26 A very helpful discussion is W. Knox, 'Apprenticeship and De-skilling in Britain, 1850–1914', *International Review of Social History*, vol. 31 (1986), pp. 166–84.

27 Charles Shaw, *When I was a Child*, [1903], extract repr. in Burnett (ed.), *Useful Toil*, p. 302.

28 The Journeyman Engineer [Thomas Wright], 'On the Inner Life of Workshops', in *Some Habits and Customs of the Working Classes*, London, Strahan, 1867; the passage is reprinted in Maxine Berg (ed.), *Technology and Toil in Nineteenth Century Britain*, London, CSE, 1979, p. 123.

29 Thomas Jordan's autobiography, in Burnett (ed.), *Useful Toil*, p. 103.

30 Flora Thompson, *Lark Rise to Candleford*, Harmondsworth, Penguin, 1973, p. 56.

31 Friendly Society of Iron Founders, *Annual Report* (1870).

32 I. Prothero, *Artisans and Politics in Early Nineteenth-Century London*, Folkestone, Dawson, 1979, pp. 26–7.

33 Friendly Society of Iron Founders, executive statement (June 1869); Webb Trade Union Collection, [LSE], A.XIX, p. 217.

34 'A Shipwright of the Tyne', *Newcastle Chronicle*, 14 March 1851.

35 *Working Men and Women*, London, Strahan, 1879, chapter 10.

36 Cited in Richard Fynes, *The Miners of Northumberland and Durham*, [1873], repr. East Ardsley, SP Publishers, 1973, p. 278.

37 See especially ' "Fierce Questions and Taunts": Married Life in Working-Class London, 1870–1914', *Feminist Studies*, vol. 8, no. 3, (1982) pp. 575–602; 'Survival Networks: Women's Neighbourhood Sharing in London before World War One', *History Workshop*, vol. 15, (1983), pp. 4–27; 'Not the Sort that would Sit on the Doorstep'.

38 See, for one instance of this, D. B. Reid's 'Report on the State of Large Towns: the Northern Coal District', *Parliamentary Papers* 1845 [610], XVIII. A stimulating discussion of social policy in the period emphasizing both class and gender dimensions is Frank Mort, *Dangerous Sexualities*, London, Routledge, 1987.

39 Sally Alexander, 'Women, Class and Sexual Difference in the 1830s and 1840s', *History Workshop*, vol. 17, (1984), p. 146.

40 *Newcastle . . . as it is . . . an Address by the Newcastle . . . Temperance Society*, Newcastle, 1850, p. 60.
41 Catherine Hall, 'The Tale of Samuel and Jemima: Gender and Working Class Culture in Early Nineteenth-Century England', in H. Kaye and K. McClelland (eds), *E. P. Thompson: Critical Perspectives*, Cambridge, Polity, 1990.
42 *Newcastle Weekly Chronicle*, 20 February 1869.
43 Cited in Tholfsen, *Working-class Radicalism*, p. 247.

5

'I LIVE BUT NOT YET I FOR CHRIST LIVETH IN ME'

Men and masculinity in the Salvation Army, 1865–90

Pamela J. Walker

When Elijah Cadman, chimney-sweep and pugilist, heard a street-preacher speaking of sin and salvation, he resolved to be a new man. He knocked down the seats at his boxing school and gave the rope to an old woman for a clothes line; he gave up his pipe, the pubs and his old companions and in 1876 he joined the Salvation Army. Founded in 1865 by William and Catherine Booth to bring Christianity to the working class of East London, the Salvation Army drew adherents from a group notorious for its indifference and even hostility to Christian institutions. For urban, working-class men like Cadman, religious conversion meant abandoning many of the habits and pleasures common to them. Converts not only turned away from much of their community life but were rejected by others. Workmates and neighbours ridiculed and taunted the faithful and called them effeminate. But Salvationist men embraced a new manliness created by the Army's men and women to enable men to dedicate themselves to personal holiness and the salvation of others.

The Salvation Army was not for the nominal Christian: it required an arduous conversion and repeated public testimony describing one's sinful past and present sanctification. According to Salvationist belief, conversion entailed a visible, public rejection of many components of working-class community life. Salvationists wore an 'S' on their collar from the moment of conversion, thus marking themselves off from the rest of working-class society. This presented particular difficulties for men. Mid nineteenth-century Christianity was more often associated with a feminine piety and emotionalism than with any masculine virtue. Salvationists declared the pugilism, betting and drinking which were all associated with working-class masculinity to be sinful. By rejecting these activities, Salvationist men placed themselves outside the institutions and activities that displayed and defined working-class

92

manliness. As a result, Salvationist men were vulnerable to ridicule and attack at work, home and in the streets. Gangs of young men knocked off their hats and pelted them with rotting food. Riots erupted when gangs tried to keep the preachers off their streets and to protect their pubs and music halls from Salvation Army 'attack'. Salvationists were also ridiculed and called effeminate by their elite critics. A *St Stephen's Review* illustration of 1892, for example, depicts William Booth in female dress, one arm aloft shaking a tambourine, while three imbecilic men cheer and wave.

The challenge to prevailing conventions of defining and displaying masculinity was not limited to men; the very presence of women in the Salvation Army disrupted the masculine monopoly on social and religious authority. In an era when sex-segregated workplaces, associations and leisure pursuits predominated and men took the leadership of most working-class organizations and held exclusive claim to religious authority, the Salvation Army was a notable exception. Women sat on decision-making bodies,[1] testified of their experience, ran mission stations,[2] sometimes for wages equal to those of men,[3] wore uniforms, and preached indoors and out. Female authority was constrained by notions of femininity, particularly in the domestic sphere. Still, these were unusually prominent and vocal women and they horrified and angered observers, both lay and clerical alike; they were abused by street gangs and railed at by clergymen.

Remarkably, the Salvation Army succeeded in attracting the urban working class to its halls despite its demands and the hostility it evoked in others. After the first decade it claimed two thousand members in London[4] and by 1887, 53,571 people gathered at Salvation Army halls in London one Sunday.[5] Officers were drawn from across the spectrum of working-class occupations from the casual to the skilled.[6] Remaining records of corps membership suggest a predominance of semi-skilled and unskilled workers, along with a few skilled.[7] Describing a service in 1867, the *Tower Hamlets Independent* wrote of a hall overflowing with people 'of the very lowest class, as may be supposed, but there is a fair sprinkling of a higher grade, such as serving maids and sempstresses.'[8] Other denominations acknowledged the Army's success with that previously unreached constituency, debated the reasons for that success and even imitated some of its methods.[9]

The large number of working-class men who withstood ridicule and assault, who spent most of their leisure hours evangelizing and attending meetings and who ran mission stations under very difficult conditions for low wages is especially striking. The appeal could have

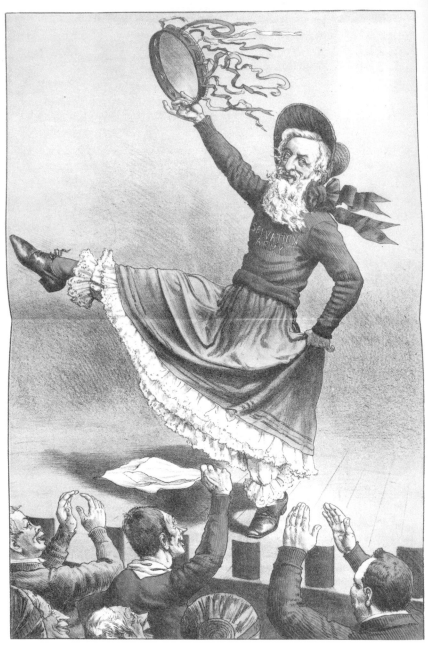

6 'Ta-ra-ra Booth-dee-ar!' Cartoon of William Booth, *St Stephens Review*, 1892. 'Ta-ra-ra-boomdeay' was a popular song of that year. (By kind permission of the British Library)

been a respectability that religion might confer on those who would adopt its standards. The Salvation Army, however, did not provide a route to bourgeois respectability. The ecstatic preaching and hymn singing were a direct criticism of the staid, established middle-class denominations and were deplored by those same Christians. Moreover, Salvationists' passionate conviction that all the saved were fit to preach and evangelize challenged the dominant belief that only educated men could properly interpret and spread God's word. To many in the Church, the Salvation Army was an unwelcome affront and their sentiments were often shared by those in local government who sought to contain the Army's presence in their towns.[10] Within working-class communities, respectability was a complex category; it is clear, however, that a man was unlikely to attain that status by joining the Salvation Army. For the working-class, any religious adherence was unusual but the Army's revivalist meetings and uniforms made converts appear odd or even ridiculous when conformity to neighbourhood standards of behaviour was an important element in working-class notions of respectability.[11] For those who craved self-improvement or the companionship of other men, working men's associations, including Friendly Societies, trade unions and various clubs, were available and did not demand that members disassociate themselves from so much of working-class community life. Joining the Salvation Army was neither a simple nor an obvious choice for a working-class man. But what did draw working-class men to this religion is revealed when they related their experience of conversion; their stories described what they relinquished and what they gained when they joined the Salvation Army.

Salvationist women and men communicated their faith to the unconverted in a number of ways: they relied on preaching; hymns; pamphlets that explained beliefs and practices and periodicals that reported the Army's work across the country.[12] They also used the example of their personal dedication to righteousness and the salvation of others. A central theme in all this evangelical work was the conversion story. Conversion stories helped to define and explain sin and to guide the unregenerate along the path to salvation. At a typical meeting, for example, several people would rise and describe how they had lived in sin and ignorance until they heard God's plan for salvation, and thus were saved. These stories figured prominently in the newspaper reports from the mission stations. Particularly dramatic cases when, for example, a former persecutor of the Army joined its ranks, were widely circulated and repeated. Issues of the *War Cry* in the 1880s

typically included a biography of an officer that detailed the person's conversion.

Through a study of these conversion stories, we see reasons for the particular appeal of the Salvation Army for working-class men. Its working-class evangelists took their preaching out of the chapels where only believers were to be found and into the streets and public houses. The theology was simple; the only thing necessary was utter faith in Christ. Men could not help but hear this message and there was no reason they could not embrace it immediately. Wearing a uniform, rejecting the public house in favour of the mission hall and testifying to his faith in public, took a man out of the 'heathen masses' and made him a member of God's community.

The conversion stories also reveal the conflict between women and men over the way working-class masculinity was organized. Women objected to sons and husbands spending money on beer and betting and rebelled against a masculinity that affirmed men's prerogative to spend their wages on such leisure pursuits.[13] The Salvation Army provided an institutional framework in which women could challenge men. Women were not alone in their criticism or in their efforts to reform men. Organized working-class men, including socialists and trade unionists, were critical of much working-class masculine leisure and strove to define a rational and reformed masculinity.[14] Salvationist men shared these aspirations. In their conversion stories, men described how religious conviction compelled them to reject their old ways in favour of a reconstituted gender–class identity. Converts found a new social authority as evangelists spreading God's word with other like-minded women and men. More importantly, after conversion men experienced the presence of the Holy Spirit and the power it bestowed on them. This power, they claimed, was far deeper and more significant than any power given by a secular source.

The Salvation Army began in 1865 as a religious mission to the urban working class. In the mid-1880s it began to establish some social services, but only after the publication of William Booth's *In Darkest England and the Way Out* in 1890 did the Salvation Army devote considerable attention and resources to social services to deal with the material deprivation that Booth argued was a barrier to religious conversion. Some historians interpret these schemes as a recognition that the religious message failed to reach its desired constituency while others see them as an appropriate expansion of a dynamic and lively organization.[15] Whatever the validity of these interpretations, both acknowledge a distinct shift in the Salvation Army's battle plan after

1890. This chapter examines the first twenty-five years of the Army's history when religious conversion and evangelizing were its central concerns.

THE EXPERIENCE OF CONVERSION

Conversion was the essential, critical experience for all Salvationists. Necessary for membership, it also assured a place in Heaven. All applicants to the officers' Training Home were required to write out their personal experience of conversion. Salvation Army meetings typically included several conversion stories and biographies inevitably told of this great transformation. Converts were encouraged to testify of their experience and continue using their story to guide others and remain close to God. Because conversion freed the penitent from the grip of sin, the veracity and spiritual state of an individual could be judged against that story. William Booth, for example, questioned how a Mr Hardy could claim to be fully converted. 'How could he have sold rotten hams and preached at the same time?'[16] Conversion occurred in two stages. First, the individual became 'convicted of sin', aware of sin and actively seeking forgiveness. Once forgiven, the penitent then turned to God and prayed for holiness. Holiness offered complete deliverance from sin because it removed the original, inborn, sin. It was 'an inward transformation into the very likeness of Christ.'[17] The presence of the Holy Spirit harmonized the heart, mind and will with God.[18]

In the conversion stories, the moment of conversion was invested with significance by contrasting it to the misdeeds of an earlier life. In their testimonies, Salvationist men emphasized their youthful ignorance of God's ways. As Elijah Cadman's mother lay on her deathbed, 'she shook hands with the five of us, and asked us to meet her in heaven. It was the only time I heard about heaven, till years after . . .'[19] Cornelius Smith was 'dragged up in darkness, misery and sin, and became daring and wicked'.[20] Even a religious education did little to alert men to their real state. Emmanuel Rolfe, confirmed in the Church at 15, found 'it brought no evident change in heart or life'.[21]

Ignorance left these men unable to understand fully or interpret the events that befell them in their day-to-day lives. Frank Smith learned early to 'chose the devilish and the bad' and his ignorance of God left him unable to see that God 'was speaking to me in various ways, by several narrow escapes of life . . .'.[22] These events seemed random until religious conviction revealed their true meaning. Captain Sutton 'went

into deep, deepest sin and had some narrow escapes of my life. Once, while in drink, I fell from a waggon, my clothes catching on the prongs of a pitchfork, if it had not been for the mercy of God, they must have gone straight through me, and my poor soul in hell.'[23]

Because working conditions and domestic arrangements were so dangerous, not surprisingly 'narrow escapes' figure prominently in these testimonies. This was particularly true for men who were far more likely than women to die violently.[24] The realization that close calls were purposeful, planned acts of God illustrated a sharp break with past ways of understanding. Prior to conversion the world had appeared chaotic and governed by random events. Faith offered a way to interpret these 'narrow escapes' as God's warning. It invited men to interpret painful and frightening events as signs of God's love for them. Moreover, it offered men a way to effectively reorient themselves in the world. Faith made them safe as God had no need to warn his steadfast followers and even in death they felt assured of God's mercy. That lesson was made abundantly clear by a story related by Major Dowdle. When Dowdle refused beer from a workmate, the man eagerly drank it himself. Later that day the man was found dead, '. . . his body was picked up by a guard of the train who was running on the down line as we were running on the up line'.[25]

The Salvation Army invaded neighbourhoods, bringing the 'heathen masses' a new perception of the world and their place in it. The unconverted were unlikely to acquire Christian understanding on their own: they did not attend church or chapel, they never read the Bible and they never heard preaching. Evangelists, from the time of John Wesley, thought outdoor preaching the best way to reach the masses. Salvationists were enthusiastic outdoor preachers, despite the sustained opposition to their efforts. One mission station reported,

> Thank God! That is our song in Brick Lane. The butchers have been trying to stop us again by bringing out their knives and chopping with them upon their blocks, and rattling their irons, while men and boys have shouted and rowed until the noise has been deafening.[26]

The Salvationists hawked their faith alongside the butchers and the costermongers. They borrowed the language of the street vendors when they called out that they had riches without price. They joined the clamour of the street in order that their words might strike the sin-soaked multitudes as they worked, shopped or walked to the pub. They occasionally invaded the shops that men frequented. For example, one

Salvationist went into a barber shop and asked to be shaved. While the barber worked, his three comrades spoke to the barber and the other customers of 'their sins and their Saviour'.[27]

The Salvationists used words – spoken and sung – to convey their message; conversion came first through the ears. They did not advocate sustained Bible study or the reading of Christian literature to prepare for conversion nor did they believe that the penitent must await a distinct call from God. The spoken word was a means to conversion especially suited to working-class men. Listening required no special skill or knowledge. Like the salvation they offered, the words of the Salvationists were made available to all who would but listen. When one preacher was obliged to shout over the voices of the crowd, his voice carried a great distance and reached a young man buying a bird. Ordinarily, 'he would not have heard a single sentence, but now he heard it all, not a word was lost'.[28] Charles Rich learned from his strict Calvinist parents that he must wait until God, in His own time, revealed Himself. But when he heard an outdoor preacher proclaim that he might seek salvation now, he became deeply troubled. Rich fell on his knees and asked God who answered with a light that filled Rich's soul.[29] Another man testified that he was drawn by the noise of the Army and followed them to the hall, never expecting to be touched by the words of the Captain. He sat, listening, but felt sure he was beyond help. 'I said, "If there is a God, tell me what to do," and the words rung in my ears, "Take up the cross and follow me." I arose and rushed to the penitent form . . .'[30]

Salvation, moreover, was available immediately.

> One Monday night, a robust young navvy was heard cursing in the High Street. When he got to the hall, attracted by the singing, he went in; and the Spirit of the Lord smote him down; he came right out, and at half-past eleven, after some of the hottest struggles with the powers of darkness . . . he was enabled to cast himself, just as he was, on the atoning blood; he came in cursing and he went out singing the praises of Jesus.[31]

John Allen, a 'well-known stalwart form of blackguard navvy', was arrested by the words of an open-air preacher but when he attended a tea-meeting he was reluctant to come down to the penitent form. About thirty men and women surrounded him and prayed for his salvation. After twenty minutes, '. . . he jumped, and shouted, again and again, "The Blood of Jesus cleanses me from all sin" '.[32] One man, having just returned from five years' transportation, attended a

meeting. 'I came in here and I got saved.'[33] These men had no time to waste. The long hours of work left little time for preparing the way. Disease and accident could strike a man dead in a moment and this salvation was available in a moment. A religion of the heart, of faith and of understanding which was derived from the experience of conversion itself could be embraced immediately. Conversion became *the* necessary event. The 'vilest of the vile' could in a moment be washed clean in that 'fountain filled with blood, drawn from Immanuel's veins'.

Conversion was sensational; it was a dramatic, ecstatic, bodily experience. Softness, melting and light characterized the moment of transformation for some. The night Valentine Case sat up praying and seeking God, 'My whole body seemed to be melting under the influence that was upon me . . . the perspiration ran off me, the sheets were quite wet.'[34] For others, the change was marked by sharp bodily struggle. Cornelius Smith wrote,

> I was unconscious until I fell on the floor, and they told me afterward that I lay there wallowing and foaming for half an hour . . . Then I came to myself, and I seemed to hear the voice of Jesus saying, 'Thou dumb and deaf spirit, come out of him, and enter him no more,' and the spirit rent me sore and came out that same hour . . . The bands fell off, my tongue was loosened, and I immediately rose and told the people that Christ had saved me.[35]

While he lay on the floor his son thought him dead.[36] John Allen 'began to groan and bellow like a bullock' as he prayed for mercy.[37]

Physical attributes that were often thought to characterize the masculinity of the penitent, such as great size or strength, were of no help in spiritual struggles. Indeed, conversion stories often paired bodily strength with spiritual poverty and resistance. 'One night a six-foot navvy, with tears streaming down his face, took hold of my hand, saying "You are right and I am wrong, what shall I do?" '[38] The most unlikely men were overwhelmed by the experience. 'We never shall forget one occasion when a gipsy had come in and found salvation. To see five big men hugging and kissing one another, while the tears poured down their faces . . . did us all good.'[39] One 'desperate character' came to the mission hall where his 'hard heart was broken; he was converted and became a little child'.[40] The successful penitent lost control over the body, became soft and receptive, a receptacle for God. One man found that despite his outward conformity to Methodist tenets, he still craved more. At last God spoke to him and said,

'Give me your will and I will give you holiness' . . . it seemed unbearable, anything but this. But while bowed at His feet I felt the Divine influence loosening my bonds, and setting me free, until I said at last, 'Lord, I give my will, I give it all to thee.'[41]

John Trenhail was 'bathed in tears, my heart was melted and the darkness went away'.[42] Captain Kilbey wrote, 'Dying to me was hard work; but when I was willing to let go all, God gave me His smile and His favour.'[43] The process of conversion permitted men, or even compelled them, to relinquish their reliance on physical strength and individual will, the traits which signified working-class masculinity. Strength and endurance were necessary for their labour, particularly for the unskilled who were valued by employers for little else. Men's size and strength distinguished them from women and was the justification used by trade unions and employers to exclude women from many categories of employment. For many men, their strength was also a source of pride and they found ways to display their prowess in leisure pursuits. For Salvationists however, it was these very traits that kept men estranged from God. To achieve holiness they needed to become new men. They declared that from the moment of conversion, 'I live but yet not I for Christ liveth in me' (Gal. ii. 23).

SIN AND SALVATION

Salvationists believed that everyone was tainted by original sin and could not help but do wrong even if they earnestly strove to do good and to conform to the rituals of the Church. Holiness offered the only way out because it removed original sin and harmonized the convert's will with the will of God. For Salvationist men, sin took particular, distinct forms. Theirs were not primarily sins of the mind – heretical beliefs, anger towards God, or pride – but rather sins of the body, which were often leisure activities common to working-class, urban men. Drinking, attending the theatres and music halls, pugilism and gambling were the sins that sent these men to the penitent form, weeping in remorse.

Drink was an important element in working men's lives.[44] A bricklayer testified that his foreman told him, 'I should never be a good tradesman unless I could drink and smoke along with the other men.'[45] 'Sunderland Bob' recalled his father handing him a beer can and saying, 'Sup Bob; I shall make a mon o' thee yet.'[46] Drink symbolized manliness and adulthood, and spending money on drink was the prerogative

of the working man. Wages were divided between the household expenses, a woman's responsibility, and the man's own money for drink, tobacco and other pleasures. John Allen, the Salvation navvy, said

> I could average twenty-eight shillings a week, and quite thought myself a man at eighteen, of course, getting a man's wages, and began to think if I earned the money I ought to spend it to enjoy myself. Being partly led by those who were older than myself, and partly by my own inclinations, at the end of three years I became strong in sin. The Oriental Music Hall used to be my favourite resort. I became an experienced, noted swearer, and not particular about a fight if put upon.[47]

Workmates and neighbours were united in the congeniality of the pub and music hall, where buying rounds expressed friendship and good will. Having money to spend displayed a man's independence and ability to earn.[48]

Drink was just one leisure pursuit associated with working-class men. Gambling, keeping dogs and pigeons and pugilism were all popular pleasures. Men could be found on Sundays in the streets, buying and selling their birds, placing a bet or watching a fight. These pursuits allowed men to define and display manliness at a time when the periodic, seasonal and poorly paid employment available to proletarian men undermined their status as rightful heads of households.[49] The inability to secure that status lent a particular significance to the way men used leisure. Pugilism was a performance of bodily strength and mastery which could provide an opportunity to display a masculinity based upon prowess and valour. Betting on pugilism, or animal fights and races, held the promise of money in a way not totally dissimilar to that provided by much available work: it required skill but it also depended on a certain element of chance.[50] These activities offered a masculine comaraderie that defined itself through the explicit exclusion of women.

The Army condemned all these institutions and activities and thus reduced these elements of urban, working-class masculinity to sin. The attempt to redefine masculinity emerged from the conflicts between men and women. Both mothers and sons and wives and husbands argued about the consequences of drinking and betting. They fought over the proportion of household income to be allocated to men's leisure pursuits or women's budget for food and rent. Social historians have shown how these struggles between men and women were endemic to working-class urban communities.[51] The Salvation Army

gave religious expression to these conflicts. Its temperance stance, for example, originated with Catherine Mumford Booth. She became convinced of the evils of alcohol after watching her father, and perhaps also her brother, succumb to drink. She chastised William early in their courtship for drinking port wine for his health. She sent him a book on teetotalism and told him that moderate positions on drink 'aid the progress of intemperance more than all the drunkards in the land'.[52] He was persuaded. From 1865, the Salvation Army took a strict temperance stance.

Female agency was critical not only in defining sin but in efforts to save men from alcohol. Salvationist women founded the Drunkard's Rescue Society in 1874.[53] Pairs of women would lay hold of a man on his way to the public house. They

> would arrest his attention, and talk to him, one on one side, and another on the other, thus keeping up a continual fire-fire, and volley of advice. Many a poor fellow was thus extricated from the Devil's clutches . . . [taken to the hall], surrounded and saturated by such a mighty influence as would drive the Devil out and 'Let the Master in'.[54]

Working-class women regularly fought singly and in groups to stop their husbands from spending wages in the pub.[55] The Society regularized and, more importantly, sanctified these efforts. Salvationist women sought to fortify men to resist the temptations that would consign them to fiery torments for all eternity. When they designated drinking or betting as sinful, women were redefining masculinity to exclude those elements which injured them. For Salvationist women, the struggle over money was a struggle between Christ and Satan.

Men's conversion stories, however, described the pull away from the masculine world of pubs and fighting as coming not so much from organized female efforts but from the women in their own families. When a slaughterman spent his wages in 'beer and bacca', his wife went out to char. When he found out she was attending the Army meetings he got jealous, thinking she did it just to reproach him. One drunken night he beat her badly and she implored him, ' "Let me hear you say, God forgive me, and I shall die happy." . . . It wasn't until morning light I found a voice to say what she had asked me hours before . . . and that's how I came to join the Salvationists.'[56] Her desire for his conversion was based on a concern for his spiritual condition but equally her success signalled an end to his drunkenness, his violence and perhaps even her charring. The concrete, material improvements in

this wife's lot was a common theme in women's descriptions of men's conversion. Another woman told a butcher who ridiculed the Army, 'It used to be starvation before they came . . . now he brings his wages home to me instead of taking them to the public house.'[57]

Mothers were an equally significant influence. Conversion evoked the memory of converts' mothers' words and hopes. William Ridsdel felt his conversion was in answer to his mother's fervent prayers.[58] One young man, found drunk outside a gin palace by a mission worker, wept when he heard the evangelist's voice that was so like his mother's.[59] John Trenhail got convicted of sin when he remembered his dead mother who 'could still look down and see her wayward boy'.[60] This image of a 'praying mother' was standard in nineteenth-century religious writing. The Salvation Army's use of that image conveyed a sense of ways in which sin was gendered. The definition of sin became a part of the conflict between men and women, the struggle between the masculine world of the pub and the feminine world of family and piety.

CONVERTED MEN

Discontent with elements of working-class masculinity was not confined to women. Other working-class men in trade unions, socialist organizations and working men's associations shared the Salvationist women's critique of the culture of sporting and pubs. Similarly, Salvationist men deplored the money wasted on betting and drink and the futility of leisure time spent in the pubs. Unlike most working-class organizations, however, in the Salvation Army both men and women were instrumental in the articulation and resolution of conflict between women and men. The Salvation Army offered men camaraderie with other men, such as they might enjoy in a pub or a trade union, as well as co-operation with women. Salvationist men and women shared the collective experience of conversion and an organizational structure where they could dedicate their lives to the common purposes of holiness and evangelizing others. Even in marriage, Salvationists emphasized co-operation. When taking their vows, the couple was asked to affirm that their marriage would not 'lessen our devotion to God, our affection for our comrades, or our faithfulness to the Army'.[61] Working-class men had much to gain from discovering ways to collaborate with women rather than competing with them for the scarce resources of their households.

The Salvation Army offered men not only collaboration with

women but also the possibility of enhanced social authority. This was especially attractive to those who were otherwise denied such authority. The *War Cry* declared,

> How many have been straining every nerve to get into Parliament; they are ambitious of power and position. We can't all get there. Some of us don't want to. But we may all have power of a higher order and further reaching; and that is the power to 'open men's eyes' to 'turn them from darkness to light, and from the power of Satan unto God.' And this is the power offered to all God's children, even the humblest. In fact the humblest have the most of it.[62]

This righteousness that drew upon the political disenfranchisement of the working class was implicitly directed at men. Voting and political representation were exclusively male privileges and this appeal suggests that religion could compensate men who were excluded from political power because of their class position. The Salvation Army was particularly appropriate because each convert could actively seek personal salvation and was encouraged to help save others. The emphasis given to conversion stories meant each individual's experience was valuable and might rescue another soul from hell. Men could also take on various leadership positions from giving out a hymn to running a mission station. This authority, however, was particular and limited. First, authority was not strictly a masculine privilege. Women officers had authority equal to that of men of the same rank although men dominated the key decision-making positions. Second, the structure of the Army after 1878 strictly limited any individual authority. As General, William Booth made decisions and demanded obedience. He was assisted by his son, Bramwell Booth, and the other Booth children and their spouses, all of whom held positions of considerable authority.[63] Yet the absence of democratic decision-making and personal autonomy were believed by many to be the source of the Army's strength. George Scott Railton, who held prominent positions in the Army from its earliest years, wrote,

> We have got an organisation managed upon the simple business-like principles of a railway, with all the cohesion and co-operative force of a trades union, formed of people whose devotion, determination, and confidence are at least equal to that of the Jesuits, and yet all of whom are left to enjoy and use that

perfect spiritual freedom and independence which only the Holy Spirit can bestow on any man.[64]

Railton's comments underscore the particularity of the power that the Salvation Army offered. Social authority might have been constrained but holiness, they believed, gave the individual a freedom and power that was far more important than anything found in a human institution.[65]

Salvationists found that the Holy Spirit empowered and strengthened men in ways they could not attain on their own. 'There is an Almighty power to be got for the asking. . . . [the converted] have got it, and to make the whole world shake and tremble beneath its weight is only a question of time and arrangement.'[66] The Holy Spirit enhanced the potency of a convert, making the otherwise impossible possible. The presence of the Holy Spirit compensated for the lack of other kinds of power. 'You may be very little, and they may be very big; you very weak and they seemingly strong; but depend upon it, He who promised you strength according to your day can enable you to overcome them if you are determined to do it . . . CRASH! HALLELUJAH!'[67]

This power enabled men accustomed to resolving conflict with physical force to prevail with other means. When the son of Tom Sayers, the famed pugilist, was converted at a Salvation Army meeting, they rejoiced that he would wrestle with God no more.[68] Even the 'Hallelujah Wrestler' would not fight back when he was attacked in a riot. He was dragged from his horse and beaten on the head until he was unconscious. Tempted to retaliate, he resisted knowing that 'If I had no hat then, I should have a crown hereafter, and a jewel in that crown for the battle I fought in Sheffield'.[69] If pugilism, or street, fighting, was a performance of masculine prowess, Salvationists' refusal to fight displayed an even greater power that resided in their bodies. This power was not derived from superior physical strength but from the power of the Holy Spirit. It pervaded the entire body, transforming the features, so 'it seemed to beam on his face and look out of his eyes'.[70]

When men were filled with the presence of the Holy Spirit, they could draw upon its power. Yet turning from drinking to praying, from keeping pigeons to singing hymns, put men in conflict with dominant definitions of manliness and this meant youth gangs and newspapers critics alike accused them of effeminacy. The Salvation Army, however, never meant to reject the entire construct of working-class masculinity but rather it sought to link masculinity with religious

conviction. One man asked a meeting, 'Do you think now religion unmans me? Do I look any the worse for being a Christian?'[71] Indeed one editorial argued that 'gentle, well-meaning faith' would not do for men. A 'brawnier manliness' was needed. 'Religion will not conquer either the admiration or the affections of men by effeminacy, but by strength. . . . The spirit of religion is the spirit of great power.'[72]

Already several organizations, notably the Boys' Brigade and the YMCA, had tried to bring a Christianity imbued with an ideal of manliness to the working class but their beliefs did not engender the same difficulties. These all-male organizations offered fighting and games, strength and discipline as means to achieve a Christian state. Since boxing and sports were already popular working-class male pursuits and the religious demands were light, membership did not represent a break with the larger community in the way demanded by the Salvationists. The sports and camaraderie were the main draw for working-class boys; prayer and hymns were tolerated as the price of admission to the ring or field.[73]

The Salvation Army found its own ways to emphasize the 'manliness' of its faith. The knee drills, the volleys of 'Hallelujah' shouted out by Captains and Majors dressed in uniforms endowed the Salvation Army with the aura of that most masculine institution, the military. The uniform, a contemporary novel commented, 'encourages the stronger sex to strut about like so many small military people'.[74] Even Christ got a rank. 'The Captain of the Sons of Light Will Appear on His White Charger Wearing the Blood-Stained Uniform of the Great Battle.'[75]

Military rank was not the only title that emphasized a masculine status within this religious movement. 'The Salvation Navvy' or 'Hallelujah Shoeblack' tied these working-class occupations to piety. The class and gender of the convert were made obvious and significant. Navvies were thought to be strong men more likely found in a pub than prayer meeting and even a 'Hallelujah Railway Guard' was an obvious reference to a male worker. The religious faith that captured them was made strong by association. Women, in contrast, were called by their names, like 'Happy Eliza' or, more generally, 'Hallelujah Lasses'.

The physical appearance of Salvationist men was used to surprise observers. When a man came forward to speak at a meeting, one woman said, 'Oh, he looks more like a butcher than a preacher.'[76] The strength and size of a preacher underscored his manliness and ability to conquer sin. A *Daily Telegraph* writer anticipated a sermon of gentle remonstrance and persuasion but was amazed to see just the opposite.

PAMELA J. WALKER

He lost not a moment in shilly-shally, but seized Satan by the horns at once, and commenced abusing him in a tone and at a rate which must have convinced the Evil One that he was in the hands of a person who not only had no dread of him, but was hot and eager to rouse him to a fury, and then give him battle to the death. The preacher was a short, thickset man, with short cropped hair, and no shirt collar, and his coat was buttoned over his breast. His gestures were prodigiously energetic, and the consequence was, that before he had preached ten minutes he had worked his wrists well through the coat cuffs – wrists of a size that matched well with his ponderous fists, which except when engaged with the prayer book, were tightly clenched.[77]

The absence of a collar, his large wrists shooting out of his sleeves, and his great energy made obvious that he was a working-class man. His struggle with Satan resembled nothing more than a street fight. Since his class and gender were presumed to be obstacles to conversion, that emphasis stressed the power of this faith.

When they described themselves as former drinkers, gamblers and fighters, Salvationist men dramatized the depth of the transformation but, more importantly, they reinterpreted the meaning of those activities. When a man testified that he had earned a living boxing and training rats[78] or how, while he bargained for a bird, he was convicted of sin,[79] he affirmed that he was masculine by the standards of that working-class culture he lived in. But Salvationists went further. When they rejected that standard, they claimed to be *more* manly. 'It takes a man, with God's help, to sign the pledge and keep it, any fool or donkey can drink.'[80]

When Elijah Cadman resolved to become a new man, he tore apart his boxing school because it was fighting and drinking that kept him from God. The elements of working-class masculinity that Salvationists believed estranged men from God were declared dispensable, and even unmanly. Finding new ways to define masculinity allowed men to resolve their conflicts with women and to collaborate with them, to retain a camaraderie with other men, and ultimately to perceive themselves as more powerful because they were at one with God.

ACKNOWLEDGEMENTS

Major J. Fairbank, Mr Gordon Taylor and the staff at the Salvation Army Heritage Centre, London have been unfailingly generous and

kind and I thank them. Thanks to Judith Walkowitz, John Gillis and Peter Mandler for their perceptive criticism and to the participants at a Rutgers Center for Historical Analysis seminar who commented on an earlier draft of this chapter. Thanks also to Michael Budd, Varda Burstyn, Jerma Jackson, Elizabeth Walker, Susan Whitney and especially to Brenda Clarke, to whom this chapter is dedicated.

NOTES

1 Twenty-eight men and six women sat on the first conference of the Christian Mission in 1870.
2 The first woman to run a mission station was Annie Davis in 1875. In 1876, four of the twelve stations were run by women.
3 In a letter of 3 August 1876 to F. Thursfield, George Scot Railton wrote, 'We do not see why a sister should not receive as much as a brother if she does the work and raises the finances as well'. *Letterbooks* (The Christian Mission, 1876).
4 *Minutes* (Christian Mission Conference, 1875).
5 K. S. Inglis, *Churches and the Working-Class in Victorian England*, London, Routledge, 1963, p. 196.
6 *Disposition of Forces* (1883); see also Christine Ward, 'Social Sources of the Salvation Army, 1865–1890', M.Phil thesis, University of London, 1970.
7 *Membership Book* (Whitechapel Mission, Christian Mission, n.d. [late 1870s]). This is the only membership book to have survived the Blitz. It is undated and does not appear to have been kept systematically. The picture of mission members drawn from this, obituaries and biographies and from the available census data on those who appeared on the early circuit plans, all suggest this occupational base. I am grateful to Mr Frank Hardy for his assistance with the census materials.
8 *Tower Hamlets Independent* (London), 23 November 1867, p. 6.
9 The Church Army is one example of an organization modelled after the Salvation Army. See K. S. Inglis, p. 114.
10 V. Bailey, 'Salvation Army Riots, the "Skelton Army" and Legal Authority in a Provincial Town', in A. P. Donajgrodzki (ed.), *Social Control in Nineteenth Century Britain*, London, Croom Helm, 1977; Stuart Mews, 'The General and the Bishops: Alternative Responses to Dechristianization,' in T. R. Gourvish and Alan O'Day (eds), *Later Victorian Britain, 1867–1900*, London, Macmillan, 1988; Asa Briggs, 'The Salvation Army in Sussex, 1883–92', in M. J. Kirch (ed.), *Studies in Sussex Church History*, London, Leopard's Head Press, 1981.
11 Peter Bailey, ' "Will the Real Bill Banks Please Stand Up?": Towards a Role Analysis of Mid-Victorian Working-Class Respectability', *Journal of Social History*, vol. 12, no. 3 (spring 1979); Ellen Ross, ' "Not the Sort that would Sit on the Doorstep": Respectability in Pre-World War I London Neighbourhoods', *International Labor and Working-Class History*, vol. 27 (spring 1985); and on evangelical religion and respectability, Hugh McLeod, *Class and Religion in Late Victorian London*, London, Croom Helm, 1974.

12 The periodicals were: *East London Evangelist*, (October 1868–December 1869); *Christian Mission Magazine* (January 1870–December 1878); *The Salvationist* (January 1879–December 1879) and *The War Cry* (December 1879–). From the 1880s, the Salvation Army also published periodicals for children, for its officers, on its social service programme and a number of local newspapers covering the work of the Army outside Britain.

13 Ellen Ross, 'Fierce Questions and Taunts: Married Life in Working-Class London, 1870–1914', *Feminist Studies*, vol. 8 no. 3, (fall 1982); Ellen Ross, 'Survival Networks: Women's Neighbourhood Sharing in London before World War One', *History Workshop*, vol. 15 (spring 1983) and Gareth Stedman Jones, 'Working-Class Culture and Politics in London, 1870–1900: Notes on the Remaking of a Working Class', *Journal of Social History*, vol. 7, no. 4 (summer 1974).

14 Victor Bailey, 'In Darkest England and the Way Out: the Salvation Army, Social Reform and the Labour Movement, 1885–1910', *International Review of Social History*, vol. 29, part 2, (1984) links socialist and Salvationist ideals and methods of working-class reform.

15 F. de L. Booth-Tucker, *The Life of Catherine Booth: the Mother of the Salvation Army*, 2 vols, London, Fleming Revell, 1892; General Frederick Coutts, *Bread for My Neighbour: the Social Influence of the Salvation Army*, London, Hodder & Stoughton, 1978; St John Ervine, *God's Soldier: General William Booth*, 2 vols, London, Heineman, 1934; Ann Higgenbotham, *The Unmarried Mother and Her Child in Victorian London, 1834–1914*, Ph.D. thesis, Indiana University, 1985; Norman Murdoch, *The Salvation Army: an Anglo-American Revivalist Social Mission*, Ph.D. thesis, University of Cincinnati, 1985 and Robert Sandall, *The History of the Salvation Army*, 6 vols, London, The Salvation Army, 1947–73.

16 W. Booth to Br. Lamb, 23 May 1876, *Letterbooks*, (The Christian Mission).

17 Catherine Mumford Booth, *Holiness: Being an Address Delivered at St. James' Hall, Piccadilly London*, London: The Salvation Army Publishers, n.d. p. 10.

18 The idea of holiness, or entire sanctification, was first detailed by John Wesley in *A Plain Account of Christian Perfection, As Believed and Taught by the Rev. John Wesley from the Year 1725 to 1765* (1767). The Salvationists' interpretation of this doctrine was drawn from Wesley but, unlike him, they believed it was necessary and available to all Christians. Wesley did not himself ever claim to have attained this state. See Albert C. Outler (ed.) *John Wesley*, Oxford, Oxford University Press, 1964. By the 1850s, this doctrine was no longer the object of the intense scrutiny and debate among Methodists that it became in the Salvation Army. See [Joseph Barker], *The History and Confessions of a Man*, London, Wortley, 1846, for a Methodist criticism of the doctrine. Other Christian denominations were especially critical of this element of Salvationist theology.

19 *The Christian*, 29 May 1879, p. 12.

20 Cornelius Smith, *The Life Story of Gipsy Cornelius Smith*, London: John Heywood, n.d. [1890], p. 9.

21 Anon., *A Short Sketch of the Life of Captain Emmanuel Rolfe*, two pence pamphlet published by the Salvation Army, n.d.

22 *War Cry* (London), 21 September 1882, p. 1. (hereafter *WC*).

23 *WC*, 26 October 1882, p. 2.

24 M. Greenwood, *et al.*, 'Deaths by Violence, 1837–1937', *Journal of the Royal Statistical Society*, vol. 104, part 12, (1941).
25 *WC*, 9 October 1880, p. 4.
26 *Christian Mission Magazine*, August 1876, p. 189 (hereafter *CMM*).
27 *WC*, 24 March 1881, p. 4.
28 *East London Evangelist* November 1868, p. 29 (hereafter *ELE*).
29 'Candidate's Personal Experience', Charles Rich File, Salvation Army Heritage Centre, London.
30 *WC*, 7 June 1884, p. 2.
31 *ELE*, July 1869, p. 155.
32 Geo. R., *The Salvation Navvy: Being An Account of the Life, Death and Victories of John Allen of the Salvation Army*, London, 272 Whitechapel Road E., 1880, p. 17.
33 *WC*, 5 June 1880, p. 3.
34 *WC*, 16 March 1882, p. 1.
35 Cornelius Smith, *Life Story*, p. 41.
36 Rodney Smith, *Gipsy Smith: His Life and Work*, London, National Council of Evangelical Free Churches, 1902, p. 50.
37 Geo. R., *Salvation Navvy*, p. 17.
38 *CMM*, May 1876, p. 111.
39 *CMM*, June 1874, p. 166.
40 *CMM*, March 1874, p. 83.
41 *WC*, 19 January 1884, p. 1.
42 *WC*, 4 December 1880, p. 1.
43 *WC*, 9 February 1882, p. 1.
44 Peter Bailey, *Leisure and Class in Victorian England*, London, Routledge, 1978; Ross, 'Fierce Questions' and 'Survival Networks'; and Stedman Jones, 'Working Class Culture'.
45 *WC*, 30 March 1882, p. 2.
46 *WC*, 10 December 1881, p. 1.
47 Geo. R., *Salvation Navvy*, p. 26.
48 P. Bailey, *Leisure and Class*; Ross, 'Fierce Quotations' and 'Survival Networks'; and Stedman Jones, 'Working Class Culture'.
49 On the status of head of household see Geoffrey Crossick, *An Artisan Elite in Victorian Society*, London, Croom Helm, 1978 and Michelle Barrett and Mary MacIntosh, 'The "Family Wage": Some Problems for Socialists and Feminists', in *Capital and Class*, vol. 11 (1980) for an overview of this issue in nineteenth-century social policy.
50 Elliot J. Gorn, *The Manly Art: Bare-Knuckle Prize Fighting in America*, Ithaca, Cornell University Press, 1986, analyses pugilism in America in these terms. Paul Willis, *Learning to Labour*, Farnborough: Saxon House, 1977 analyses the link between masculinity and physical labour in contemporary Britain in a way that also informs this interpretation.
51 Ross, 'Fierce Questions' and 'Survival Networks'; Stedman Jones, 'Working Class Culture'.
52 Catherine Mumford to William Booth, 27 December 1852, Add Ms. 64799, British Library Manuscripts.
53 *CMM*, February and March 1874.
54 *WC*, 3 February 1881, p. 4.
55 Ross, 'Fierce Questions'.

56 *Daily Telegraph* (London), 3 February 1882, p. 5.
57 *WC*, 27 January 1881, p. 2.
58 *WC*, 6 November 1880, p. 1.
59 *WC*, 16 March 1882, p. 1.
60 *WC*, 4 December 1880, p. 1.
61 Sandall, *History*, vol. II, p. 314.
62 *WC*, 24 April 1880, p.1.
63 Seven of the eight Booth children and their spouses held positions of considerable authority from an early age. After 1890 arguments erupted between the children and their father and among the children resulting in a series of acrimonious splits. See Randall, *History*, vols 2 and 3 and St John Ervine, *God's Soldier*, vol. 2.
64 Quoted in Sandall, *History*, vol. 1, p. 237.
65 Several accounts, including those of the Booth children, describe how individuals fought against the strict orders of the leadership. See, for example, R. Smith, *Gypsy Smith*; Ford C. Ottman, *Herbert Booth: a Biography*, New York: Doubleday, Doran and Co., 1928.
66 *WC*, 30 November 1882, p. 1.
67 *WC*, March 1873, p. 36.
68 *WC*, 5 January 1882, p. 1.
69 *WC*, 4 May 1882, p. 1.
70 *WC*, 27 January 1881, p. 4.
71 *CMM*, September 1874, p. 245.
72 *CMM*, March 1874, p. 71.
73 Muscular Christianity was one prominent attempt to make Christianity 'manly'. See Norman Vance, *Sinews of the Spirit: the Ideal of Christian Manliness in Victorian Literature and Religious Thought*, Cambridge, Cambridge University Press, 1985; Michael Rosenthal, *The Character Factory: Baden Powell and the Origins of the Boy Scout Movement*, New York, Pantheon 1984; and John Springhall, 'Building Character in the British Boy: the Attempt to Extend Christian Manliness to Working-Class Adolescents, 1880–1914', in J. A. Mangan and James Walvin (eds), *Manliness and Morality: Middle-Class Masculinity in Britain and America*, Manchester, Manchester University Press, 1984.
74 John Law, *In Darkest London: Captain Lobe*, London, William Reeves, n.d., p. 242.
75 *CMM*, November 1875, p. 291.
76 *WC*, 27 January 1881, p. 4.
77 Quoted in *CMM*, October 1871, p. 159.
78 *WC*, 10 November 1881, p. 1.
79 *ELE*, November 1868, p. 29.
80 *WC*, 30 March 1882, p. 1.

6

THE BLOND BEDOUIN

Lawrence of Arabia, imperial adventure and the imagining of English–British masculinity

Graham Dawson

Lawrence of Arabia remains a name to conjure with. The story of the English intelligence officer who lived among Bedouin Arabs, became the commander of their guerrilla army, and led them to freedom during the latter part of the First World War, has proved to be one of the enduring myths of military manhood in twentieth-century Western culture. In 1988–9, one hundred years after his birth and seventy years after his Arabian adventure was at an end, two major new biographies appeared, together with an exhibition in London.[1] The reissue, in a painstakingly restored version, of David Lean's 225–minute epic film *Lawrence of Arabia* (1962) 'attracted extraordinary attention' when released in the United States: 'Pictures of a youthful Peter O'Toole, resplendent in white robes, have emblazoned newspapers and magazines across the country'.[2]

This success, repeated in Britain and elsewhere,[3] suggests the continuing fascination of the Lawrence legend: due most especially, perhaps, to the arresting visual iconography of the 'white Arab'. As a marketing hook provoking curiosity about the film, this image establishes the motivating enigma of its narrative as one concerning the identity of the hero. With its intimations of cross-dressing and disguise, it promises the pleasures of narrative play with cultural difference in an exotic 'Oriental' setting; but also of the spectacle of that most masculine of men, the soldier, elaborately arrayed in flowing skirts, in transgression of gender fixities.

This enigma of identity was foregrounded too, at the originating moment of the Lawrence legend, when in August 1919, Lowell Thomas brought to London his New York 'travelogue', *With Allenby in Palestine*. Thomas, an American journalist, had met Lawrence in Jerusalem in January 1918, and was allowed by General Allenby's British Army HQ in Cairo to visit him at his base camp at Akaba, on the Red Sea coast,

provided he published nothing until after the war. In the course of celebrating Allenby's overall campaign in the Middle East, Thomas's multi-media show used film and slide material accompanied by a narrative commentary to introduce audiences to Lawrence. A report on the show in *The Sphere* was subtitled 'A Remarkable Film Lecture telling the Strange Story of Colonel T. E. Lawrence, the leader of the Arab Army'; and carried photos of Lawrence in Arab dress. As the popularity of the Lawrence material gradually became evident, Thomas changed the name of the show to 'With Allenby in Palestine and Lawrence in Arabia'. This performance, which played for several months to packed houses at the Covent Garden Royal Opera House, the Royal Albert Hall and other major London venues before touring the provinces and the British Empire, was eventually seen by audiences totalling over four million people.[4] By November 1919, the public image that Thomas constructed for Lawrence had made him a world figure: 'the first media legend' and 'the most celebrated soldier of the First World War'.[5]

Although no text of Thomas's 1919 lecture survives, his Lawrence narrative was published in serial form in *The Strand Magazine* (1920), under the title 'The Uncrowned King of Arabia'. Then as now, the hook was a romantic fascination with the 'mysterious' hero of 'The Greatest Romance of Real Life'; all the more 'remarkable' and 'amazing' because, claims Thomas, it is not merely a story, but a history of real events, the romantic hero a real man.[6]

> An Englishman was supposed to be in command of an army of wild Bedouins somewhere in the trackless deserts of the far-off land of the *'Arabian Nights'* . . . In Egypt and Palestine I heard *fantastic tales* of his exploits . . . Lawrence became to me *a new Oriental legend in the making*, and until the day I met him . . . I had been unable to picture him as *a real person*. Cairo, Jerusalem, Damascus, Bagdad, in fact all the cities of the Near East, are so full of *colour and romance* that the merest mention of them is sufficient to stimulate *the imagination of matter-of-fact Westerners*, who are suddenly spirited away on the magic carpet of memory to scenes familiar through the *fairy story-books* of childhood. So I had come to the conclusion that *Lawrence was the product only of western imagination overheated by exuberant contact with the East. But the myth turned out to be very much of a reality.* [my emphases][7]

Here, the familiar Western imaginative geography of an exotic and romantic Orient, which underpins Thomas's own interest in Lawrence, is evoked for the reader and indeed strengthened, by its denial in the

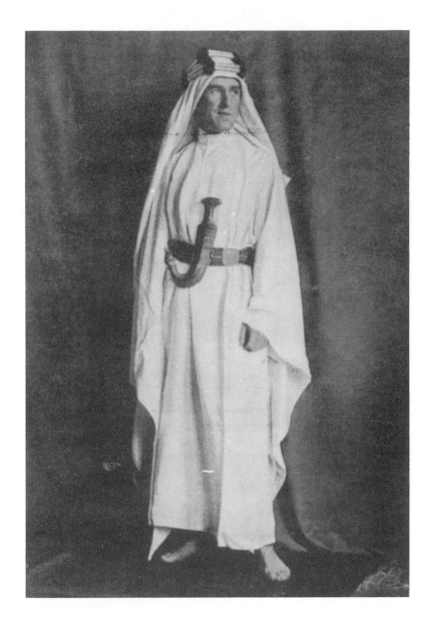

7 'In his desert robes he looked like the reincarnation of one of the prophets of old.' One of Harry Chase's photographs of Lawrence, which was used in Lowell Thomas's travelogue, and later in *With Lawrence in Arabia,* with the accompanying caption

"THE UNCROWNED KING OF ARABIA"
COLONEL T·E·LAWRENCE

THE MOST ROMANTIC CAREER OF MODERN TIMES. *By Lowell Thomas*

This instalment introduces Colonel Lawrence to the reader and gives an outline of the striking facts which, later on, are to be described in full. See the announcement at the end of the article.

HOW I FIRST MET LAWRENCE.

ONE day, not long after General Allenby had captured Jerusalem, I happened to be in front of a bazaar on Christian Street remonstrating with a fat old Turkish shopkeeper who was attempting to charge twenty piastres for a handful of dates. My attention was drawn to a group of Arabs walking in the direction of the Damascus Gate, in the direction of the Holy City. Not what caused me to drop my tirade against the high cost of dates, because Palestine is inhabited by a far greater number of Arabs than Jews. My curiosity was excited by a single Bedouin, who stood

out in sharp relief from all his companions. He was wearing an aqal, kufiah, and abba such as are worn in the Near East only by native rulers. In his belt was fastened the short curved gold sword of a prince of Mecca, insignia that marked him as a descendant of the Prophet.

Christian Street is one of the most picturesque and kaleidoscopic thoroughfares in all Asia Minor. Russian Jews, Greek priests in tall black hats and flowing robes, desert nomads in goatskin coats like those worn in the time of Abraham, Turks with red tarbooshes, Arab merchants lending a brilliant note with their gay turbans and gowns—all rub elbows in that narrow lane of bazaars and shops and coffee-houses that leads to the Church of the Holy Sepulchre. Jerusalem is not a melting-pot. It is an uncompromising meeting-place of East and West. Here are accentuated, as if sharply outlined in black and white by the desert sun, the racial peculiarities of Christian, Jewish, and Mohammedan peoples. A stranger must, indeed, have something extraordinary about him to attract attention in the streets of the Holy City. But this young Bedouin passed by in his magnificent royal robes, the crowds in front of the bazaars turned to look at him.

It was not merely his costume. It was not the majesty with which he carried his

COLONEL T. E. LAWRENCE.

Copyright, 1919, by Lowell Thomas.

SEE OPPOSITE PAGE

WILL CREATE A SENSATION.

The Greatest Romance of Real Life

ever told—the Life-Story of Colonel Lawrence, who raised an army of 200,000 Arabs. Colonel Lawrence is now admittedly

One of our World Heroes.

For many years he lived with the Arabs. To them he became a great white god. They would not have betrayed him for all the gold in the world. At twenty-six he was

the uncrowned King of the Hejaz, Prince of Mecca.

His fame will go down to posterity. His amazing life has been written by Mr. Lowell Thomas, who met and lived with Lawrence in the deserts of Arabia, and whose thrilling account of the campaign in the Holy Land has attracted nearly half a million people to the Albert Hall and Covent Garden Opera House.

Mr. LLOYD GEORGE says:

"Everything that Mr. Lowell Thomas says about Colonel Lawrence is true. In my opinion, Colonel Lawrence is one of the most remarkable and romantic figures of modern times."

8 The first instalment of Lowell Thomas's romance, which introduced Lawrence of Arabia to British readers, appeared in *The Strand Magazine*, January 1920. (By kind permission of the Sherlock Holmes Collection, Marylebone Library, Westminster Libraries)

name of facts and reality. For it enables Thomas to use all the motifs of romantic investment, fascination and curiosity in his own treatment of Lawrence's story, while affirming their truth-status (life being stranger than fiction).

The specific focus of this, in Thomas's opening description of his fortuitous 'discovery' of Lawrence, is his very identity as 'an Englishman'. 'One day, not long after General Allenby had captured Jerusalem, I happened to be in front of a bazaar on Christian Street' when 'my curiosity was excited' by 'a group of Arabs'. Among them was 'a single Bedouin who stood out in sharp relief from all his companions'. Not only Thomas, but 'the crowds in front of the bazaars turned to look at him'. That this man 'must . . . have something extraordinary about him' to attract attention in such a way is reinforced by Thomas's description of Christian Street as 'one of the most picturesque and kaleidoscopic thoroughfares in all Asia Minor';

> Russian Jews, Greek priests in tall black hats and flowing robes, desert nomads in goat-skin coats like those worn in the time of Abraham, Turks with red tarbooshes, Arab merchants lending a brilliant note with their gay turbans and gowns – all rub elbows in that narrow lane of bazaars and shops and coffee-houses that leads to the Church of the Holy Sepulchre.

The colourful costumes function here as signs of the exotic richness of teaming Eastern life, timeless and unchanging since Biblical times: fascinating markers of cultural difference, rendered visible in this 'uncompromising meeting place of East and West', where 'the racial peculiarities of Christian, Jewish and Mohammedan peoples . . . are accentuated'. The extraordinary Arab 'stands out', as supremely different amidst this throng of difference, by his contradiction of those 'racial peculiarities'. He is wearing the 'costume' of a native ruler, carries in his belt 'the short, curved gold sword of a prince of Mecca, insignia that marked him as a descendent of the Prophet'. He carries himself 'with majesty . . . every inch a king', and looks like he had 'stepped out of the pages of the *Arabian Nights*'. That he is 'real', however, and not a fictional character, is paradoxically attested by the most remarkable thing about him:

> The striking fact was that the mysterious prince of Mecca looked no more like a son of Ishmael than an Abyssinian looks like one of Stefansson's Eskimos. Bedouins, although of the Caucasian race, have had their skins scorched by the relentless desert sun until their complexions are the colour of lava. But this chap was as

blond as a Scandinavian [. . .] The nomadic sons of Ishmael all wear flowing beards, as their ancestors did in the time of Abraham. The youth with the curved gold sword was clean-shaven [. . .] His blue eyes, oblivious to the surroundings, were wrapped in some inner contemplation.[8]

This 'blond Bedouin' attracts the curiosity of Thomas's narrator (and readers), by his disruption of the signs of cultural difference, evident in the visible contradiction between his Arab costume and his 'Scandinavian' racial features. 'Who could he be?'[9]

This enigma of identity provokes Thomas's narrative search for the truth about 'my blond Bedouin' in the story which follows. That it should continue to fascinate seventy years later bears testimony to the continuing centrality of racial conceptions of difference in the imagining of English–British (and 'Western') masculinity.[10] In this chapter, then, I want to explore the representations of English–British masculinity produced by the Lawrence legend, paying particular attention to the element of fantasy involved, and so to the ways in which Thomas is composing a form of imagined identity.

Masculine identities are lived out in the flesh, but fashioned in the imagination. This 'imagining' of masculinities is not simply a matter of defining those roles, traits or behaviours considered normal or appropriate for 'men' in any particular cultural context. Rather, it indicates the process by which such norms are subjectively entered into and lived in, or 'inhabited', so as to enable a (relatively) coherent sense of one's self as 'a man' to be secured and recognized by others. An *imagined identity* is something that has been 'made up' in the positive sense of active creation,[11] but has real effects in the world of everyday relationships, which it invests with meaning and makes intelligible in specific ways. It organizes a form that a masculine self can assume in the world (its bodily appearance and dress, its conduct and mode of relating), as well as its values and aspirations, its tastes and desires.

A necessary distinction must be made here, however, between the representation of masculinities in images and narratives, and the complexities of any such identity as it is lived out amidst the contradictory demands and recognitions generated by any actual social relations. Representations furnish a repertoire of cultural forms that can be drawn upon in the imagining of lived identities. These may be aspired to, rather than ever actually being achieved, or achievable. And into this gap flows the element of desire. The forms furnished by

representations often figure ideal and desirable masculinities, which men strive after in their efforts to make themselves into the man they want to be. Imagined identities are shot through with wish-fulfilling fantasies.

The history of masculinities must therefore include within its scope the tracing of those many and varied historical imaginings which have given shape, purpose and direction to the lives of men. It must concern itself with questions about identities and cultural difference, representations and fantasy; both at the level of textual representation and as they are lived in everyday life. Among the most durable and powerful imaginings of idealized masculinity within Western cultural traditions are those which have crystallized around the figure of the soldier as hero.

Imagining the soldier as a hero has always been achieved through the telling of stories about his dangerous and daring exploits in time of war: about, that is, his adventures. In Britain, as Martin Green has shown, there has been a close imaginative relation between adventure narratives and the British Empire. Green identifies a tradition of 'adventure tales' beginning with *Robinson Crusoe*, which, he argues, constituted 'the energizing myth of English imperialism': 'They were, collectively, the story England told itself as it went to sleep at night; and in the form of its dreams, they charged England's will with the energy to go out into the world and explore, conquer and rule'.[12] These stories celebrated Empire as 'a place where adventures took place and men became heroes'.[13] Consequently, representations of heroic masculinity became fused in an especially potent ideological configuration with representations of national and imperial identity. A 'real man' would now be defined as one who was prepared to fight (and, if necessary, to sacrifice his life) for Queen, Country and Empire. The heroic virtues of English–British manhood became intimately bound up with the imagining of Empire itself; with, that is, the imagining of imperial identity, in which the Englishman enjoyed a natural, racial superiority over the colonized peoples who had been subordinated to British imperial power.[14]

Being shaped under the specific conditions of Empire and colonization, then, these forms of imagined masculinity were necessarily constituted in the encounter with cultural difference: in relation to other, subordinated 'non-white' masculinities (as well as in complex and variable relations to femininities which were themselves also in part the product of difference marked by colonial power). The position of supremacy imagined in adventure narratives was then doubly power-

ful; their heroes being not mere men but 'Englishmen'.[15] As well as enabling the imagining of English–British adventurers as triumphant heroes in relation to various colonized 'others', the Empire also seemed to furnish the real possibility of living out those imaginings in everyday experience. The intense excitement generated by opportunities for heroic adventure offered to Englishmen by the Empire in turn appeared to be confirmed by the stories of their deeds accomplished in far-off lands. Adventure stories told of the conquering might of British generals like Clive, Napier, Havelock, Wolseley, Roberts and Kitchener; of massive wealth to be won; and of the god-like power and influence enjoyed by Englishmen over native populations. Sir Walter Scott, for example, commenting on the 'adventure potential' of the Indian subcontinent, suggested that generals like Clive 'influenced great events like Jove himself'.[16] The tradition of imperialist military adventure, then, enabled the imagining of a secure, powerful and indeed virtually omnipotent English–British masculinity.

Like other forms of 'colonial discourse', however, it tended also to register both a fascination with and fear of the colonized 'other'; including, specifically, those 'other' masculinities, which possess, in their very subordination, qualities that may appear to be antithetical to the Englishman; and which exist within the narrative as a troubling, disturbing or even overtly desired presence.[17] These disturbing qualities of the colonial encounter, however, are registered and explored more directly in a parallel development that increased in imaginative power towards and after the turn of the century: a tradition of ironic subversion and commentary upon heroic adventure epitomized most clearly by Conrad's *Heart of Darkness*.[18] Here, the omnipotent imperial masculinity fragments into its obverse: a masculinity haunted by an experience of otherness that is no longer other people, but is now lodged within the psyche; a masculinity torn and split by psychic conflict, and divided against itself.

The Lawrence legend is interesting, once placed within this context of imperial adventure and its imagining of masculinity, for two main reasons. Firstly, Lowell Thomas's blond Bedouin is clearly an imperial adventure hero. In arguing this, I take issue with an assumption, in much of the critical writing on English literary adventure, that heroic military adventure is to be associated primarily with the Victorian Empire; and that it never recovered from the passivity of mass slaughter ushered in by the mechanized trench warfare of the Western Front. Paul Fussell, for example, sees the battle of the Somme, 1916, as the turning point where the heroic idiom of military adventure proved

utterly inadequate to cope with the hitherto unimaginable experience of trench warfare, and gave way to irony in which war was no longer seen as heroic opportunity, but rather as the very figure of dystopian hell on earth.[19]

Such accounts seriously misjudge the continuing centrality of war adventure stories and their versions of heroic masculinity beyond the First World War and into the later twentieth century. They also reflect a tendency to concentrate on 'serious' and 'literary' forms at the expense of popular narratives. Andrew Rutherford, for example, argues that popular genres such as the Western, the spy story and the war film 'form part of the heroic mythology of modern urban man', and celebrate 'heroic virtues' as necessary 'if the "normal" life we value is to be protected and sustained'. But he goes on to stigmatize their 'childish assumptions' and 'ethical and psychological simplicities', preferring instead to explore modern writing which 'treat[s] heroic themes and reinvestigate[s] heroic values' while taking 'full account of the complicated, contradictory nature of adult experience'.[20] Popular narratives, though, become rather more interesting when considered in terms of their representation of masculinities; for Rutherford's argument may then be taken to imply that they imagine forms of masculinity that are ideally free of any such complexities. This is the theme I wish to pursue in analysing Thomas's Lawrence of Arabia.

A second point of interest is that Lawrence has also been represented – and represented himself – in terms of the alternative critical tradition where the adventure hero is divested of wish-fulfilling psychic investments, and contradiction, disturbance and conflict are foregrounded in their place. For example, *Seven Pillars of Wisdom*, Lawrence's epic account of his own involvement in the Arabian Revolt, is one of Rutherford's key texts. This Lawrence of Arabia, haunted and broken by the horrors of war, torture and rape, physical exhaustion and guilt, is the one established by post-1945 biographers and made familiar by David Lean's film. If my study of Thomas is considered in relation to these other narratives, the Lawrence legend can be read as a site of conflict between alternative imaginings of English–British masculinity.[21]

Thomas's narration of 'the strange story of Colonel Lawrence' as an adventure romance is the key to the legend, for adventure is the narrative form that enables the transformation of its protagonist into a hero, by means of a particular selection, ordering and treatment of narrative events. Northrop Frye, theorist of literary romance, sees it as

closely related to wish-fulfilling fantasies and dreams, imagining an ideal world more exciting, benevolent and fulfilling than our own, in which 'the ordinary laws of nature are slightly suspended: prodigies of courage and endurance, unnatural to us, are natural to [the hero of romance]'. His marvellous actions render him superior to other people and to the environment in which he moves. He is a man who is not hindered as living men are hindered, by fears, scruples, doubts, ambivalences, conflicting needs and loyalties. He is qualitatively superior to them: or at least, he is by the end of the story; and because of this, he can function as a figure of virtuous and desirable masculinity, an ideal self, of the kind that men struggle for but can never become. The romance world and the events taking place in it are subordinated to this central figure, and presented exclusively from his perspective, as a series of external risks, challenges and obstacles to be overcome in the accomplishment of his 'quest'.[22]

By narrating the story of Lawrence's involvement with the Arabian Revolt as an adventure, Thomas was able to imagine him as a man whose knowledges, skills and physical abilities were all flawless perfection; and to place him at the very centre of events, directing interest and attention towards his personal quest and achievement of heroic stature, at the expense of other aspects of the Revolt:

> He brought the disunited nomadic tribes of Arabia into a unified campaign against their Turkish oppressors [. . .] Lawrence placed himself at the head of the Bedouin army of the King of the Hejaz, drove the Turks from Arabia, and restored the Caliphate to the decendants of the Prophet . . . Lawrence freed Arabia, the holy land of millions of Mohammedans.[23]

Adventure romances, however, involve their audiences in more than just a casual witnessing of triumph. In focusing attention so powerfully on the central quest, they mobilize a deep and active identification in which 'all the reader's values are bound up with the hero'.[24] By this means, the reader's own desire becomes implicated in the narrative and invested in the successful outcome of the quest. That Thomas had produced a deeply attractive hero is clear from the phenomenal success of his show, and later his book.[25] But why should Thomas's hero have proved so popular in 1919 and 1920?

Lawrence was made into a hero at a time when the desired masculine qualities associated with idealized soldier and other heroes in the imperial tradition were palpably in contradiction with the actual social structures in which men were living and dying in the immediate

aftermath of the Great War. Lawrence's Arabian adventure can be seen to meet a widespread desire for the reassertion of a heroic English–British identity to set against the destruction not only of life but of meaning, values and beliefs, brought about by the war in Europe. Even during the war, Thomas's own motives for visiting the Middle East were propagandist, and bound up with Lord Beaverbrook's campaign 'to glorify Britain's role in the war'.[26] Dispirited by the European fronts, Thomas and his cameraman Harry Chase had been directed by Colonel John Buchan of the Ministry of Information in London, 'to search the Middle East for war stories more uplifting than any to be found in the Flanders quagmire'.[27]

Several features of the Western Front campaign rendered it inimical to adventure. Trench warfare was mechanized warfare: the mass slaughter of 'cannon-fodder' by artillery, tank and machine gun. It was static warfare, that trapped and immobilized soldiers in a nightmare landscape drained of life and beauty. It was bureaucratic warfare, conducted by means of rigidly-disciplined hierarchy and highly-organized division of labour; designed to separate, on industrial lines, those who thought (and 'managed') from those who acted; to instil unthinking obedience in the latter to decisions made elsewhere; and to orchestrate a uniformity and precision in action. The war in the Middle East, by comparison, was one of movement: in Allenby's main campaign, as well as his Arabian sideshow, much use was made of cavalry (which had been abandoned in the Western front in 1915). Some scope was granted to traditional, heroic military virtues such as enterprise, initiative, bravery. The personal qualities of individuals in action counted for something, and soldiers had some chance of experiencing themselves as powerful and effective agents. Under these conditions, war could once again furnish opportunities to imagine and test desirable masculinities. The imaginative contrast, not only with the Western Front but with the bureaucracies, the mechanization and de-humanizing division of labour in 'mass society' as a whole, could invest the adventure world with a utopian intensity of experience.[28]

The Lawrence story as told by Thomas foregrounds the wish-fulfilling features of adventure to an extreme degree, and goes to considerable lengths to mark Lawrence's imaginative distance from the military culture associated with the British generals of the Western Front. His Lawrence is no ordinary soldier but a reluctant hero made 'against the grain' from the most unlikely material:

Fate never played a stranger prank than when she transformed

Thomas Lawrence, the retiring young Oxford graduate, from a studious archaeologist into the world's champion train wrecker, the leader of a hundred thrilling raids, commander of an army, creator of princes and terror of Turks and Germans.[29]

Thomas's repeated designation of Lawrence as a 'scholar' and 'student', and description of him as taciturn, shy, a loner and a recluse more at home in the arcanities of books, and in the past, than in the political and military conflicts that are making the future, establishes a contrast between the inner life and the public world of conflict and action.[30] Later, while 'trekking across the desert' together, Lawrence tells Thomas 'that he thoroughly disliked war and everything that savoured of the military and that as soon as the war was over he intended to go back to archaeology'.[31] As well as intensifying the marvellous quality of Lawrence's transformation, these details suggest a contrast in modes of masculinity between traditional images of the military man of action and a more 'passive', contemplative masculinity which may even be inscribed as 'feminine' or 'effeminate'.[32] For example, Lawrence's 'otherworldliness' is linked by Thomas to his aura of inscrutability, with his perpetual faint smile mysterious as the Mona Lisa. Seeing Lawrence for the first time in 'Christian Street' (sic), Thomas is impressed not only by his 'majesty' but by his 'serene, almost saintly' expression, like 'one of the apostles', as if he were a soldier-saint, or a Christian knight from the age of chivalry.[33] Modern masculinities, by contrast, find it difficult to combine effectively these 'active' and 'contemplative' qualities. Their imagined integration in Thomas's Lawrence suggests, then, not merely a distance from the traditional English–British military establishment, but an alternative and superior mode of being a man.

This theme is developed through Lawrence's 'unmilitary' character. He 'hardly knew the difference between "right incline" and "present arms" ', and he scorns the protocols of rank and military decoration and refuses to be 'correct' in uniform:

> I have seen him in the streets of Cairo without belt, and with unpolished boots – negligence next to high treason in the British Army. To my knowledge he was the only British officer in the war who so completely disregarded all the little precisions and military formalities for which the British are famous. Lawrence rarely saluted, and when he did it was simply with a wave of the hand, as though he were saying, 'Halloa, old man' to a pal. I have never seen him stand to attention [. . .].[34]

The incongruity of this contrast is developed at length by Thomas, in an extended play upon conventional representations of military manhood. For example, Thomas foregrounds, and heightens, the significance of Lawrence's youthfulness.[35] The precondition for the enterprising initiative required by an adventure is often the escape, by a younger man, from the surveillance and control (but also protection) of an established and older authority, who may be coded explicitly as a father-figure. This relationship can, indeed, pose the most basic obstacle to the quest. Thomas's narrative, too, has Lawrence at General HQ in Cairo 'chafing under the red tape of Army regulations'. The quest begins with the General Staff granting his request for leave, 'delighted to have the opportunity of getting rid of the altogether too independent subordinate'.[36]

By depicting his Lawrence as rejecting and transgressing all the signs and rituals of hierarchy and discipline, Thomas is able to separate out the 'positive' and exciting qualities invested in military adventure, and preserve them from contamination by the 'negative' qualities associated with trench warfare. This opposition is captured best by Thomas's description of 'the irregular way in which he [Lawrence] does everything'.[37] After 1916, it was the 'irregular' soldier, rather than the regular army, who would prove capable of sustaining adventure interest. The guerrilla, the commando, the Special Operations forces, the spies and saboteurs who operate in the margins, 'behind enemy lines', 'in occupied territory', or in peripheral colonial theatres of war: these are the characteristic heroes of military adventure in the twentieth century.[38] In Lawrence's case, Thomas cuts his hero free of the modern world itself, imagining him as able to do as he pleases and fashion the world according to his own desires, far away from the cramped, regimented and soulless hierarchies, out in the limitless deserts of Arabia. Here, the maverick individual, the eccentric, by breaking all the rules, becomes a figure of the fully human.

There is something transgressive about Lawrence's freedom from established military authority in Thomas's story. It offers its audiences a fantasy of liberation to set against the dehumanizing and devaluing trends of modern Western 'mass' societies. Paradoxically, however, it channels this utopian impulse into a reworked imperialist form. 'Lawrence freed Arabia' for 'millions of Mohammedans'. Liberated from the destructiveness of military authority, what Lawrence does with his own freedom is to reinvest one of the oldest of all British imperialist fantasies: that of bestowing freedom on a colonized people by the exercise of imperial authority.

The arrival of Thomas in Jerusalem, then, bears testimony to a continuing Western desire for the excitement and inspiration provided by military adventures (both in books and in real life), and to the tendency to seek them out across the frontiers of one of those peripheral zones of the world inhabited by colonized (or colonizable) peoples. In turning away from the Western Front to the Middle East – the Orient – as an imaginative location of more inspiring military adventures, Thomas was projecting a romance world, designed to enable the heroic omnipotence of a (white, Western) ideal masculinity, on to real places inhabited by communities of real other people. Thomas's fantasy of Lawrence depended upon an imaginative investment in a geographical space – the Arabian desert – where Bedouin tribes had made their way of life for centuries, and were now, in 1917, aspiring to liberate themselves by overthrowing Ottoman colonial rule.[39] Edward Said has given the name of 'imaginative geography' to this process of 'mapping' objective space and making it significant for a given community. Said argues that the idea of an exotic, romantic 'Orient', drawn upon by Thomas, is the product of a systematic historical investment by the European (or 'Western') imagination in the geographical area to its east. This 'Orientalist' discourse is defined by Said as: 'a tradition of thought, imagery and vocabulary that has given [the idea of the Orient] reality and presence in and for the West . . . a system of representations framed by a whole set of forces that brought the Orient into Western learning, Western consciousness, and later, Western Empire.' By producing forms of ethnocentric knowledge about 'the Orient', both academic and practical, for the European consciousness at the centre – and constituting, too, a 'collection of dreams, images and vocabularies' available in the wider Western culture – Orientalist discourse enables the transformation of that space from an 'alien', threatening territory into 'colonial space', made knowable by and for Western interests, economic and political as well as cultural. It becomes a form of colonial discourse in the service of Western colonial power.[40]

When Thomas locates a romance world in the Arabian desert, and invests that space with significance as an exotic imaginative landscape replete with challenges to the ingenuity and endurance of an English adventure hero, he participates in a colonial discourse by which Western cultural identity can imagine itself in a position of superiority over its native inhabitants.[41] Orientalist knowledge both confirms and empowers the Western identities at its centre, at the expense of 'the

Oriental', who is placed as their peripheral other. Adventure set in a colonial landscape means that the idealized omnipotent masculinity of the central hero is secured in an imaginative relation to such peripheral and colonized others. In Thomas's 'Arabia', this involves an encounter with the Islamic world of the Turkish Empire and its subject people, the Arabs.

Since, in common with the broad tradition of imperialist adventure, Thomas's romance world is almost entirely a masculine world, this means an encounter with Turkish and Arab masculinities. In the Arabia of 1917–18, torn by the conflict of the Arab Revolt in which British interests were bound up with Arabs against Turks, the projections necessary to secure the omnipotence of Thomas's adventure hero make use of different strategies in each case.

In the case of the Arabs, Thomas's narrative effects a curious reversal, whereby, instead of Lawrence arriving in Arabia to help the Arabs in their revolt, the Arabs are represented as the devoted helpers on what is now Lawrence's quest to become a hero. In order to fix Lawrence as the focal point of the narrative, Thomas has to actively displace the Arabs, in structural terms, by suggesting that they lack certain qualities that Lawrence will supply. 'At almost any time in those five centuries the desert people could have freed themselves had they been able to unite. But [. . .] no-one appeared in the Near East strong enough to bring the Arabs together.'[42] While the current Arab leaders, King Hussein and Prince Feisal, are granted 'great credit' for building the Arab nationalist movement and initiating the Revolt, 'neither of them had the uncanny skill and masterly diplomatic ability to carry out their original plan'.[43] These, however, are the very qualities discovered by Lawrence. The Arabs come to recognize him as the leader without whom the Revolt cannot succeed, making him 'an Emir and a Prince of Mecca out of gratitude'.[44] Thomas suggests that the Arabs' inability to unite under a strong Arab leader – due in particular to their indiscipline, and constant fighting among themselves – is largely responsible for their failure to throw off Turkish rule and their status as 'slaves' of the culturally-inferior Ottoman Empire. These qualities attributed to the Arabs both signify British superiority[45] and constitute the major obstacle to the quest.

The theme of the quest itself is announced when Lawrence, surveying the Arab army, promises Feisal that 'his troops would be in Damascus within the year'.[46] Confronting him, however, are formidable obstacles and 'overwhelming odds'. In overcoming these challenges, Lawrence acquires new qualities and new knowledges, as

well as drawing on his existing accomplishments. Thomas presents
Lawrence's 'greatest problem' as the Arabs' tribal 'blood feuds' that in
some cases had lasted 'for centuries', thwarting the efforts of 'scores of
generals, statesmen and Sultans' to unite them in a single movement.[47]
Lawrence's success in this 'almost impossible mission' constitutes his
greatest achievement. Thomas describes his 'magic powers of
persuasion'; his 'masterly and convincing manner' whilst recruiting; his
skill and justice in settling disputes; all underpinned by his knowledge
of Arab customs and dialects, derived from his days as a scholar.[48] Even
before the quest, on joining the Cairo HQ in 1914, Lawrence is already
'an authority on the geography of the Near East'. He is able to advise
the British generals' strategic plans on the basis of 'short cuts which he
alone knew from his years of barefoot travelling'. As 'a student of
peoples', he had 'adopted native costume and tramped barefoot over
thousands of miles of unknown desert country, living with the various
Bedouin tribes, and studying the manners and customs' of peoples
throughout Turkey, Syria, Palestine, Mesopotamia and Persia, having
'a more intimate knowledge' of them 'than almost any other Euro-
pean'. Thomas claims that Lawrence speaks 'faultless Arabic' in five
dialects, and that he is 'one of the greatest living Arabic scholars'.[49]

As the Arab leader by dint of his own superiority, Lawrence can then
be put firmly in place at the centre of the revolt. Thomas credits
Lawrence alone with wiping out the centuries-old blood feud, building
up and inspiring the Arab army, masterminding the strategy of its
campaign, outmanoeuvring the enemy generals, leading the Arabs into
battle, and establishing a government in Damascus. 'In fact he was the
moving spirit of the Arabian revolution.'[50] The results of this are often
bizarre. For example, Thomas suggests that, because of Lawrence's
extensive knowledge of explosives, about which the Bedouin were
'wholly ignorant', 'Lawrence nearly always planted all his own mines,
and took the Bedouin along with him merely for company and to help carry off
the loot'.[51] On recruiting missions, 'The fact that *Lawrence was
accompanied by Emir Feisal* [rather than, as might have been expected, the
other way round!], the most popular of King Hussein's sons, assured
him [not, of course, Feisal] of the heartiest possible welcome wherever
he went'[52] (my emphases). The Arab leaders and their forces, instead of
pursuing their own revolt by their own means, with help from
Lawrence, come to occupy the place of devoted helpers on his quest to
become a hero.

In dealing with the Turks – who constitute an obstacle of a different
sort, as the enemy against whom Lawrence leads the Arabs – Thomas

utilizes a similar Orientalist strategy of a binary dichotomy whose positive terms are always associated with the West and negative ones with the East. Whereas Thomas's characterization of the Arabs, and of Lawrence's relation to them, is far more complex and includes recognition of positive qualities (see below, pp. 130, 132), as enemies, the Turks become the recipients of all that is negative in a straightforwardly 'demonizing' manner characteristic of much wartime propaganda. They are 'tyrannical oppressors' who had managed to 'usurp the leadership of Islam', and 'governed the Arabs as though they were an inferior race' for five hundred years. As Muslims, they are 'impious', paying mere lip service to Islamic mores, and so ignorant of sacred law that they even bombard the most holy mosque in Mecca. Turkish troops commit 'atrocities against [Arab] women and children' and practise gruesome methods of torture. They have absolutely no qualities worthy of respect, and so merit the 'utter scorn' of the hero. They are also represented as powerless against Lawrence. Consistently 'outwitted', overwhelmed and eventually demoralized, the Turkish forces pose no threat to Lawrence in Thomas's story, and function merely to be defeated by Lawrence's superior leadership and 'strategic genius', underpinned by 'his superior knowledge of the topography of the country'. Once exposed to military combat, Lawrence distinguishes himself by his courage (he always charges at the front of his troops, is 'in the thick' of every fight). He is casual about danger, and demonstrates his 'utter scorn of the enemy' by 'strolling on foot through the Turkish lines'. Thomas witnesses one occasion when Lawrence allows Turkish soldiers hoping to take him prisoner to advance to 'within a few yards . . . and then, with a speed that would have made an Arizona gunman green with envy, whipped his [. . .] revolver from the folds of his gown and shot six Turks in their tracks'. He is, of course, 'a perfect shot'.[53]

Where Lawrence is clever, the Turks are stupid. Lawrence's bravery is matched by the Turks' cowardice, his skill by their incompetence. All the heroic qualities discovered by Lawrence on the quest find their opposite, by implication if not direct attribution, in the Turks. As the devalued, contemptible and worthless 'bad object', the Turks therefore deserve the punishment and destruction meted out to them by the hero.[54] In narrative terms, they exist only in order to be defeated: to be outmanoeuvred, tricked, surprised, captured, paralysed, shot and blown up. Moreover, since they are deserving recipients of Lawrence's righteous violence, he is licensed to take pleasure in it, as 'sport', free from guilt or remorse at his destructiveness: ' "Do you know, one of

the most glorious sights I have ever seen is a trainload of Turkish soldiers going up in the air, after the explosion of a mine?" ' [55]

The third obstacle to the quest is the Arabian desert landscape itself in its sheer vastness of scale and difficulty of terrain. 'The distance from Damascus to Aleppo alone is greater than the distance from London to Rome, and great sweeps of desert separate nearly all the important points.' [56] Thomas himself claims to accompany Lawrence on a raid which takes 'two days hard riding across a country more barren than the mountains of the moon, and through valleys that would make Death Valley look like an oasis'. [57]

If his overcoming of the first two obstacles equips Lawrence with the leadership and martial qualities of the traditional English–British soldier hero, it is in his overcoming of this third obstacle that the imaginative resonance of the legend derives. For 'when Lawrence left the coast of Arabia and plunged into the desert he shed his European clothing and habit of mind and became a Bedouin'. [58] He learns to traverse the desert Arab-style, by camel; acquiring a 'thorough knowledge' of their ways through 'exhaustive study', and becoming (according to one Arab leader) 'one of the finest camel-drivers that ever trekked the desert'. [59] He eats only the simple Arab food, and even 'worked out his problems in true Arab manner'. This can be seen as an extension of Lawrence's studious interest in, and appreciation of, Arab customs and culture; which he values as 'an entirely *different* and older civilisation than his own' (my emphasis). [60] Those very qualities that distinguish the Arabs from British military culture provide opportunities for an Englishman to experience a different way of being. When Thomas visits him at Akaba, Lawrence has 'lived so long in the desert that it was more natural for him to act like an Arab nomad than a European'. He has been '*entirely successful* in transforming himself into a Bedouin' (my emphasis). [61]

Acquiring Bedouin ways in the desert enables Lawrence to lead the Arab army under his command in a successful guerrilla war behind enemy lines in Turkish-occupied Arabia. The focal point for this is the Hejaz railway, connecting the Turkish garrisons at Medina and Maan with Damascus. Lawrence becomes an expert saboteur. [62] His success lies in the Arab army's ability to take the Turks by surprise, due to its greater flexibility of movement and Lawrence's 'superior knowledge of the topography of the country'. Having 'wiped out' a Turkish post near Maan, for example.

The young Englishman and his band of Bedouins disappeared in

the blue, swallowed up in the desert so far as the Turks were
concerned, until the evening of the following day, when they
reappeared out of the mist many miles distant at another point on
the railway. Here Lawrence merrily planted a few mines,
demolished a whole mile of track, and destroyed a train.[63]

So successful are these tactics that Thomas records only one 'unsatis-
factory' expedition, when Lawrence and sixty Arabs blow up a train
carrying the Turkish Commander-in-Chief and one thousand troops
near Deraa; and have to fight a 'pitched battle' against 'overwhelming
odds', suffering twenty casualties before escaping.[64]

As well as guerrilla raids against the Turks, Lawrence marches his
growing army 700 miles across the desert and along the coast;
maintaining 'a perfect liaison' with the Royal Navy which results in the
capture of the strategic coastal towns of Yambu and El Wijh.[65] He also
builds up his army along the way, mustering fifty thousand Arabs. In a
decisive move, he then leads a smaller force of about 1,100 northwards
to Akaba, 'his most important objective'. After defeating 'a crack
Turkish battalion' at the battle of Aba-el-Lissan for the loss of only two
Arabs, and achieving numerous smaller victories, Arabs from the
northern tribes come 'by the hundreds' to join him; while entire
Turkish garrisons surrender without a fight. Finally, Akaba itself falls
to the Arabs, as a result of 'Lawrence's spectacular manoeuvre, when
he accomplished what the Turks thought was impossible' and leads his
army of ten thousand Bedouins over the King Solomon Mountains –
'high, jagged, almost impassable, arid mountains' – and down into the
town; where 'the Turks and Germans were so paralysed by the feat . . .
that they were ready to surrender at once'. The fall of Akaba marks the
close of the penultimate stage in Lawrence's quest, and opens the
possibility of its successful completion: the invasion of Syria. It also
brings the first public recognition of his achievement, from Allenby
himself, to whom Lawrence communicates his news personally after an
epic camel ride, 'continuously for 22 hours at top speed across the
mountains and deserts of the Sinai peninsular', undertaken 'to save his
army from starvation'. Allenby promotes Lawrence to a colonelcy and
sends him back to Akaba with 'unlimited power and resources' as the
right wing of his allied army.[66]

In the final stage of the quest, Allenby and Lawrence together plan
the invasion of Palestine and Syria, with Lawrence effectively doing
the work of a lieutenant-general, and insisting on a starting date for the
campaign to fit in with the rainy season in Arabia. By 'forced marches',

Lawrence and the Bedouin army 'swept north across the deserts east of
the Dead Sea', destroying their final railway bridge at Deraa, before
pushing on ahead of Allenby to Damascus itself; where 'they drove the
Turks out of the city after a hot hand-to-hand fight in the streets', and
liberate the city. Thomas describes how Lawrence governs Damascus
'until he could organise the Arab leaders and turn over the government
to them'; and then how he and Allenby join forces again to free Beirut
and sweep the Turks from Aleppo.[67] But the fulfilment of the quest
comes with Lawrence's 'official entry' as victor into Damascus, 'the
city which was the ultimate goal of his whole campaign'.

> Hundreds and hundreds of thousands of Arabs, including the
> entire population of Damascus, the oldest city in the world [. . .]
> and thousands and thousands of the wild Bedouin tribes from the
> fringes of the desert packed [the streets] and jammed the bazaar
> section as Lawrence rode through the city, dressed in the garb of
> a prince of Mecca. Howling dervishes ran in front of him,
> dancing and sticking their knives into their flesh, while behind
> him came his flying column of picturesque Arabian knights. As
> Lawrence passed the gates of Damascus the inhabitants of that
> city, which was once the most glorious city of the East, realised
> that they had at last been freed from the Turkish yoke. [. . .] As
> they saw [the mysterious Englishman] come swinging along on
> the back of his camel, it seemed as though all the people of
> Damascus shouted his name in one joyful chorus. For more than
> ten miles along the streets of the city the crowds gave this
> Englishmen one of the greatest ovations ever given to any man.[68]

The quest ends, then, with Lawrence's triumphal entry into Damascas,
to the acclaim and recognition of the Arabs as their hero and liberator.

'Becoming an Arab', in Thomas's narrative, is therefore an essential
component of Lawrence's transformation into an adventure hero. For if
romantic adventure is now only imaginable in the colonial peripheries,
the qualities of the inhabitants, which enable them to operate freely in
the peripheral landscape, themselves become desirable and necessary if
Western man is to become a hero. These idealized masculine qualities
felt to be lacking from the modern world are therefore discovered in –
or rather projected into – the world of the other. Thomas's Arabs are
characterized in terms of a traditional, pre-modern, chivalric mascu-
linity. Unlike the Turks, the Arab peoples are the inheritors of an
ancient civilization: ' "The pure Arab of the desert belongs to a race

which built some of the first civilisation", he [Lawrence] said. "They had a philosophy and a literature when the natives of the British Isles were savages. [. . .] [They] live as their forefathers lived thousands of years before Christ" '.[69] They are devout, patriotic, take great pride in their ancestry, and abide (unlike the 'treacherous Turks') by an 'unwritten law of the desert', placing much emphasis on hospitability. Their Sherifian leaders such as Feisal are granted great dignity, their ceremonial is 'splendid and barbaric', and their characters are often passionate and colourful. Above all, their fighting capabilities are prodigious and include 'a headlong unreasoning dash and courage', and great powers of endurance.[70] Both their nobility and their qualities and skills are linked to a wild, primitive anarchic masculine energy represented most powerfully by Auda abu Tayi: 'a born brigand', 'the greatest hero of modern Arabian history', and 'the most celebrated desert fighter for four generations'. He is an epic figure who recites epic tales, and claims to have killed seventy-five men in hand-to-hand combat (excluding Turks, whom he classifies in a derogatory fashion as 'women'); to have been wounded twenty-two times and to have married twenty-eight times.[71] Auda's tribe, too, is larger-than-life:

> They cause more trouble, have more enemies and take part in more blood-feuds than any other tribe. They are the most obstinate and unruly and quarrelsome people I've ever met. They seem to have no fear. One small boy [. . .] will take a rifle and engage in battle against 20 men. No man in the tribe will recognise any other as a sheikh [. . .] [They] are unable to unite among themselves even when attacked from outside.[72]

We can see here how the desired qualities of Arab masculinity are also the very qualities that mark Arab inferiority, and ultimately sub-ordination, to Lawrence's Englishness. For Thomas's narrative is involved in a complex negotiation whereby those Arab qualities coded as positive and felt to be lacking by English–British masculinity may be desired without, however, threatening imperial superiority. Thomas's constant insistance on the Arabs' boyish enthusiasm, innocence and indiscipline serves this end. He describes their pleasure in the thrills of raiding and winning 'loot'; their 'playfulness' and 'carelessness' on train-blowing expeditions; their coveting of Lawrence's robes, 'more gorgeous than anything they had ever seen before [. . .] His playful followers, like children, wanted them'.[73] This combination of qualities – both epic and childish – inevitably renders the Arabs into figures of fun, out of a burlesque; and Thomas actually describes Lawrence's

devoted personal bodyguard – 'a select band of picked men [. . .] every one of them a famous fighting man' – as 'a comic opera crew'. The potentially threatening quality of their primitive anarchic energy (they parade around Cairo 'bristling with pistols and daggers, causing much uneasiness wherever they went') can thus be dissipated in affectionate laughter at their pranks.[74]

In a second, linked strategy, however, Thomas imagines Lawrence's 'becoming an Arab' as providing opportunities to prove his own superiority as an Englishman, by becoming a better Arab than the Arabs themselves. Thomas claims that Lawrence 'outdid them from camel riding to speaking their own language'. Apparently, 'only one Bedo among Lawrence's followers [. . .] could stand the pace when he extended himself to the limit' on camelback. On one journey, the pair are said to have ridden for twenty-two hours per day for three days; covering three hundred miles, a distance which normally took twelve days; and settling 'a record for camel-riding which will probably stand for many years'. Auda, 'the acme of everything Arabic', recognizes this as 'the secret of Lawrence's success': ' "By the Beard of the Prophet", he roared, "this fair-haired son of Allah can do everything that we do even better than we do it ourselves." '[75] Thomas emphasizes the importance of this in Lawrence's ability to win the leadership of the Bedouin:

> Lawrence won the admiration and undying devotion of the Arabs because of his understanding of them, through his proficiency in their dialects, and his rare knowledge of their religion . . . and even more, perhaps, because of his fearlessness and reckless courage, his ability to outdo them in nearly everything in which they themselves excelled.[76]

By 'becoming an Arab', then, Lawrence secures the admiration and devotion of the Arabs through not only emulating but excelling in their own qualities, as well as surpassing them with his own. For it is also the means whereby his knowledge of Arab customs can materialize as power, since of course Lawrence does not give up his superior Western knowledges when he becomes an Arab, but rather, lives according to them.

Significantly, the meeting of cultures is not reciprocal. Lawrence, the European, can 'go native'; but the natives are not enabled to 'go civilized'.[77]

Although they frequently asked him questions regarding his own

country, he invariably led the conversation back to local Arab affairs, he scrupulously avoided drawing comparisons between European and Arabian ways, and he seemed to have an insatiable desire to learn as much information about the peoples and parts of the country he was in as possible.[78]

The flow of information is all one way, along lines dictated by relations of power, which implicate knowledge in power, and invest power in knowledge. This is evident, too, in another crucial withholding of knowledge practised by Lawrence: his decision 'not to instruct the Arabs in the use of high explosives'.[79]

Lawrence does not, in fact, 'become an Arab', if by that is meant to cease being an Englishman. Thomas describes his participation in Arab customs as calculatedly selective, and designed to enhance his prestige. He 'never entered into competition with the Bedouins unless he was certain first that he could excel them', and 'he made it a rule never to speak unless he had something special to say', and could speak with knowledge and authority.[80] This personal authority is supported by the materiality of British imperial power: gunboats, explosives, machine guns and 'the unlimited financial support of the British Government'.[81] He is, says Thomas, 'like an actor playing a part':

> The Bedouin never saw him excepting when he was at top notch. He cultivated the character of a man of mystery. He usually dressed in beautiful robes of pure white. In order that his garb should always look spotlessly clean he carried three or four special changes of raiment on an extra camel. He also made it a point to shave every day, although frequently they were dry shaves due to the scarcity of water.[82]

This detail about shaving is important, since attention to civilized toilette in remote and uncivilized parts of the Empire was one of the traditional attributes of the Englishman.[83] One of the most obviously contradictory signs of the 'blond Bedouin' – the absence of a beard – is no accident, but a carefully contrived sign of Englishness, which helps to establish the combination of 'mystery', purity and authority that distinguishes him from the Arabs. The image Lawrence assembles for them involves a complex balancing of likeness and difference.

Traditionally, the superiority of white imperial Englishness was guaranteed by a clear demarcation of difference, policed by powerful fears about the moral and psychic effects of 'going native'. By contrast, the structure of fantasy in Thomas's narrative can best be explained as a

projective identification.[84] Valued masculine qualities felt to be marginalized, excluded or even lost to Englishness are projected on to the Arabs. The English hero, in identifying himself with this 'other', empathizing with it, taking its side, and imagining himself in its terms, is then able to repossess those qualities. This identification with the other is then, in turn, 'introjected', or incorporated back as a part of himself, in the form of the other, into the Englishman's own identity, which is thus strengthened in imagination through a new combination of qualities. The Arab who is also clearly an Englishman, the 'blond Bedouin', incorporates all the desired qualities of Arab masculinity into an Englishman, whilst simultaneously retaining his Englishness in and through the qualities and knowledges which the Arabs are unable to emulate. His reckless courage, his endurance, his ability to move at will in the desert landscape as an Arab are combined with an Englishman's disciplined application of knowledges, an Englishman's access to finance and the modern technologies of war. Thomas's 'Lawrence of Arabia' is a hero who enjoys the best of both worlds. He is a man with everything.[85]

Thomas's adventure, then, displays a fascination with alternative forms of masculine identity, but imagines Lawrence as resolving them into a new kind of ideal unity and coherence: an omnipotently powerful masculinity for post-1918 Britain. The figure of the blond Bedouin as soldier hero simultaneously offers an imaginary resolution to contradictions within English–British masculinity, between the contemplative intellectual and the man of action; and resolves the contradiction between modern and traditional masculinities, whereby epic qualities can be repossessed in a modern form. The very qualities in Lawrence which mark his difference from conventional military masculinity – his youth, his contemplative otherworldliness, his studious intellectuality – are recoded as essentially English virtues through Lawrence's encounter with the Arabs. Integrating the qualities of the Arabs with those English virtues makes possible the rejuvenation of the soldier hero as an ideal, removing him from the dominant conditions of modern warfare and exposing him to conditions in the colonial periphery where adventure opportunities still abound. Integrating Arab epic qualities with his own equips Lawrence with alternative forms of martial value, which combine with his intellectuality to establish his superiority over regular British military manhood. But the blond Bedouin also represents the management, in fantasy, of the threat to Lawrence's own identity as an Englishman posed by Arab otherness. Integrating those threatening qualities within

himself both divests of its disturbing power the colonized and subordinated other, and reaffirms the superiority of a strengthened Englishness.

In Thomas's fantasy of Lawrence, then, neither the Turks who are triumphantly destroyed nor the Arabs who become wild, childlike and picturesque helpers present any serious threat to Lawrence's superiority, either morally, physically, or psychically. His omnipotence as an Englishman is manifested in his control over both Bedouin and Turkish others, who alike bend to his will, in a fantasy of the totally secure and unproblematic superiority of English–British manhood. But there is a final twist to Thomas's fantasy of omnipotent masculinity, and this concerns the question of femininity. Thomas's Arabia is virtually devoid of women.[86] It is then all the more striking that Lawrence himself is often presented in a distinctly feminine light. Many of his qualities are codable as feminine in opposition both to Arab and conventional British military masculinities; for example, his boyishness and lack of a beard, his small size, his modesty and shyness. On several occasions, Thomas explicitly describes Lawrence as feminine. 'He was so shy that when General Storrs or some other officer tried to compliment him on one of his wild expeditions into the desert, he would get red as a schoolgirl and look down at his feet.'[87] And at his first meeting with Allenby (the crucial first recognition of the hero), 'the youthful lieutenant' (who had just endured a camel-ride of superhuman length and arduousness!) 'looked very much like a Circassian girl in Arab costume'.[88] These evocations of a feminine Lawrence – which perform no necessary narrative function – add another dimension to the fantasy of Lawrence as the man who has everything. He is a perfect man who is at the very same time also womanly, able to integrate femininity within himself, and thus to transcend gender difference. In becoming womanly at the very same moment that masculinity is reaffirmed in its superiority, the Lawrence fantasy also manages the potential threat posed by femininity to a wholly masculine world from which it has been banished. Articulated with the racial fantasy of the blond Bedouin, wherein the threatening qualities of racial difference appear to dissolve at the very same moment as Englishness is reaffirmed in its superiority, we can also discern another: the dissolving of gender difference to sustain the power of masculinity.[89]

In Thomas's narrative, 'Lawrence' achieves recognition as a hero on his triumphal entry into Damascus. But public recognition of T. E. Lawrence was actually dependent upon Thomas's own narration of the

Lawrence story. 'Lawrence's entry into Damascus' must be considered primarily as an event in that narrative, rather than as a 'realistic' representation of 'what really happened' in an historical sense. Even had events occurred as Thomas describes them – and there has been controversy over this[90] – the narration of those events to a British (and Western) public counted for more than the events themselves in establishing Lawrence's stature as a hero. Although Thomas claims to be simply relaying the truth about him in his story,[91] in narrating Lawrence's deeds as an adventure romance, he is actively constructing him as a British hero: 'a man who will be blazoned on the romantic pages of history with Sir Walter Raleigh, Sir Francis Drake, Lord Clive, Chinese Gordon, and Kitchener of Khartoum'.[92] For heroes are made not by their deeds but by the stories that are told about them.

The Lawrence story has been told and retold, in contradictory and conflicting versions, over seventy years during which British imperial authority has been challenged and then eroded away. The radical re-assessment of Lawrence's heroic reputation in biographies from the mid-1950s and early 1960s was coterminous with the Suez debacle and colonial wars in Malaya, Kenya and Cyprus; and Lawrence became one of the figures through which the impact of the loss of Empire upon English–British masculinity could be registered.[93] In the history of the Lawrence legend, then, can be read this other history: of imaginative investment in an ideal form of imperial masculinity, and of its increasing disturbance and breakdown as it enters a post-colonial world.

NOTES

1 Malcolm Brown and Julia Cave, *A Touch of Genius: the Life of T. E. Lawrence,* London, Dent 1988; Jeremy Wilson, *Lawrence of Arabia: the Authorised Biography of T. E. Lawrence,* London, Heinemann, 1989; *Lawrence of Arabia,* an exhibition at the National Portrait Gallery, London, 9 December 1988 – 12 March 1989.
2 *The Guardian,* 9 February 1989; *Lawrence of Arabia,* directed by David Lean, for Horizon, 1962. The remake appeared in February 1989, Columbia Tri-Star Films.
3 By May 1989, the remake had grossed $4.6 million in the USA. The Odeon, Marble Arch, took more than £12,000 in advance bookings. *Sunday Times,* 28 May 1989, p. C11. Another reviewer claimed that the film 'outshone all the newcomers at the Cannes Film Festival'. *Daily Telegraph,* 25 May 1989, p. 20.
4 Wilson, *Lawrence of Arabia,* pp. 622–6; *The Sphere,* 23 August 1919.
5 Stephen E. Tabachnick and Christopher Matheson, *Images of Lawrence,* London, Jonathan Cape, 1988, dustjacket and p. 22.

6 Desmond Stewart, *T. E. Lawrence*, London, Paladin Grafton, 1979, p. 197; Lowell Thomas, ' "The Uncrowned King of Arabia" ', Colonel T. E. Lawrence, the Most Romantic Career of Modern Times', *The Strand Magazine*, vol. 59 (Jan.–June 1920), pp. 40–53, 141–53, 251–61, and 330–38. In 1921, Lawrence described these articles as 'about 70% inaccurate and about 10% inaccurate and offensive to those Arabs and Englishmen who took part in the Arab Campaign. They were partly impure imagination, partly perverted quotation of articles (by myself and others) [on the campaign]'; this despite, according to Wilson, the omission at Lawrence's request, of 'the most outrageous inventions' that had appeared in the original articles in the American magazine, *Asia*. Wilson, *Lawrence of Arabia*, pp. 652–3. For the controversy surrounding the nature and extent of Lawrence's 'collaboration' with Thomas, see Tabachnick, *Images*, pp. 37–8; and Stewart, *T. E. Lawrence*, pp. 196–8. Thomas later expanded his material into the first book-length biography of Lawrence, *With Lawrence in Arabia*, London, Hutchinson, 1925. The analysis that follows, however, is based upon the earlier and shorter version, referred to hereafter as *Strand*.

7 *Strand*, pp. 40, 42–3.

8 *Strand*, p. 42.

9 *Strand*, pp. 41–2.

10 The common interchangeability of 'English' and 'British' as designations of identity poses problems for any historian or cultural analyst who is sensitive to the full range of national identities within 'the United Kingdom of Great Britain and (Northern) Ireland', and yet wishes to explore the common 'Britishness' that has resulted from belonging to 'the imperial race'. On one hand, as Benedict Anderson has argued (*Imagined Communities*, London, Verso, 1983, pp. 84–9), Scottish (and Welsh and Irish) people could make the journey into the metropolitan centre of Britain, and from thence to the colonial periphery where they could enjoy the privileges that followed from 'being British'. On the other, the use of 'English' as a synonym for this broader identity co-exists with its more restricted sense, marking the hegemony of England within the United Kingdom. I use the phrase 'English–British' to draw attention to these problems, and to indicate that what is described as 'English' is often the product of the imperial British state; while conversely, 'Englishness' is often embedded within what is taken to be 'British'.

11 See Anderson, *Imagined Communities*, pp. 15–16.

12 Martin Green, *Dreams of Adventure, Deeds of Empire*, New York, Basic Books, 1979, p. 3.

13 Green, *Dreams*, p. 37.

14 Graham Dawson, 'Soldier Heroes and War Stories: Adventure Narratives of War, Masculinity and the Nation in British Popular Culture, 1850 – Present', doctoral thesis to be submitted at the University of Birmingham, 1991.

15 Brian V. Street, *The Savage in Literature*, London, Routledge, 1975, chapter 2. These English heroes triumph most effortlessly in the late nineteenth-century boys' romance fiction epitomized by G. A. Henty and H. Rider Haggard, and in boys' magazine stories. See Green, *Dreams* chapter 6; Brian Street, 'Reading the Novels of Empire: Race and Ideology in the Classic Tale of Adventure', in David Dabydeen (ed.), *The Black Presence in English*

Literature, Manchester, Manchester University Press, 1985; Frances M. Mannsaker, 'The Dog that Didn't Bark: the Subject Races in Imperial Fiction at the Turn of the Century', also in Dabydeen, *Black Presence*; John M. MacKenzie, *Propaganda and Empire: the Manipulation of British Public Opinion 1880–1960*, Manchester, Manchester University Press, 1984, chapter 8; Kelly Boyd, in the present volume, pp. 145–67.

16 Green, *Dreams*, p. 113.

17 Homi Bhabha, 'The Other Question: Difference, Discrimination and the Discourse of Colonialism', in F. Barker *et al.* (eds), *Literature, Politics and Theory*, London, Methuen, 1986.

18 Joseph Conrad, *Heart of Darkness*, Harmondsworth, Penguin, 1973. See, too, Conrad's *Lord Jim*, New York, Norton, 1968; and Fredric Jameson's discussion of the divided subjectivity of its protagonist in *The Political Unconscious*, London, Methuen, 1981, chapter 5.

19 Paul Fussell, *The Great War and Modern Memory*, Oxford, Oxford University Press, 1975, chapter 1, pp. 12–13, 18–23. Cf. Bernard Bergonzi, *Heroes' Twilight: a Study of the Literature of the Great War*, London, Constable 1965: '. . . after the mechanized, large-scale slaughter on the Somme in July 1916 . . . the traditional mythology of heroism and the hero, the Hotspurian mode of self-assertion . . . had ceased to be viable', p. 17.

20 Andrew Rutherford, *The Literature of War: Studies in Heroic Virtue*, Basingstoke and London, Macmillan 1989, pp. 9–10.

21 T. E. Lawrence, *Seven Pillars of Wisdom*, Harmondsworth, Penguin, 1962; Rutherford, *Literature of War*, chapter 3, pp. 38–63. On post-1945 biographers, see Tabachnick, *Images*, pp. 51–68. See Dawson, *Soldier Heroes* for the development of this argument.

22 Northrop Frye, *The Anatomy of Criticism*, Princeton, Princeton University Press, 1957, esp. pp. 33–4, 186–7, 195–6.

23 *Strand*, p. 42.

24 Frye, *Anatomy*, pp. 186–7.

25 See note 6.

26 Tabachnick, *Images*, p. 37.

27 Stewart, *T. E. Lawrence*, p. 169. On the myth that Buchan based the hero of his novel *Greenmantle*, London, Hodder & Stoughton, 1916 on Lawrence, see Stewart, p. 145.

28 On the experience of mechanized warfare on the Western Front, see Eric J. Leed, *No Man's Land: Combat and Identity in World War I*, Cambridge, Cambridge University Press, 1979, pp. 29–32; and Rutherford, *Literature of War*, pp. 65–9, who also (pp. 47 and 68) compares the Arabian 'sideshow'. See also Leed's explanation (pp. 59–69) of the European enthusiasm for war in August 1914 in terms of a sense of 'liberation' from modern economic activity into 'a field of freedom, uncertainty and risk, a field upon which a character and an identity would be realised – a character who was the antithesis of "economic man" '. (My argument requires that 'man', in Leed's generalized sense here of 'human', be gendered. That the 'combatants' he writes about are all men is not an organizing principle of his book.) This belief in war as a means 'to escape the "soul-killing mechanism of modern technological society" ' produced a profound disillusionment under Western Front conditions. See in particular Leed's argument about

the profound stasis of trench life, and ensuing fantasies of mobility, in chapter 4, especially pp. 121–6 and 162. On the utopian element in popular cultural forms as a locus for desires and impulses unrealisable within capitalist social relations, see R. Dyer, 'Utopia and Entertainment', in R. Altman (ed.), *Genre: the Musical*, London, Routledge, 1981.

29 *Strand*, p. 141.

30 *Strand*, pp. 42–4, 52.

31 *Strand*, p. 52.

32 Significantly, Thomas does not exploit the ironic potential of the 'scholar-soldier' incongruity. See Frye, *Anatomy*, pp. 33–5, on the element of the marvellous in romance, contrasted to irony. On the 'feminine' man, see A. Easthope's discussion of the iconography of Christ, *What A Man's Gotta Do: the Masculine Myth in Popular Culture*, London, Paladin, 1986, pp. 23–5.

33 *Strand*, pp. 150, 42. Green, *Dreams*, suggests that chivalric romance furnished T. E. Lawrence with the 'energizing myth' of his own self-imagining (pp. 326–7); Jeffrey Meyers, *The Wounded Spirit: a Study of 'Seven Pillars of Wisdom'*, London, Martin Brian and O'Keefe, 1973, (chapter 7, pp. 114–29) sees a chivalric 'ideal self' as being a central component in Lawrence's personality.

34 *Strand*, p. 52. (But cf. p. 51 where he is described saluting Allenby!) See Leed, *No Man's Land*, pp. 55–6 on drill as an expression of 'the values of community inherent in the army'. Paradoxically, he uses Lawrence's post-war experience in the army and RAF as an exemplar of one who valued the military life for its structure: a measure of the distance between the 'biographical' T. E. Lawrence and Thomas's imaginary 'Lawrence of Arabia'.

35 E.g. 'The English lad just out of college', *Strand* p. 253. Two years are stripped from Lawrence's age on his entry to Damascus to make him 28 years old, p. 152. See Green, *Dreams* (pp. 82–3) on the close association between the idea of the 'young man' and adventures of 'empire, frontier, exploration'.

36 *Strand*, pp. 46–7.

37 *Strand*, p. 46.

38 On the military influence of T. E. Lawrence on the conduct of desert operations and partisan activity during the Second World War (which are the source of many of its heroic narratives), see Tabachnick, *Images*, p. 125.

39 Suleiman Mousa, *T. E. Lawrence: an Arab View*, Oxford, Oxford University Press, 1966.

40 Edward W. Said, *Orientalism*, London, Routledge, 1978, pp. 2–8, 41, 54–5, 73, 116–17, 201–11.

41 The disorienting 'strangeness' encountered by Western travellers, conquerors, and administrators in the Oriental landscape and the customary ways of its inhabitants, posed a 'threat to their composure and equanimity' to which Orientalist discourse was a response. Said, *Orientalism*, p. 87; pp. 93–5. Cf. Leed on the 'imaginative topography' of trench war, with its 'zones of danger' (p. 121).

42 *Strand*, p. 48.

43 *Strand*, p. 253.

44 *Strand*, p. 52.

45 Cf. Social Darwinist theories that the existant power of a conquering race is evidence of their 'fitness' to rule. Christine Bolt, *Victorian Attitudes to Race*, London, Routledge, 1971, chapter 1 esp. p. 21.

46 *Strand*, p. 144.

47 *Strand*, pp. 47–8.

48 *Strand*, pp. 52, 144–5, 150, 257.

49 *Strand*, pp. 44, 46, 49, 146.

50 *Strand*, p. 253; see too p. 53.

51 *Strand*, p. 142, my emphasis.

52 *Strand*, p. 145, my emphasis.

53 *Strand*, pp. 46, 48, 50–3, 143, 148.

54 I am drawing here on the concepts of 'good and bad objects', and theories of idealization, denigration and destructive fantasies developed in Kleinian psychoanalysis. In Kleinian terms, the contrasting qualities attributed by Thomas to Turks and Arabs represents a 'splitting' of the Islamic other into bad and good objects, or aspects: the enemies of the quest and its helpers, respectively. The phantasized destruction of the bad object may contribute to the idealization of the self as omnipotently powerful. Hanna Segal explains that 'an object of contempt is not an object worthy of guilt, and the contempt that is experienced in relation to such an object becomes a justification for further attacks on it'. *Introduction to the Work of Melanie Klein*, London, Hogarth Press, 1973, p. 84. See also the Introduction to Juliet Mitchell (ed.), *The Selected Melanie Klein*, Harmondsworth, Penguin, 1986; and Melanie Klein, 'Love, Guilt and Reparation', in M. Klein and J. Riviere, *Love, Hate and Reparation*, London, Hogarth Press and the Institute of Psychoanalysis, 1937, pp. 96–8.

55 *Strand*, pp. 141–2. Cf. Stewart, *T. E. Lawrence*, pp. 178–80, for analysis of the oscillations in Lawrence's letters home about 'train-bashing', which describe it variously in the 'schoolboy language' attributed to him by Thomas, and as a nerve-shattering nightmare: 'This killing and killing of Turks is horrible'.

56 *Strand*, p. 47.

57 *Strand*, p. 141.

58 *Strand*, pp. 253–4.

59 *Strand*, p. 260; p. 53.

60 *Strand*, p. 253.

61 *Strand*, p. 43; p. 258.

62 'I discovered that [he] knew as much about high explosives as he did about archaeology . . . [and that] he knew the Turkish system of transportation and patrols as well as the Turks did themselves' (p. 142). Thomas claims that Lawrence had blown up a total of seventy-nine trains and bridges in eighteen months.

63 *Strand*, p. 46; p. 147.

64 *Strand*, p. 142.

65 *Strand*, pp. 144–5.

66 *Strand*, pp. 148–9.

67 *Strand*, pp. 151–3.

68 *Strand*, p. 153.

69 *Strand*, p. 258.

70 *Strand*, pp. 144, 252, 255, 335.
71 *Strand*, pp. 330–4.
72 *Strand*, p. 332.
73 *Strand*, p. 260; pp. 142–3, p. 329.
74 *Strand*, p. 255, p. 259.
75 *Strand*, p. 253.
76 *Strand*, p. 53.
77 I am grateful to Tim Youngs for this insight.
78 *Strand*, p. 260.
79 *Strand*, p. 142.
80 *Strand*, p. 251.
81 'Through Lawrence's hands a stream of over a million dollars in gold poured into Arabia each month', *Strand*, p. 256. Thomas describes the Arabs' belief in Lawrence's 'untold wealth' as being crucial to his prestige with them (p. 161); while the help he received from the British Navy in the Red Sea 'was partly responsible for the impression which the King [Hussein] had of Great Britain's unlimited power' (pp. 144–5). See also p. 149.
82 *Strand*, p. 251.
83 See, for example, Captain Good in H. Rider Haggard's *King Solomon's Mines*, Harmondsworth, Penguin, 1958, pp. 15, 91–2; and the immaculately-attired chief accountant at the trading station in the African interior in Conrad, *Heart of Darkness*, pp. 25–6. Marlow, Conrad's narrator, is astonished by this 'miracle'; while Thomas states that it was 'always a mystery to me how he [Lawrence] kept so immaculate' in the desert.
84 Mitchell, *Klein*, p. 20.
85 Cf. Street, *The Savage*, p. 20, who identifies a 'reconciling [of] English superiority with romantic primitivism' in Rider Haggard's Sir Henry Curtis and Rice Burroughs's Tarzan.
86 Arab women are mentioned, fleetingly, on only four occasions: as victims of Turkish atrocities (p. 148), 'veiled beauties' (p. 259), jealous wives (p. 332) and villagers fleeing a Turkish attack (p. 337). In his book, Thomas devotes a short chapter to Arab women and gender relations, beginning thus: ' "Perhaps the reason why women played such a small part in the War . . .", explained Colonel Lawrence, "was because their men-folk wear the skirts and are prejudiced against petticoats". Then adding philosophically, "Perhaps that is one of the reasons why I am so fond of Arabia. So far as I know, it is the only country left where men rule!" ' *With Lawrence*, pp. 188–94. Curiously, he also includes an incident where Arab women are actively engaged in armed combat, and 'fought with as great valour as their husbands and brothers, and played a vital role in routing the Turks', pp. 184–5. On the 'subversive' link between women and military combat, see Dorothy Sheridan, 'Ambivalent Memories: Women and the 1939–45 War in Britain', *Oral History Journal*, vol. 18, no. 1, spring 1990, p. 38.
87 *Strand*, p. 52.
88 *Strand*, p. 50.
89 Thomas articulates this most clearly in the words he attributes to Auda abu Tayi, in the passage already referred to: 'This fair-haired son of Allah can do everything that we do even better than we do it ourselves. He has the

face and hair of a Circassian beauty, the physique of an onyx (Arabian ibex), the courage of Abu Bekr, and the wisdom of Omar'. *Strand*, p. 253.

90 See Wilson, *Lawrence of Arabia*, p. 1107, on the 'who got there first' controversy. Stewart, *T. E. Lawrence*, p. 205, suggests that Lawrence drove into the city (on 1 October) in a car accompanied by another British officer, to find that 'the streets were already crammed with shouting, laughing crowds, exuberant round Arab warriors on horses and camels . . . Damascus had been freed, without fighting, around noon on 30 September (by an independent Arab force). This peaceful transition to Arab rule was the result of an accommodation between departing Turks and resident Arabs.' Lawrence, *Seven Pillars*, pp. 664–9, confirms the peaceful-entry-and-crowded-streets scenario, but Tabachnick, *Images*, p. 72, quotes another of his accounts, in which '[my] memory of the entry into Damascus was of a quietness and emptiness of street, and of myself crying like a baby'. Thomas's claim that, after Damascus, Lawrence was involved in the capture of Beirut and Aleppo (see above, p. 132) was untrue, and was not included in *With Lawrence*. Thomas's narrative, in both article and book form, abounds with factual inaccuracies, important omissions and controversial claims, which over thirty subsequent biographers have assessed and challenged. Tabachnick, *Images*, provides the best short introduction to these competing versions, and an evaluation of the evidence they muster.

91 Thomas strengthens this effect by writing himself into the story as its rather bluff, matter-of-fact first-person narrator, who authenticates the truth of the story by evoking in order to deny its improbable and fictional quality: 'a story that I should have hesitated to believe had I not actually been with him in the desert', *Strand*, p. 48. See also pp. 42–3.

92 *Strand*, p. 42.

93 Bernard Porter, *The Lion's Share: a Short History of British Imperialism 1859–1970*, London, Longman, 1975, pp. 324–6.

7

KNOWING YOUR PLACE

The tensions of manliness in boys' story papers, 1918–39[1]

Kelly Boyd

Between the two world wars, the ideals of manliness in boys' story papers changed. In society, manliness was an ideology almost invisible to the naked eye, and few men considered their own gender to be problematic. In contrast, in boys' story papers the ideal of manliness was constantly stressed. As the standard reading matter for male youths beyond the age of ten, they presented an opportunity for socializing British youth in subjects from imperialism to racism to sexism. The story papers are therefore an important source for exploring contemporary definitions of manliness.

As this book makes clear, masculinity is always in flux. In the Victorian period, story papers teemed with aristocratic boy heroes who held sway by virtue of their arrogance or superior class position, while selfish impulses dictated their actions. By the first two decades of the twentieth century, aristocratic heroes still appeared, but members of the lower-middle and artisan classes also became protagonists and a tension had developed between individual endeavours and community requirements. In the inter-war years, the democratization of the hero was complete: aristocrats almost disappeared and leading characters were usually ordinary boys learning to fit into a society over which they had little control.

Victorian heroes had travelled the world in an effort to prove their masculinity, but inter-war adventures tended to be set in the more familiar surroundings of school and playing field. Once depicted as dimwitted or shifty-eyed, working-class characters came to be imbued with more of the attributes associated with manly behaviour: bravery, leadership and nobility. At the same time, the heroes of these stories forfeited much of their independence of action. Inter-war heroes had to learn to be obedient, to compromise and to submit to the greater knowledge of their elders and their community.

Working-class boys in the literature of the inter-war years in-
creasingly abdicated authority over their lives, forbidden the freedom
of the streets by the requirements of the classroom and the demands of
employers. Independence of action was supplanted by the knowledge of
when to follow the advice of elders, whether teachers or parents. At
the same time, while earlier heroes had often relied on cleverness to
resolve problems, narratives increasingly focused on displays of brute
strength. From classroom to imperial outpost, heroes relied more on
physical power than quick thinking to outwit their enemies. While
manliness in the past had been linked to an ability to master any
situation by a combination of bodily strength and native wit, the heroes
of these adventures were much more willing to dominate any foe
physically. There was more fighting, bleeding and brutality in the
pages of the inter-war story papers than ever before. Furthermore, the
growing emphasis on obedience to parents, teachers and employers as a
signifier of manliness meant that for the first time adult characters
inhabited sizeable roles as story heroes. Schoolmasters like 'the Big
Stiff' and aviators like Biggles caught the imagination of readers,
offering varied models of behaviour.[2] This chapter will explore the
way this emphasis on violence and submission to one's elders' better
judgement was conveyed in boys' reading.

I

Boys' story papers were a widely popular form of entertainment read
by boys, or more accurately, youths from the age of ten. Pre-
dominantly serial stories, they were not overtly didactic, but part of
boys' fantasy life. It is possible to extract from them much of the
dominant ideology of the period. In *Adventure, Mystery and Romance*,
John Cawelti argues that formula literature fulfils psychological needs
of readers yearning to escape from the boredom and routine of
industrial society.[3] For him, formula literature is revealing as a
collective cultural product which successfully articulates a pattern of
fantasy. Cawelti sees in formula literature a dialectical relationship
which first affirms existing interests and attitudes by presenting an
imaginary world aligned with these interests. Second, it resolves
tensions and ambiguities resulting from conflicting interests of differ-
ent groups within a culture. Third, formula literature permits the
exploration of the boundary between the permitted and the forbidden
in a safe context. Finally, Cawelti conceives formula literature as
helping to assimilate changes in values to traditional imaginative
constructs. Although his own work deals with more 'adult' genres, such

as spy stories, crime fiction and the western, Cawelti's analysis can also apply to the tales included in boys' story papers. They were rife with formulaic stories sometimes set in schools, often peopled with detectives and later with science fiction characters. They illustrate conventional ideas of manliness by dramatizing the dilemmas by which men are forged in the non-threatening arena of fiction, while at the same time offering new ways of imagining these problems.

Cawelti explores several types of moral fantasies, that is, tales which are set within a material reality, in which 'the characters and the situations they confront are still governed by the general truths of human experience'.[4] This is the dominant mode of the fiction of boys' story papers; even in the inter-war years, when science fiction began to appear, the characters were governed by certain moral verities, and the extraordinary was often made conventional. One type of moral fantasy, the adventure story, was the dominant type of boys' fiction. Although Cawelti recognizes a wide range of plot types, the essence of the adventure story is its exploration of the character of the hero. What is sought is how he will respond to the tasks at hand. While romance stories focus on how women deal with the world around them, the adventure story offers the reader an observation post from which the struggles of men can be observed. Manliness is one of the central goals of character-formation, and the boys' story paper offered readers a place to see this in the making.[5]

While Victorian heroes were constantly exhorted to be 'manly',[6] the participants in inter-war stories framed their discourse in another way. This is not to say that gender was considered unproblematic during these years, nor does it indicate that certain ideals for boys cannot be teased from these texts. But it indicates a reluctance to confront the complexities of modern gender ideology, and a preference for focusing on questions of the individual's role in society. Within this wider concern, manliness is defined.[7]

The urge to avoid the problem of gender is most startlingly revealed in the pages of a new publisher to the scene, D. C. Thomson (who virtually banished women from the pages of its boys' magazines), but it is also clear in the papers of the Amalgamated Press, whose firm grip on the market at the turn of the century had slipped and who soon found itself imitating the form and content of its competitor. D. C. Thomson was a family firm located in Dundee whose original interests had been in shipbuilding. They entered the publishing business almost by default, after acquiring several newspapers which, in 1905, they finally decided to consolidate. From the beginning they aimed at

reaching a mass market, and in 1921 they entered the field of boys' story papers with *Adventure*, a weekly which combined the format pioneered by the Amalgamated Press with an enthusiasm for rough-edged heroes. In the next few years it was joined by *The Rover, The Wizard* (both 1922), *The Vanguard* (1923), *The Skipper* (1930), and *The Hotspur* (1933); most would last well into the 1970s. These, excluding *The Vanguard*, were collectively known as the Big Five. The Amalgamated Press had been founded by Alfred Harmsworth (later Lord Northcliffe) in the 1890s. One of its great successes was in the field of boys' story papers and it dominated this market from the publication of *The Marvel* (1893) and the *Union Jack* (1894). In the next half century it offered several dozen titles which dominated the market until the emergence of the Thomson papers in the 1920s. Perhaps its best-known titles were *The Gem* and *The Magnet* which featured the school stories of Frank Richards (the pen name of Charles Hamilton).

Occasional readership allowed a wide variety of magazines to continue, but the Thomson papers managed to captivate most boys' imaginations. Circulation figures for the Thomson papers have never been made public, but one estimation of the *Wizard*'s pre-war sales placed the weekly figure at 800,000. In contrast, the Amalgamated Press papers experienced falling numbers of readers, the *Magnet*'s popularity falling from 200,000 purchasers each week in the 1920s to around 40,000 by 1939.[8] Tastes had changed, as one former reader noted many years later: 'The *Magnet* was considered highbrow and even today I regard it as an adult paper. The Wharton Rebel series, for example, was too involved for young boys. The Thomson papers were for boys . . . They were what boys wanted and not what adults thought they ought to have.'[9] Before 1914, working-class boys in Salford rushed to meet the latest shipment of *Magnets* at the railway station.[10] After the war their imaginations were fired by Thomson's outlandish tales. The Wharton rebel series in the *Magnet* explored the struggle of Harry Wharton to control his temper and fit into a new school. Many memoirs mentioned similar tales as extremely helpful to their authors' efforts to understand and deal with the world of school (both residential and day, private and state).[11] In the inter-war years these tales were perceived as too difficult to understand by the same types of boys whose fathers would have experienced no difficulties with them. The mass market readership had shifted to a different style of magazine which packed a very different punch.

Of course, the reasons boys were attracted to papers extended beyond the pleasures of the text. Both Thomson and the Amalgamated

Press vigorously practised new marketing techniques. For example, Thomson's *Rover* pioneered the buying of sports stars' names to place on stories.[12] Giveaways had been on the scene since the earliest days of periodicals, but earlier offers of free ponies or paid emigration to Canada were not duplicated in the inter-war years. Instead publishers offered code rings and whistles, football pictures and albums. As Paul West recalled when he weighed up the attractions of different papers many years later in his autobiography:

> The *Boy's Own Paper* never gave you free gifts . . . Photographs of the boys who read it appeared inside and all those boys looked well-to-do, with fathers who administered colonies. Now and then a father wrote in to compliment the paper on its decency and straightforward Britishness, which I suppose were the very things that made the paper boring to us. It was a monthly, too, whereas you got a *Wizard* every week, and sometimes such free gifts as a potato-gun, an evil mask, an album of footballers and a matchstick gun. It was a fetish with us to collect free gifts . . . I used to go in with my blanket question: 'Please have you any comics with free gifts in them?' Usually there was one at least.[13]

West was very aware of the differences in the papers he could buy, and astutely detected a marked difference in the class of the readers papers were meant for. As the son of a skilled worker in Derbyshire, he had little interest in looking at photographs of his richer peers.[14] Instead he avidly consumed the Thomson papers, buying *Wizard* and *Hotspur* each week, then trading them with friends. To him even the *Champion*, the most successful boys' magazine issued by the Amalgamated Press in these years, seemed 'too genteel, too decent'.[15]

If boys read 'bloods' (the derisory term of the era) in great numbers, it was often only after a struggle with their parents, and could offer an early battlefield for parent/child conflict. As in earlier decades the story papers were considered unsuitable reading by many parents. One reader later recalled:

> In those days, too, before children's comics became pre-dominantly picture strips, there was plenty of solid reading matter to be found in the *Wizard, Hotspur, Skipper, Rover* and *Adventure*. Oddly enough, considering the other things they let me read, my parents regarded these as 'trash' and never allowed me to buy them. Even more oddly, once I smuggled them into the house after swapping marbles or conkers for them, I was allowed to read them if I kept them decently out of sight. In this

KELLY BOYD

surreptitious manner I read my way through vast quantities of them.[16]

This was a typical pattern, although sometimes parents would become converted to the papers and buy them for their children or sometimes admit to enjoying the tales themselves.[17]

II

Unlike those of earlier eras, the stories offered in the 1920s and 1930s had a significant relation to the realities of boys' lives. In the inter-war years their existence was increasingly dominated by the educational system, by efforts to construct a rational system of time spent outside school or work, by changes in the way the legal system treated young delinquents, and by the shrinking opportunities for long-term employment in an economy affected by world depression. These factors are only beginning to engage the attention of social historians who have combined the traditional skills of institutional investigation with new techniques of oral history to sketch a portrait of boyhood in the years between 1918 and 1939.[18] Many of these changes are reflected in the pages of the story papers that dominated the era.

During the years that followed the Great War, the period of adolescence continued to lengthen. In the Victorian era, young children could expect to complete their schooling early and generally worked as they learned. By the 1920s and the passage of several education acts and the Children and Young Persons Act of 1924, youths could expect to attend school up until age 14. Once they had reached the age of work, they would be less independent than earlier generations had been. There were fewer apprenticeships available and at higher cost. If they did work, their opportunities for continued employment looked bleak in the 1920s. Their free hours would be occupied by cinema-going, sport, and consumption of mass market literature, until they began to court.

School had always been a popular setting for boy's stories since the publication of Thomas Hughes's *Tom Brown's Schooldays* (1857). During the Victorian period many tales were set in posh public schools like the thinly disguised Eton of 'Jack Harkaway's Schooldays' in *Boys of England* (1871). These tales featured aristocratic boys who demonstrated their manliness through their arrogant superiority to members of lesser social standing and their contempt for schoolmasters. The Edwardian school was typified in the creations of Frank Richards, especially Greyfriars. Besides the memorable comic character, Billy Bunter, the

tale revolved around a gallery of boys from many backgrounds. Most were solid members of the upper middle class like Harry Wharton, but a broad selection of characters confronted the strains of manly behaviour. School remained a popular setting for stories as boys' lives were increasingly dominated by it in the inter-war years. The characters in these tales were clearly meant to represent the readers and an examination of this subgenre reveals some of the configurations of manliness during the inter-war years. Although the school stories of Frank Richards continued to sell throughout the era, they were, as Orwell noted, firmly situated in a pre-war idea of the boys' public boarding school; these were the school stories whose popularity one survey suggested was waning.[19]

In the Thomson papers public schools vied with state schools for the attention of readers. The most famous of the former was the Red Circle school in *The Hotspur* which differed from its predecessors in several ways. The Red Circle's most striking feature was its changing cast of characters, instead of one group who dominated its pages year after year. Rather than letting readers focus on one or two heroes to the exclusion of all others, the school itself was the star. Boys moved up to higher forms and finally left the school; they were replaced by new boys and younger brothers. Activities revolved around three houses, each with a geographical focus, allowing readers around the world to have a foothold in the school.[20] But most noticeable is the lack of pretension on the part of the creators. Few aristocrats attended this school, and its denizens were more interested in scrapping than in good deeds. Violence was omnipresent. Boys were often depicted beating each other up, flogging one another or being flogged by the masters. There was a punishment room into which malefactors were locked (like solitary confinement). Scores were settled by lying in wait and jumping someone. This most frequently happened when a new boy refused to bow to the predetermined hierarchy of the school. Sometimes he was a bully, like Spike Moran, a newly-arrived American and son of world boxing champion 'Killer' Moran. Spike is arrogant and abrasive, bullies young boys (demanding a fag, a privilege reserved for sixth formers) and wears a plaid suit instead of the school uniform. The cure for his presumptuousness, orchestrated by popular master 'Dixie' Dale, is to have another boy, Canadian Joe Rawlinson, jump him and physically teach him his place. The passage below is typical in its blend of violence and arrogance.

The bully frowned at the sight of his old adversary. [He and

Rawlinson had scrapped before.] He was still smarting from Dixie's cane and glad of the chance to vent his feelings on somebody. He let drive.

There was nobody to see the fight that followed. All the chaps were in their studies. It was going to be a fight to the death.

The bully was staggered by that first attack. Joe seemed to be here, there and everywhere. He pounded in blows from all angles and Moran rocked.

Then, trying one of his tricks, the American caught Joe in the stomach. Gasping with pain the other went down. Everything seemed to swim around him. . . .

Up the Canadian came again and went for the bully. For the first time Moran began to retreat. He got as far as the wall near the gates, and then set to work, with every dirty trick he knew, to get Joe down.

Twice his opponent dropped and came up again. Joe wasn't going to give in. . . .

So, half-fainting, hardly knowing what he was doing. Joe drove in blow after blow. The bully was gasping and groaning and was hitting wildly at the air.

Joe's first caught him on the chin. As he staggered back another punch followed. It was squarely between the eyes and the Terror of Yank House dropped like a stone.

He lay there blubbering while Joe stood over him. Like all bullies Moran was a coward when he had met his match.

'Get up!' Joe panted. 'I haven't finished!'

Moran did get up, picking up a big brick as he did so. He received a hook to the jaw that knocked him out clean as a whistle.[21]

Several things are noticeable from this scene. First, violent scenes were common in much of the fiction, with little lip service paid to the ideals of fair play which were expounded by Frank Richards in the Greyfriars stories. The Marquess of Queensberry rules were broadly interpreted in the inter-war tales. Second, in earlier stories the boxing ring would have been important as a public venue for enforcing community norms on the offender; here one boy lays in wait for the other. This repudiates the use of formal combat as a means of restressing the boundaries of community. Finally, earlier stories would not have dared let a master become involved in the efforts to discipline one boy in the ways of the school. Here Dixie Dale orchestrates the American boy's socialization

at the hands of another North American. This is another illustration of the way adult characters had become the moral arbiters in story papers.

More numerous than the boarding school stories are those set in local state schools. With the establishment of 'senior' schools and a higher school-leaving age, these became more popular as the venue for action and more feasible as a focus for boys' adventures. One popular series, 'The Big Stiff', was set in the Old School in Pendlebury village and retailed the methods new teacher Septimus Green employed to interest his pupils in their schoolwork.[22] His initial action of destroying the cane and banishing physical punishment in favour of making school more interesting for the boys is typical of these tales. The stories validated a vision of education that students had repeatedly argued for in school strikes since the turn of the century.[23] Rather than threatening the lads with corporal punishment or humiliation, Green, or as the boys called him, 'the Big Stiff', and his fellows in other serials, taught by appealing to boys on their own level. The dazzling schoolmaster was a common feature of these stories, which often took place in local schools far away from Britain without changing the actions of the characters at all. Thus 'Thick-Ear Donovan' was the schoolmaster who tamed the western town of Poison Valley, and 'Mississippi Mike, M.A.' helped introduce education to Louisiana in exchange for not being hanged.[24]

Unlike Victorian school stories, where schoolmasters functioned only as the butt of schoolboy derision, or as bullies to be rebelled against, in the D. C. Thomson papers they served as models for their pupils and by extension for readers.[25] Even though they might be situated in outlandish plots, they functioned as exemplars within the stories. At once it is notable that there was no obsession with proving their manliness or masculinity on the part of any of these characters. For the most part they remained at ease with their place in the world, certain of their ideas, and did not deign to discourse on manliness. By their actions they revealed more concern with instituting better methods of teaching and of rescuing their pupils from evil parents and oppressive institutions. For example, the 'Big Stiff' battled a student's convict father and the Poor Law authorities to ameliorate his pupil Tommy Mulligan's existence.[26] Tommy's father wanted him to leave school to become a burglar, while the Poor Law Authorities bureaucratically insisted Tommy be placed in the workhouse for his own protection. In his successful effort to help Tommy, the Big Stiff exhibited a prime feature of traditional manliness: the strength of character to pursue a goal although it may be unpopular and even though unorthodox methods may be required to achieve it.

Some school texts dealt more directly with the socialization of boys. *The Pilot* ran two series of particular interest in delineating the ideology of manliness and character during the inter-war period. The tales dealt with the problems of assimilating two very different boys to English society and exhibited some of the differences and similarities expected of boys of different classes.

'The Schoolboy Cannibal Earl' initially appeared in the first fifteen issues of *The Pilot* in 1935, and in a slightly abridged version in the *Boys' Friend Threepenny Library* a year later. It owed a great debt to Edgar Rice Burroughs's Tarzan books, but reshaped them for a young audience by centring the action on a boy brought up in the wilds of Africa by his mother and a tribe of cannibals.[27] The tension was created by opposing his early training as an M'Bela tribesman to the requirements imposed on him after his recovery from Africa and return to England, to a society where he is a nobleman.

'The Schoolboy Cannibal Earl' was one of the most informative of all the stories examined in terms of its clear depiction of proper behaviour for a British boy. Although couched in slapstick comedy, it delineated the culture of masculinity together with an emphasis on ancestry and birth.

The plot is simple. As a babe, Jack Scotton is taken by his parents into darkest Africa where his father, heir to the Earldom of Claremont, hopes to find gold and recoup the family fortune. Instead, he is eaten by cannibals who then allow his widow to live with them and raise her son. By his tenth birthday Jack is to be made a proper warrior-in-training and his mother decides to kill him and herself, rather than see her son become a cannibal warrior. Before this can happen, the witch doctor has her poisoned and Jack goes to live with the other boys of the village. By the time he is 16, he is a chief of the warriors and leads his fellows into battle against the very group sent to find him and tell him his grandfather is dead and he is now earl. They return him to England and enrol him in a public school, where it is hoped he will be assimilated. As is typical in these tales there is a disappointed heir who plots against Jack but is eventually foiled.

If Jack is to be transformed into a suitable boy, the tale requires other examples of behaviour for him both to emulate and to react against. The former are represented by his tutor and his lawyer, while the latter takes the form of disappointed heirs and relatives. Jack's great-uncle, Augustus Scotton and his son Leo, are examples of the decadent meanness of unsound men. They are cowards who pay others to do their killing (or kidnapping). On the other hand, Mr Dane, Jack's tutor,

is an example of muscular Christianity. As games master he tries to 'civilize' Jack through sports and behavioural examples drawn in comparison to native life. Jack's solicitor Mr Wilson, is an exemplar of reason who weighs right and wrong and shuns a dogmatic approach to the boy.

During the story the reader sees Jack transformed from 'proper savage' to 'proper gentleman', as he learns the ways of interpreting English behaviour while drawing analogies to jungle life. For example, his ideas of self-defence lead him to strike his housemaster the first time he is caned, until the analogy of headman is explained to him. Told it is right to defend the weak, he at first attacks a constable carting off a diminutive malefactor. Set upon by an assassin sent by his cousin, he is uncertain whether or not to fight back until reassured by his companions that this time it is necessary.

Jack must learn to make choices and he often reasons badly. But by the tale's end his own good breeding and Mr Dane's coaching have taught him about British civilization and how to behave within its constraints. Jack's manliness is never under suspicion here. With his education at the hands of primitive savages there is no worry that he will be soft. The M'Bela themselves removed him at an early age from the exclusive care of his mother, who despaired of him living a decent civilized life. This may be seen as analogous to the practice of upper- and upper-middle-class families of relegating boys to preparatory and public schools where they lived mainly in the society of other boys. In fact, Jack notes this himself when he is told that a school is

'a place where you will be taught all there is to know about life and the world generally You'll find a large number of boys and youths there being trained for their future positions in life'.

'Like the totem-house where old Munga initiated us into the tribal secrets, I suppose?' said Jack. 'Is there a witch-doctor in charge of the place?'

'The headmaster! Yes – well, I suppose you could liken him to a witch-doctor', said Wilson, with a laugh.[28]

The fact that civilized society replicated primitive society was a way of affirming that modern society was not so effete as once feared. The variation between the behaviour taught to Jack in his two different 'schools' was more one of degree than of absolute difference. He had to learn to apply the lessons he learned with the other boys in the kraal to life in modern England: his instincts were basically correct, but the rapidity with which he assessed a situation and dealt with it were not

proper for modern life. As Mr Wilson goes on to argue, there are some things that are taboo. Mr Wilson entreats him to 'picture your masters . . . as witch-doctors who are trying to turn you into a thoroughly educated and initiated young warrior. If you accept any taboo they place on certain places and things you will later on understand just why such taboos were made.'[29] Jack is forced to steer his energies and ideas into more conventional channels like boxing or running.

Jack Scotton is presented as a grand manly example who despises weakness and values strength over other attributes. His physical power alone exempts him from fears of effeminacy. Clearly he can physically dominate the other boys, as well as several of the masters, and his willingness to use skills such as tracking prey stands him in good stead with his contemporaries.

Another serial from *The Pilot* in 1935 was 'The Worst Boy at Borsted', about the efforts of young Jim Templeman to get out of borstal, where he had been sent for four years for killing a man.[30] Declaring he is innocent, he causes trouble from the start. Unbeknown to him, the borstal governor's secretary, Laring, has framed him to get the inheritance Jim is unaware he is to receive and plots his death. But after this plot is foiled Jim is not permitted to leave Borsted, both for lack of evidence and because he is a discipline problem. He is only set free later when his Australian solicitor appears.

This tale is typical of the inter-war years in the toughness of its characters, but reveals how uncertain the editors were about what would please readers. Jim Templeman has clearly been wronged and he has been framed, but his kicking against the system does not stem from that alone. He has a long record of what today would be called 'an attitude problem'. He is sullen, arrogant, violent, rude, and paranoid by turn.[31] At the story's beginning it is established that he has been expelled from schools for such behaviour and he begins his time in Borsted by acting up. The story is also, to some extent, an indictment of the methods used by the prison governor and warders to deal with problem boys. Their automatic response is to beat discipline into the lads. Much in the way of the 'schoolboy cannibal earl', Jim seeks to retaliate physically. But where Jack Scotton quickly proceeded to the use of reason to deal with his strange new world, Jim continues to rely on brute force. In some ways the tale is contradictory: one minute it indicts the system which creates a monolithic establishment seeking to impose discipline and self-control above all else (even justice); the next minute it indicates that these values are to be prized above other traits and that boys who will not conform merit incarceration.

Although Jim is innocent of murder, he remains a disruptive force in an adult world. For boys reading this, many tied down to dull classrooms or menial jobs, some with acquaintances or relatives sent to borstal, Jim's relentless fight against authority, destructive or divine, must have given them pause. The story validated rebellion and offered a release to its readers.

Despite its criticism of the borstal system, these school stories worked together to argue that to be a part of modern society one must yield to certain of its dictates. As Jack and Jim are remoulded, each is taught to reject his belief that he can shape society to his own way of thinking. They do this by maintaining a masculine posture which combines physical power and dominance over inferiors (the working class, the truly guilty) with a recognition that they need the guidance of certain adults, usually their teachers or perhaps their guardians. Jack is encouraged to fight with opponents, but within the safe bounds of the boxing ring rather than by ambushing them. He is also taught to fight by certain rules (timed fights, the use of gloves) rather than the sort of knock-down, drag-out, biting and scratching to which he is used.[32] Jim's plight is more problematic. He, again, is a discipline problem. The decision to keep him imprisoned for his refusal to submit to the definitions of society is not so much questioned in the story as are the methods used by adults better to socialize him. He is both admired for his tenacity in the face of pressure and castigated for his inability to fit into society. Standing up for yourself is a central tenet of manliness, but in the inter-war years so was responsibility to a larger community. Jim must be tamed, but not at the expense of his physical ebullience or his tenacity. While institutionalized, he will be recast and his rough edges filed away. The function of such a story is to defend the existing social order. This had to be done without sacrificing completely such things as male aggression, or the ability to assess situations quickly, but it had to be channelled into socially acceptable forms. Both Jack and Jim found their energies rechannelled rather than transformed.

III

School stories are the most obvious starting point for the definition of manliness in this period, but they were not the most popular genre of stories at the time. Two surveys noted that boys much preferred adventure stories.[33] The tales discussed above successfully combined both, but many more focused on boys who had already left school and were seeking their fortunes in the larger world. Publishers echoed

boys' admiration of adventure stories. One editor quoted a famous explorer as arguing:

> I do not believe there is one healthy, full-blooded boy or man in this country whose heart does not thrill at the thought of adventures, or who does not live for the day when he will get the opportunity to bring off some daring deeds. If there's a spice of danger, all the better. Adventure is the breath of life![34]

The editor could not help offering his own endorsement of this thought, while promising that his paper's pages would fulfil all these desires.

Unlike in the adventure tales of the Victorian era, heroes were not cast away on a desert isle. Adventures were increasingly situated within Britain rather than overseas and they tended to revolve around some sporting talent of the hero. This could vary between dare-devil motorcycle racing and prowess on the links. Foreign adventure tended to turn on the pursuit of wealth, sometimes through the employment of natural talents (sports again), but often through the exploitation of stupid natives. Both types of adventure endorsed success and fame as worthy goals for boys to pursue.

The sporting tale had been a feature in earlier periods, but with the marked difference that the aspiration to successful sportsmanship was generally portrayed as more important than crass commercialism.[35] For example, Geoffrey Gordon's 'The Factory Batsman' (1915), published in the transitional period before the inter-war years, rehearsed a fairly familiar plot.[36] It is worth examining in some detail in order to contrast it with the attitudes expressed just a few years later. The hero, Bob Wakefield, is an accomplished sportsman owing to his rigorous training at a fine public school, but at 18, his father, self-made steel tycoon Sir Robert Wakefield, plans for him to learn the family business from the ground up. When Bob is asked to play cricket for the county, his father forbids him and threatens to disown him if he plays. Bob represents the purity of sport, especially in his desire to continue his career as a cricketer. Sir Robert is portrayed as a mean-spirited man, selfishly privileging his own business over the needs of the community, especially its need for the sporting skills of Bob. Bob wishes to combine his cricket-playing with work, but Sir Robert sees business as an all-or-nothing proposition, and refuses to support his son so he can remain a gentleman player. Bob, of course, wins this struggle, and the story serves to indict crude commercial needs when they conflict with athleticism and gentlemanly behaviour. The younger Wakefield turns

professional, but in his spare time manages to foil the evil manager's attempt to disinherit him and kill his father.[37] Bob is an exemplar, who never stoops to underhand deeds or rejects his father, even under duress. Instead, he attempts to reconcile his parent to a higher need, that of society, and urges him to reject his obsession with business.[38] As an exemplar he reflects the tensions of the Edwardian years, when obedience to parents formed a central ideal of the ideology of manliness. But he also is reminiscent of the arrogant heroes of the Victorian era, when adult characters generally seemed to belong to some degenerate class of society. Bob's refusal to be led by his father confirms his masculinity.

It is instructive to compare a similar tale of the inter-war period, 'Peter Sticks It'.[39] Here the cult of games gains the upper hand from the beginning. Peter Nicholls, scion of a shipping family, displeases his father by earning poor marks at nautical college; instead he spends his time excelling at games (golf, rugby, swimming and boxing). Angry at his father's disapproval, he storms out to find a berth as a common sailor, but his father secretly arranges for him to be hired on the S.S. Tampico, bound for Vera Cruz with a cargo of steel rods. Peter reveals his natural leadership abilities in the course of the voyage, utilizing each of his sporting skills to make the trip profitable.

It is easy to see where the skills developed by boxing, swimming and rugby might come in handy, but it is the use of golf which is most telling here. After reaching port the captain discovers a civil war has erupted and his promised return cargo of frozen beef has gone to the army. He hears that a cargo of arms is being sent to the port of Tampico, but is unable to square the deal. Peter discovers the shipper is an avid golfer so he borrows the captain's clubs and challenges the shipper to a match. If Peter wins, the Tampico gets the cargo at Steele's asking price, if he loses they take the cargo at the competitor's price. Either way the Tampico gets the business, but Peter narrowly wins so the higher price prevails. Here Peter is combining capitalism with sport in a way increasingly to be used by businessmen in the twentieth century. More deals are made in these informal settings than in offices, and at the voyage's end, Peter's father admits the utility of sporting skills as Peter returns to college to sharpen these (and his academic skills) before taking his proper place in the company.[40]

This is quite a contrast to the story of 'The Factory Batsman'. In the earlier tale, Sir Robert Wakefield had been portrayed as a mean-spirited old man, unwilling to see the merits of sport, and unreasonably insistent that his son must choose business over sport completely, while

Mr Nicholls is upset because Peter has failed to balance learning and sport. When his son ships out, this is presented as a manly choice to make and Nicholls facilitates his son's struggle to prove himself, yet leaves him the room to fail or succeed on his own. While cricket for Bob remains a sport mainly to be pursued for pleasure, with no relation to business, the use of golf in the latter story exposed the infiltration of the playing field on to the battlefield of business. The manly ideal of the sportsman playing the game had been adapted by businessmen to facilitate deals and prove trustworthiness. The hero, too, had changed. In 1915, Bob Wakefield revealed few doubts about the course he should take and happily ignored his father's wishes. By the tale's end his actions were completely vindicated and a reunion was in order. But this was at the expense of Sir Robert admitting he had been completely wrong about Bob's decision to continue to play cricket for the county. Seven years later Peter Nicholls is portrayed as being headstrong in his rejection of his father's wishes: his father approves of his decision to try to strike out on his own, feeling it will offer Peter a chance to experience the vagaries of the world. Although he arranges for Peter's berth on the S.S. Tampico, after that he leaves the lad to prove himself. When Peter uses all his sporting skills to the shipping firm's advantage. Mr Nicholls feels no trepidation about admitting he had under-estimated their usefulness. But at the same time, Peter must compromise too. He admits that the academic courses at the nautical college are as useful as the skills developed in sport, and he agrees to return to college to perfect them. Although the Edwardian period might have incorporated concern for parental notions, there was still room for challenging a father's wrong-headed ideas. In the Edwardian years adults were still depicted as weak, and the greatest strength always lay in the young. By the inter-war years, Peter is shown that his father is not all wrong, and is led to concede his greater discernment about some matters. He proves himself on the brink of adulthood by his insistence on going to sea as an ordinary sailor, and his wish to prove himself with no special favours. Unlike Bob, Peter has no moral superiority over his father. He merely demonstrates the usefulness of non-academic skills in the business world. Manliness, then, is represented in this period partly as the willingness to test the boundaries of parental opinions, and partly as the ability to concede that one's elders may occasionally have the right idea. In other words, one should test one's beliefs, but recognize other people's competence.

IV

The ideals of manliness which inter-war publishers offered to readers served conflicting purposes. On the one hand, they confirmed a conception of behaviour held by the creators of these periodicals. There was the further enshrinement of self-discipline and obedience to parents, teachers and employers as an admirable trait. Stories like those featuring the Big Stiff presented adults as friendly, shepherding characters who could help a boy on his way to becoming a decent man. But other conceptions are present as well. In 'The Worst Boy in Borsted' a continuing theme is the need to tame the hero and eradicate his defiance of societal needs. For this reason he is prevented leaving 'Borsted' when he is proved innocent. At the same time, his other qualities of leadership and courage in the face of great odds are elevated and praised by the other boys in the story. These two sets of characteristics may seem to be at odds, but on closer examination one can be harnessed for use by the other. Leadership and courage were praiseworthy when they led back to an acceptance of society as it was constituted and are not implemented for a critique of the social system. As long as Jim Templeman is struggling against evil figures who are trying to subvert the greater purposes of society, his actions are presented in a favourable light. But the moment he is set against benign figures who just wish to help him adapt better to the world, he is once more criticized. Characters like Jack Scotton (the Schoolboy Cannibal Earl) and Jim Templeman are easily recognizable as figures who test the limits of society. Scotton's exposure to another culture (the cannibal culture of the M'Bela in Africa) means he must readjust from a society which advocates physical combat as a means of setting boundaries to one which has a strict, albeit more hidden, structure. Templeman experiences the strictures of a borstal education whose chief purpose seems to be to eradicate any individuality. By the end of his story he has learned to work with others and has been refabricated for a new society.

Additionally these stories reinforced in the boys' minds who the proper guides to manliness and adulthood were – teachers and parents. The Big Stiff mediated the learning process very directly as he devised new ways of engaging his pupils in their schoolwork and the world around them. Fathers like Mr Nicholls, in 'Peter Sticks It', worked behind the scenes to allow sons the space to prove themselves. If they advanced an argument, their sons eventually accepted it, generally after a spell in the 'real world' which made them recognize the merit of

their parents' point of view. Even Jack Scotton, the Schoolboy Cannibal Earl, was not left wild to grow up independently. He was carefully trained first in the totem-house by the witch doctor, then by the masters in his school. A Victorian hero would have emerged perfect with little interference from structured training.

The literature of the inter-war years posited manliness as a process arrived at through education, and suggested the class-based nature of what was expected of the manly boy. Although aristocratic characters like the schoolboy cannibal earl appeared occasionally, most of the heroes came from humbler backgrounds. For all boys there was an emphasis on obedience to elders, but this was especially emphasized by stories set in local state schools. The Big Stiff's pupils were recalcitrant, surly, street urchins until he appeared to reform them into biddable boys. If Jim Templeman was heir to a fortune in Australia and, therefore deserved to be considered a leader of boys, the other inmates at the borstal were portrayed as light-fingered, shifty-eyed examples of the criminal classes. They were accorded respect only when they submitted to Jim's leadership and learned not to subvert the system. Where Jim, as a virtuous, wronged figure, was sympathetically treated for stealing a warder's dinner, when his pal Fatty revealed this to be a common strategy among the inmates, Jim is disgusted. His motives were not theirs.

Although the tales did not discourse directly about the nature of manliness, they presented a clear vision of how boys ought to act. Owing to the largely working-class nature of the audience, these patterns conformed more closely to the way the publishers wished to construct working-class manliness than to the paradigm the youths might have erected for themselves. Perhaps the move to represent the class nature of manliness emanated from a world where class distinctions seemed to be under threat in the wake of the Great War. Publishers were witnessing a world-wide economic crisis, labour unrest culminating in the general strike of 1926, the enfranchisement of the entire adult population and by the late 1930s the likelihood of another war. All of these combined to make the structure of society seem less secure than ever before. The large population movements occasioned by the Great War and the reconstruction of industrial society combined to challenge the mythic placidity of English society.[41] Indeed, when the General Strike erupted in 1926, some believed class war was breaking out and revolution was incipient.[42] The changing status of women in British society also alarmed many. Women had finally achieved the vote in 1918, and had moved into many new

occupations during the war. Although most women were forced out of these new jobs in the 1920s, many more wished to retain the independence new types of employment offered; their reluctance to return to domestic employment was most noticeable.[43] Working-class men also gained parity at the ballot box in 1918, sparking fears that they would use the franchise to gain control of high politics and force some form of socialism on the country. Few of these fears had any real basis. Women seldom united to better their chances economically, and men lobbied successfully in many industries to retain their own favoured position.[44] Both men and women preferred to vote for the Conservative Party. But during the inter-war years there was much uncertainty about the form that society would take. Much worry focused on the family, which was perceived to be failing in its responsibility for socialization. Although some researchers now believe that wartime pressures had little effect on family structure, contemporary observers worried about the stresses on families who had survived the war.[45] It does not seem very surprising then, that boys' stories emphasized a type of masculinity which reinforced traditional sources of guidance (fathers, employers and teachers) and which stressed not the individual but the community. Buttressing and strengthening the existing structures of society may have seemed the best way of slowing down the negative changes which were perceived at the time.

NOTES

1 This essay is taken from my doctoral dissertation: 'Wait Till I'm a Man': Manliness in British Boys' Story Papers, 1855–1940, under the direction of Dr John R. Gillis, Rutgers University; a version of it was presented at the London History Workshop Seminar, July 1989. For helpful comments and criticisms, I would like to thank Susan Thorne, Michael Roper, John Tosh, Tim Hitchcock and Rohan McWilliam.

2 Biggles was first introduced in *Modern Boy* in 1931, but his greatest popularity was a result of publication in hardback editions which chiefly appealed to middle-class readers. Due to constraints of space he will not be discussed below.

3 John G. Cawelti, *Adventure, Mystery, and Romance: Formula Stories as Art and Popular Culture*, Chicago, University of Chicago Press, 1976, see esp. chapters 1 and 2.

4 Cawelti, *Adventure*, p. 38.

5 Popular formula literature is also explored by Michael Denning in his examination of American nineteenth-century dime novels, *Mechanic Accents: Dime Novels and Working-Class Culture in America*, London, Verso, 1987. Although Denning is concerned with adult responses to popular literature,

he persuasively argues that this fiction is a good source for examining the tensions between management and labour in the nineteenth century, among other topics. It is from this imaginative literature that the historian can extract the mindset of labour and explore the ways the proletariat coped with the increasingly tense relations between the classes. Denning's study dissects both the dime novel industry and the tales. He is extremely fortunate that the industry evoked much contemporary comment, and left greater records than its British equivalent.

6 For a discussion of the types of Victorian manliness, see Norman Vance, 'The Ideal of Manliness', in Brian Simon and Ian Bradley (eds), *The Victorian Public School: Studies in the Development of an Educational Institution*, Dublin, Gill & Macmillan, 1975. pp. 115–28, and Norman Vance, *The Sinews of the Spirit: the Ideal of Christian Manliness in Victorian Literature and Religious Thought*, Cambridge, Cambridge University Press, 1985. For a discussion of this and broader issues in boys' story papers specifically, see Louis James, 'Tom Brown's Imperialist Sons', *Victorian Studies*, vol. 17 (1973), pp. 89–99; Patrick Dunae, 'Boy's Literature', *Victorian Studies*, vol. 24 (1980), pp. 105–21, and Patrick Dunae, *British Juvenile Literature in an Age of Empire: 1880–1914*, D.Phil. thesis, Victoria University of Manchester, December 1975.

7 Another approach to this material might be through the debate on 'social control', but there is little direct evidence that the publishers of these papers were trying to create a docile working class; see A. P. Donajgrodzki, *Social Control in Nineteenth Century Britain*, London, Croom Helm, 1977; Gareth Stedman Jones, 'Class Expression versus Social Control? A Critique of Recent Trends in the Social History of Leisure', *History Workshop Journal*, no. 4 (1977), pp. 162–70; F. M. L. Thompson, 'Social Control in Victorian Britain', *Economic History Review*, 2nd series, vol. 34 (1981), pp. 189–208.

8 Kevin Carpenter (comp.), *Penny Dreadfuls and Comics: English Periodicals for Children from Victorian times to the Present Day*, London, Victoria and Albert Museum, 1983, p. 58 for the Amalgamated Press data, p. 65 for the Thomson figures.

9 P. J. Hangar, 'Thomson Papers Were for Boys', *Story Paper Collector's Digest*, vol. 16, no. 184, (1962), p. 7.

10 Robert Roberts, *The Classic Slum: Salford Life in the First Quarter of the Century*, Manchester, Manchester University Press, 1971, pp. 127–8. Roberts described the excitement a new issue of the *Magnet* engendered in youths and their struggle to emulate their favourite characters.

11 See, for example, Chaim Bermant, *Coming Home*, London, Allen & Unwin, 1976, pp. 79–81; F. J. Brown, *Journal of a Stranger: a Subobjective Narrative*, Maidstone, Londinium Press, 1979, p. 23; Derek Davies, 'Memoir', in Ronald Goldman (ed.), *Breakthrough: Autobiographical Accounts of the Education of Some Socially Disadvantaged Children*, London, Routledge, 1968, pp. 30–1; Vernon Scannell, *The Tiger and the Rose: an Autobiography*, London, Robson, 1983, p. 71; Paul West, *I, Said the Sparrow*, London, Hutchinson, 1963, pp. 79–80; Jim Wolveridge, *'Ain't It Grand!' or 'This Was Stepney'*, London, Journeyman, 1981, pp. 29–34.

12 Derek Adley and Bill Lofts, 'Dixon Hawke – and the Thomson Papers', *Story Paper Collector's Digest*, vol. 15, no. 177 (1961), p. 5.

13 West, *I, Said the Sparrow*, p. 80; Scannell, *Tiger*, p. 71.

14 Additional biographical information from John Burnett, David Vincent and David Mayall (eds), *The Autobiography of the Working Class*, Brighton, Harvester, 1987, vol. 2, no. 814.

15 West, *I, Said the Sparrow*, p. 79.

16 Davies, 'Memoir', p. 31.

17 See, for example, A. J. P. Taylor, *A Personal History*, London, Hamish Hamilton, 1983, pp. 25–6; and Scannell, *Tiger*, p. 75.

18 John R. Gillis, *Youth and History: Tradition and Change in European Age Relations, 1770–present*, London, Academic Press, 1981, chapter 4; Stephen Humphries, *Hooligans or Rebels? An Oral History of Working-Class Childhood and Youth, 1889–1939*, Oxford, Blackwell, 1981, and John O. Springhall, *Coming of Age*, Dublin, Gill & Macmillan, 1986, are recent works which contain extended treatments of the inter-war years.

19 George Orwell, 'Boys' Weeklies', *Horizon*, vol. 1 (April 1940); Frank Richards [Charles Hamilton], 'Reply to George Orwell', *Horizon*, vol. 1 (May 1940), pp. 346–55; they have been reprinted in Sonia Orwell and Ian Angus (eds), *The Collected Essays, Journalism and Letters of George Orwell*, London, Secker & Warburg, 1970, vol. 1, pp. 460–93. According to Carpenter, *Penny Dreadfuls and Comics*, p. 58, although readership remained high during the 1920s, by 1939 circulation had fallen from a peak of 200,000 per week to 40,000 per week for *The Magnet* and 16,000 per week for *The Gem*. J. H. Engledow and William Farr, *The Reading and Other Interests of School Children in Saint Pancras*, London, Passmere Edwards Research Series, no 2, 1933, pp. 10–11, presents a fascinating dissection of the changing tastes of young readers in the inter-war years and reveals story papers to be one of the favourite types of reading matter for boys from 11 to 14. This was especially true for those who received minimal education. See also A. J. Jenkinson, *What do Boys and Girls Read?*, London, Methuen, 1940, for a wider survey, which confirms the findings of the earlier study.

20 These were Home House (for British boys), Colonial or 'Conk' House (for Empire boys), and Transatlantic or 'Yank' House (for American and Canadian boys).

21 'The Terror of Yank House', *Hotspur*, vol. 1, no. 7 (14 October 1933), pp. 185–6.

22 The Big Stiff was a continuing character during the inter-war years, beginning as a teacher and later becoming a school inspector. Between 1933 and 1938 he featured as hero of seven different series of stories.

23 Dave Marson, *Children's Strikes of 1911*, Oxford, History Workshop, 1973, and Humphries, *Hooligans or Rebels?*, chapter 4, both deal extensively with the hundreds of school strikes during the period; Betka Zamoyska, *The Burston Rebellion*, London, Ariel Books/BBC, 1985, examines one celebrated strike. A constant request was the abandonment of the cane, although this was seldom the issue which sparked dissent.

24 Both appeared in the *Wizard*.

25 See, for example, the derision heaped upon Mr Mole in the Jack Harkaway tales, in particular 'Jack Harkaway's After Schooldays: His Adventures Afloat and Ashore', *Boys of England*, vol. 11, no. 270–vol. 12, no. 305, (1872).

26 This plot developed over the course of the first series of Big Stiff stories in *Hotspur*, vol. 1 (1933).

27 This was a popular subgenre; see also the stories of Bayrak, who was lost in the South Pacific, *Wizard* (1929).

28 Tex Rivers, 'The Schoolboy Cannibal Earl', *The Boys' Friend Library*, n.s., no. 546 (1 October 1936), p. 18.

29 Rivers, 'Schoolboy Cannibal Earl', p. 19.

30 'The Worst Boy at Borsted', *The Pilot*, nos. 2–23 (1935–6). Borstals are penal reformatories for youths aged 16 to 21. Established in 1900, they at first put a heavy emphasis on discipline to reform inmates, but by the 1930s placed a higher premium on education. For a short history of the movement, see Roger Hood, *Borstal Reassessed*, London, Heinemann, 1965, pp. 1–62.

31 Note the following ways of describing Jim: 'tough, untamed and defiant', p. 59; 'perpetually sullen', p.124; and 'a born leader – someone who could "put it over the warders and the governor" ', p. 184. Only the last sings his praises, but this celebrates his subversive qualities, as an underground leader. The establishment view is best summed up by the appeal board, who term him 'a sturdy, self-opinionated, unruly youngster obviously in need of discipline', p. 472.

32 This corresponds to the strengthening of rules for amateur boxing discussed in Stan Shipley, 'Boxing', in Tony Mason (ed.), *Sport in Britain: a Social History*, Cambridge, Cambridge University Press, 1989, pp. 78–115.

33 Engledow and Farr, *Reading*, p. 10; and Jenkinson, *What do Boys and Girls Read?*, p. 16.

34 'You and the Editor', *The Adventure*, no. 1 (21 September 1921), p. 3.

35 See J. A. Mangan, *Athleticism in the Victorian and Edwardian Public School: the Emergence and Consolidation of an Educational Ideology*, Cambridge, Cambridge University Press, 1981; Joe Maguire, 'Images of Manliness and Competing Ways of Living in Late Victorian and Edwardian England', *British Journal of Sports History*, vol. 3 (1986), pp. 265–87, and Jeffry Hill, ' "First-Class" Cricket and the Leagues: Some Notes on the Development of English Cricket, 1900–1940', *International Journal of the History of Sport*, vol. 4 (1987), pp. 68–71.

36 Geoffrey Gordon [J. G. Jones], 'The Factory Batsman: a Rousing Tale of Cricket and Factory Life', *Boys' Friend Threepenny Library*, no. 306 (July 1915); it first appeared in *Boys' Realm*, nos. 629–39.

37 His dedication to the game is especially admirable in a period when turning professional was never done by a gentleman as it could only be seen as a decline in status. See Jack William, 'Cricket', in Mason (ed.), *Sport in Britain*, pp. 116–45.

38 Similar ideas predominate in Martin Wiener, *English Culture and the Decline of the Industrial Spirit, 1850–1980*, Cambridge, Cambridge University Press, 1981.

39 *The Adventure*, no. 17 (17 January 1922), pp. 1–13.

40 John Lowerson, 'Golf', in Mason (ed.), *Sport in Britain*, pp. 187–214.

41 For an overview, see Sean Glynn and John Oxborrow, *Interwar Britain: a Social and Economic History*, London, Allen Lane, 1984. For the impact of the Great War, see Arthur Marwick, *The Deluge: British Society and the First World War*, London, Bodley Head, 1965: Bernard Waites, *A Class Society at War:*

England, 1914–1918, Leamington Spa, Berg, 1987. On individual decades, see Noreen Branson, *Britain in the Nineteen Twenties*, London, Weidenfeld & Nicolson, 1975: Chris Cook and John Stevenson, *The Slump*, London, Jonathan Cape, 1977; John Saville and Alun Hawkins, 'The 1930s: a Revisionist History', *Socialist Register* (1979), pp. 89–100.

42 Margaret Morris, *The General Strike*, Harmondsworth, Penguin, 1976; Julian Symons, *The General Strike: a Historical Portrait*, London, Cresset, 1957.

43 See Marwick, *Deluge*; Jane Lewis, *Women in England 1870–1950: Sexual Division and Social Change*, Brighton, Wheatsheaf, 1984; Jane Lewis (ed.), *Labour and Love: Women's Experience of Home and Family, 1850–1940*, Oxford, Blackwell, 1986; Diana Gittins, *Fair Sex: Family Size and Structure, 1900–1939*, London, Hutchinson, 1982.

44 For examples see Alison Oram, ' "Embittered, Sexless or Homosexual": Attacks on Spinster Teachers, 1918–39', in Arina Angerman *et al.* (eds), *Current Issues in Women's History*, London, Routledge, 1989, pp. 183–202; Sonya O. Rose, 'Gender Antagonism and Class Conflict: Exclusionary Strategies of Male Trade Unionists in Nineteenth-Century Britain', *Social History*, vol. 13 (1988), pp. 191–208; and Keith Grint, 'Women and Equality: the Acquisition of Equal Pay in the Post Office, 1870–1961', *Sociology*, vol. 22 (1988), pp. 87–108.

45 This is cogently argued in Richard Wall and Jay Winter (eds), *The Upheaval of War: Family, Work and Welfare in Europe, 1914–1918*, Cambridge, Cambridge University Press, 1989, pp. 1–6.

8

MUMMY, MATRON AND THE MAIDS

Feminine presence and absence in male institutions, 1934–63

Peter M. Lewis

INTRODUCTION

'Don't you ever talk about home, or your mothers and sisters . . . or they'll call you home-sick or mama's darling.' Tom's advice to the new boy Arthur occurs at a moment in Hughes's *Tom Brown's Schooldays* when Tom has come through the first rites of passage. No longer at the bottom of the pile, he returns with his friends for a new term, eager to use his hard-won experience, 'work the system' and have some fun. The new boys' trunks are being unpacked in the matron's room, and some woollen night-caps are revealed to the mocking delight of the older boys – 'the work of loving fingers in some distant country home. The kind mother and sisters, who sewed that delicate stitching with aching hearts, little thought of the trouble they might be bringing on the young head for which they were meant.' But the teasing is abandoned when the matron transmits the orders of the headmaster, Dr Arnold: Tom is to take on the responsibility of looking after the delicate new boy and bring him to tea that day with the Doctor's wife.[1]

So, a century before the period covered by this chapter, the cast which is its focus is assembled in the archetypical public school story: the absent mother and sisters, the matron and the head/housemaster's wife who take their role, and the (mainly female) work force whose labour supports the institution. 'The maids', though off-stage in Hughes's story and recognized only by their labour, are necessary to complete a male universe of compelling persistence. My argument in this chapter is that male institutions like boarding schools (but also including the army) construct a system in which masculinity is defined by absence of the feminine. Boys are removed from home because home is the site above all of a compassionate love (but also of other 'feminine' qualities and emotions) which weakens resolve and impedes

progress to manhood. The institution proscribes women and systematically disparages or devalues all 'womanly' traits and characteristics. But, since caring and nurturing functions are women's work, which men cannot undertake without demeaning themselves, some women are necessary in the all-male world. As masters' wives, they substitute for mother, dispensing tea and sympathy but, like her, are sexually unattainable. The maids, symbols of that other boundary, class, are doubly forbidden: on them a competitive male bravado is focused. Positioned ambiguously between the two poles, the matron, privy to the secrets of laundry and personal health, patrols the boundary of public and private.

I don't remember exactly when I first read *Tom Brown's Schooldays* but, like a number of books and stories I first encountered in childhood, it has a quite precise location in my mind's eye: the grounds of another public school (not Tom Brown's Rugby) where my father taught. In a quaint, childish superimposition that had no regard for realism, stories like the Garden of Eden, the siege of Troy, *Just William*, were all set, and stay set now, in different corners of this remembered landscape. The double focus of memory that places *Tom Brown* by the squash courts of Wellington College in the 1940s can, then, usefully serve as a reminder, throughout this account of the institutions I experienced in the first thirty years of my life, of two features of the work that goes into constructing autobiographical images.

First, this historical 'double vision' draws attention to the two-way exchange between past and present in accounts of this kind. The hand that adjusts the lens is always contemporary, and where one is at any particular point affects the telling. My position can be deduced from the observations which follow shortly about the sources, method, assumptions and home background that underpin my account.

Second, superimposing my Wellington College on Tom Brown's Rugby underlines the importance of other published accounts (fiction, autobiography, memoirs, history) both in the present construction of my story and in the contemporary experience of living and interpreting it. Again, a two-way process operates: the original reading was coloured by what Raymond Williams called a 'structure of feeling' – a 'felt sense of the quality of life at a particular place and time'.[2] This feeling in turn colours repeated rereadings or, more often, retellings in the imagination. The published sources become in this way virtually actors in the story.

A primary source are the letters I wrote home from the age of eight onwards, most of which have survived and which I recently reread. I use them to supplement memory with the caution due towards texts

whose production, as I grew older, became increasingly more calculated: what is *not* recorded in them is often the most significant. My mother's diaries, which she kept up till around the time I was 11, allow a cross-check on dates and convey a feeling for the family atmosphere and routine. Conversations with my parents' contemporaries – servants and colleagues – provide some evidence about my childhood years. Besides the historical and fictional accounts referred to above I shall be drawing on sociological studies of institutions and on contemporary analyses of masculinity.

The public school features to an unusual (though not unique) extent in my story, but for generations of pupils before and after me it was also the dominant institution in the sequence which helped to make a middle class, casting its shadows before into the prep school and after into the army and university. Its influence stretches further, I would argue, out of all proportion to the numbers actually experiencing the system, for public school values and organizational arrangements were widely adopted in grammar and state schools for both boys and girls.

This is not to suggest that the 'influence' had uniform effect; even among members of the class and gender directly exposed to it, the public school ethos was met with varying degrees of resistance and appropriation. But that a version of masculinity, inscribed within values so systematically inculcated over so long a period, and authorized by a dominant class, has till recently been accepted as natural and desirable, is a matter of historical note. My account traces a personal path through the institutions, taken by one who at the time conformed, competing and achieving success in conventional terms. If there is anything unusual in such a path, one that stays within a particular, mainstream middle-class masculinity, it is perhaps in its being retraced by a dissenter. It may well be that dissent, or repudiation of the socialization I and contemporaries underwent is more widespread than appears. The phenomenon of 'male menopause' may, for example, be a kind of delayed 'shell-shock' resulting from the strain of coping with the stress of public life while systematically denying private feelings.[3]

Finally, I must emphasize that in focusing on school, army and university as institutions in which masculinity is developed, I do not ignore the fact that it is in the institution of the *family* that it is first formed. What stands out to me now in a reading of my letters home is the strength of the hold my family continued to exert over me as I proceeded along the institutional path – its taken-for-granted assumptions, shared history and humour, its class outlook. Much of this is available to me at a conscious level. The experience of infancy is

accessible by historical method only in fragmentary form: notes in my mother's diary, for instance, or a parlourmaid's memory of the regime of fresh air and fixed feeding times to which, following the popular advice of Dr Truby King, I was exposed. To what extent the psychic experience of this period is crucial in the formation of masculinity is a matter of debate in gender studies,[4] and is, in my case, an issue I cannot resolve here. My account assumes that the construction of a hetero-sexual identity continues through the post-oedipal period, that it is a process that is complex and conflict-ridden, and has an outcome that is 'inevitably marked by tension, contradiction and possibilities of change'.[5] It is this fragile construction, the product of family, that meets the refining fire of the first boarding school, commonly, as in my case, at the age of 8.

WELLINGTON COLLEGE 1934–42

My earliest memories are of a boarding school. When I was just over a year old my father became a housemaster ('tutor'). That meant that we went to live in a house under the same roof as thirty or forty boys, who were separated from our 'private part' by a green baize door. These were junior boys, aged between 12 and 14, waiting to go after a term or two to the main houses ('dormitories') in the rest of College.

As a family we therefore lived in public much of the time, participant observers of the process of socialization which began with the ritual of the introductory tea party for new boys and their parents, and continued for the rest of their school-life. Of course, to me, these small boys were big. I looked up to them and admired them. They provided a visible extension of the range of seniority that I experienced as the middle of three brothers. But whereas sibling rivalry was a wearisome, everyday struggle, the boys' company was something we could take or leave, as long as they would put up with us – and any rejection could not be too harsh because of our protected status. With my brothers, or more often with my best friend, John, who lived next door and whose father also taught at College, I would skirmish with mock-fights, engage in repartee, or, less tiresomely, 'field' and return cricket balls at the nets. Young as we were, we picked up on the varying degrees of success with which the boys coped with socializa-tion. We could spot wet or cissy behaviour. We admired and imitated the indices of successful masculinity conveyed by language, dress, movement. Later the ability to pick up such codes was to be useful.

Somewhat similar sparring relationships developed with the friend-

9 Which side are the boys on? Wives v. Men Cricket Match, Wellington College, 3 August, 1944, organized by Mary Lewis (seated, in dungarees); the author is seated bottom right

lier of my father's colleagues. Sometimes we overstepped the mark, but for the most part our antics were looked on with indulgence as, from within the safety of our contradictory status – children but not 'boys' (i.e. pupils) – we tested the boundaries of rank and custom. Classed in the category of 'women and children' – for example sitting in the rows reserved for families in the College chapel or in a wartime cricket match playing for the wives against the men – nevertheless we were in no doubt whose side we were really on.

My father worked hard in a job which in term time was seven days a week, evenings as well. But the job was done from home and we often saw him at work, poring over his desk in the study, parading in his academic hood and gown for Sunday chapel, coaching or playing cricket. Occasionally we were allowed to visit him in his biology lab where specimens and microscopes mingled with smells of mice and formaldehyde and the pupils seemed contentedly absorbed in practical work or watching films. He was, I later learned, an inspiring, unorthodox teacher, but strict. One incident outside the classroom made a strong impression on me. On a walk in the College grounds we passed some boys potato-picking (it must have been during the war) and one unluckily chose that moment to throw a potato at another. My father summoned him, asked his name and dormitory, and told him to report to his tutor. I couldn't equate the offence with the terrible severity of my father's tone and was awed that it could persuade the boy to report for punishment (obviously a caning) by remote control.

At home, too, he was strict and, though concerned about his children, was not able to give, any more than he had received as a child himself, affection of a close physical and emotional kind. Playing a correct stroke at cricket pleased him best: he was a brilliant club batsman and coached us from our earliest years. In argument with my mother he was exhaustive and exhausting, contrasting what he called her 'feminine' lack of logic and emotional tone with 'male' reason. He did not have us on his side at these moments, nor during his disapproving silences. Some of these took place when a maid might be summoned to the table so that my mother (it was she, at his insistence, who had to fulfil this role) could point out some fault *he* had found in cooking or place-setting. It was remote control again. Beneath the charm and the understatement, frightening demonstrations of power lay close to the surface. What evoked them and when, was not always clear to us children: it had something to do with the public/private divide, but wasn't as recognizable as the green baize door.

Clearly my mother, too, was not easy with the compart-

mentalization. Her (unpaid) job was not only to run the family and make the domestic arrangements necessary to clean and keep the dormitory running (later, after my father's promotion to another, more senior, 'dormitory' this was to include organizing the boys' meals as well – a demanding task during the period of rationing), but also to assist in the social dealings with parents. She was good at this, using tact, charm and a good memory to handle them, and providing for their sons a source of humour, sympathy and 'home'. In so doing she was fulfilling the role of women in this part of the institution; to soften, humanize, even subvert the boundary between public and private. We children, then, were made aware at once of the existence of boundaries and of a feminine discourse, unofficial but tolerated, that disregarded them.

What these rules meant, the significance of the Wellington regime, is the subject of contemporary memoirs but was at the time beyond our consciousness. The repression of the 'private' that went on in this 'public' school (perhaps the contradictory title is after all apt), the proscription of all things 'effeminate'[6] went hand in hand with an anti-intellectual conservatism that lent glamour and daring to political rebellion[7] and encouraged a thriving sexual underworld.[8]

The 'toughening process' befitted 'sons of heroes' – *heroum filii:* the College was founded in 1859 as a national memorial to the Duke of Wellington. John Shaw's distinctive architecture made space for statues and mottoes, the latter mostly in a Latin shorthand I couldn't yet translate, which spelt out an ideology of war and sacrifice: 'The path of duty is the way to glory' over a passage way that led ironically to the playing fields, on which, as we know, battles are won; '*Virtutis Fortuna Comes*' – 'Fortune favours the brave': the words easily slide into sporting metaphors; in the chapel on the war memorial the line from Horace, '*Dulce et Decorum est pro Patria Mori*' – 'It's a fine and beautiful thing to die for one's country'. The 1939–45 war gave added meaning to this rhetoric and I was not to encounter Wilfred Owen's subversion of it till much later.

AMESBURY SCHOOL, 1942–7

Before I was properly awake I could feel there was something wrong: the light was coming in from a different direction. Then I realized what I didn't at first dare accept was true: I wasn't at home. I was in a strange place – school. At the start of succeeding terms this continued to be a bad moment, the awful realization that freedom had ended. But to that first morning there was added the shock of the new.

A bell would ring and I would dress in clothes still strange to me, a uniform that the other strangers around me in the dormitory also wore. Enjoying no 'protected status' here, I was not Peter, but Lewis – and, to distinguish me from my brother, Lewis, P. In that single letter was locked away something from home, like the few possessions I was allowed to keep in my tuck-box. My number was 31, labelled over clothes peg and locker, sewn on every item of uniform, painted on my regulation-size sweet-tin and stamped in little brass tacks on to the instep of shoes and football boots.

My 'club' was New Zealand. A score of us lined up together in ranks, and, with the other sixty or so boys, similarly divided into clubs, marched military-style into meals. Other groupings assigned us each to a lavatory whither after breakfast we had to go in a prescribed order, the one who finished finding the next, a hand-over supervised by the headmaster, the Major, briskly conducting business at his study door. 'Can he go, please, Sir?' '*Can* he? That I don't know!' or a hammed pretence that you were invisible till you got the grammar right. Dispensing a barrage of quips and catch phrases, redolent of Kipling-esque military routines from the farthest Empire, the Major barked out praise and punishment accompanied in either case by painful hair-pulls or cheek, pinching.[9] 'It rained upon the Just and Unjust fella, But chiefly on the Just because the Unjust stole the Just's umbrella' was a favourite excuse for any inconsistency. Behind the parade-ground bombast was a meticulous, all-embracing organization that supervised the minutiae of our existence. Sweets were pooled and shared, books brought from home were checked and initialled as if by censor. The Major's wife with a posse of matrons and helpers ran an equally efficient domestic operation that cooked and sewed and swept and scoured, washing behind our ears, dispensing sanatogen and cod liver oil and mopping up any emotional fall-out.

The borderline between this domain of female care and the Major's disciplinary system was vague. The headmaster's wife, standing at her drawing-room window covered, like a well-placed machine-gun post, a swathe of ground at the back of the school. Once, spying from her window, she caught me using a short cut across forbidden ground and issued me with the dreaded blue cheque-form of a 'stripe'. 'Cashed in' at the Major's after-breakfast surgery, a stripe could rate a caning if you were unlucky. I felt aggrieved that the headmaster's wife should invoke the penal system, as if she, not I, were the trespasser. Perhaps, too, there was an element here of betrayal. She, married to authority and occupying the same actual and symbolic place as my mother, had

yet failed to act as my mother would have done, choosing to enforce the social order rather than subvert it.[10]

Usually, though, I was an assiduous collector of marks and 'stars'. Competition was keen and I moved up the school in the company of friendly rivals. Most of them were comrades on the games field and in the gym. While we fought each other to come first in 'fortnightly orders' and exams, and for places on the school teams, the real competition was not with each other but with time. Crossing off and counting the days in the school calendar till the end of term rationed our longing for home. But it was also, like 'mark-grubbing', a tangible compilation – in this case of the days and weeks which added up to a term – and bestowed seniority. For next term, new names on the school list 'below' us would prove where we were: 'above'. The routines of daily life were instances of one sort of time, repetitive, renewed each day, each week. Summed up, they delivered units, terms, that were the building blocks of hierarchy. School life thus became a miniature replica of the linear time which individuals experience as a life-span. The school photographs lining the corridors and the gold-lettered lists of teams in the gym showed us our predecessors, markers of a third sort of time, the *longue durée* of the institution's existence. Giddens's analysis of the way social institutions are produced and reproduced in temporal organization belongs to modern sociology,[11] but we certainly sensed the movement of time which made hierarchy tolerable, indeed, which gave it meaning and dynamic.

This was a period for me of voracious reading. One of the best things about the school was that it encouraged and made space for reading. With no public sporting achievements to admire and a pop culture still some decades over the horizon, there was a shortage of contemporary heroes (except for military ones) so we looked for them in history and literature. The titles we read dated back several decades at least. Not only was there a wartime scarcity of paper which had slowed book publishing to a trickle; it was before the explosion of publishing, including children's book publishing, which we take for granted today. Penguins were the only paperbacks and there were none in our school library. So I read through shelves of Henty and Conan Doyle, Rider Haggard, Buchan and Sapper, bound volumes of *The War Illustrated (1914–18)* and *The Boy's Own Paper*. The world view suggested by this reading was little different from that described by Paul Fussell as preparing a generation of male youth for the First World War.[12] The poetry we encountered did little to disturb this landscape. It was doled out in school selections from which all protest had been edited, or in

spirited renderings of Tennyson and Kipling delivered by the Major in quixotic interruptions of lesson time. For my tenth birthday, my father gave me the autobiography of C. B. Fry (Repton, Oxford and turn-of-the-century England athlete and cricketer). That I readily absorbed the Edwardian values of this distant hero is some indication of the time-warp in which my imagination was fastened.

Reading, and more intrusively the routines, activities and endless competition helped to distract us, as they were intended to do, from thoughts of home. But at night in the privacy of the dark in bed, homesickness could strike. To 'blub' was to break the ultimate code of behaviour. Fraser Harrison has movingly recalled the agonies he experienced in his prep school. There was no one you could turn to, not the staff, and least of all one's fellows.

> Everyone's self-respect was at stake: if one boy blubbed, the others would be poignantly reminded of their own unhappiness and brought dangerously close to blubbing themselves. He had therefore to be repressed at all costs. For most of us . . . this was the beginning of that process by which our feelings were first numbed and then disconnected, giving us the distinctive quality of the boarding-school 'man'.[13]

I'd been brought up to respect the boarding school institution and thought it was a good thing to be in one. Yet I was as keen as anyone to see my parents on the once- or twice-termly weekends when they were allowed to visit, and as desolate when the time came for them to leave on Sunday evening. The only thing to do with one's affectionate feelings was to store them deep in some tuck-box of the heart. Unlocking them was as painful as putting them away. Six times a year, at the beginning and end of holidays, not to mention the week-end 'leave-outs', this trauma had to be endured. I recall conscious efforts to 'steel my heart' – the metaphor came readily to mind from poetry and sermons.

SHERBORNE 1947–52[14]

'You look worn out. When did you last masturbate?' I gulped and tried to avoid my housemaster's searching stare.

'Yesterday.'

'Yesterday?' He was shocked. 'But yesterday was Sunday!'

This astonishing exchange, as hilarious now as it was embarrassing at the time, at least marks an advance on the pre-war official attitudes at

177

Wellington whose (head)Master, F. B. Malim, once remarked, 'There is no such thing as sex at College . . . and if there is I knock it hard on the head.'[15] Nevertheless, my housemaster would have been shocked at the cheerfully cynical culture celebrating this form of sex amongst the boys in his house, though the disciplinary system he enforced, with all its moral and religious overtones, ensured that, in a line from *The Good Ship Venus*, 'there was fuck all else to do'. As a part of physical exploration, a developing awareness of sexuality or a pleasurable accompaniment to fantasy, masturbation has its place. It was a pity then that an atmosphere of moral disapproval backed by hints of harmful effects ensured that the pleasure of 'sex with the one you love', to use Woody Allen's phrase, was blighted by anxiety and guilt. Even the fantasies that accompany the act and which might be thought more important could not be shared in a culture in which a sexual metonymy of tit and bum, penis and orgasm separated physical gratification from emotional feelings.

Sex between boys in some cases undoubtedly healed that separation. Lambert's informants testify to feelings of affection and emotional satisfaction in relations between small and older boys and, in a book which made a great impression on me before I went to Sherborne, Alec Waugh hints at the value to his (autobiographical) hero of such relationships fifty years before.[16] But it was of course the 'evil' which justified the regimentation and surveillance in Sherborne in my time. Occasionally expulsion airbrushed faces and names as comprehensively as any Communist government and with explanations as veiled and uninformative. For the most part it was a subject of gossip, little more.

As in the Wellington observed by T. C. Worsley, sex expressed in this way was for most a stage of development on the road to heterosexuality, a stage distorted, I shall argue, by the specific conditions of our existence. The homosexual alternative was in that period still invisible, the closet firmly closed, a gay discourse (the word 'gay' not yet used to describe it) non-existent. Public scandal might occasionally erupt in tabloid headlines (e.g. Burgess and Maclean in 1951) and become the subject of private, homophobic humour or music hall jokes, but comment in the public sphere disappeared as abruptly as over a school expulsion. This was an age of 'keeping up appearances'. The only arena I knew about where homosexual behaviour was countenanced was that of classical antiquity. Even to locate it here one had to adjust the frame imposed by the prudish selection of texts in school editions whose Victorian/Christian perspective marginalized a central cultural feature.

So, fed by the romantic euphemisms of pop songs of the period, we expected somehow a future with a woman ('A man without a woman / Is like a ship without a sail'). The woman would be a wife, obviously, who would do the things we had been brought up to see being done for us by mummy, matron and the maids. In return, 'doing what comes naturally' we would find sex and true love all combined. The only problem we could see was how to get some experience of the sex. Love was something you 'fell into', so presumably it required no rehearsal.

There were two girls' schools in Sherborne whose pupils were often to be seen in the town in their distinctive uniforms. To talk to a girl was to court instant retribution. Assignations were contrived in the countryside, but communication was difficult, since letters with Sherborne postmarks were suspect and invited interrogation. I managed to arrange a meeting once. The secrecy and detailed planning involved was more of a thrill than the actual encounter. I simply did not know what to do to pass from talking to what I took to be the point of the escapade – kissing. Again Lambert's study confirms that even a decade later this ignorance was common, and that the limited opportunities for meeting girls made it, as one boy told him, 'desirable to squeeze as much sex into the relationship as possible'.[17]

It did not help that at home a succession of moves, after my father had left Wellington, uprooted us from social contacts. The only chance of meeting females of my age was those days staged by other families for their daughters. With three sons and no daughters, equivalent energy and initiative in our family invariably focused on cricket. Only in the socializing that hovered around deck-chaired spectators or in drinks in the pavilion after the match might one hope to meet someone's sister or daughter.

'Teenagers', viewed from the shelter of this middle-class enclave, were a working-class phenomenon that had begun to be discussed as a social problem. In pavilion chat it was taken for granted (actually, no doubt, taken from Bowlby)[18] that divided homes or the tendency for women to work outside them, deprived these lads of a stable up-bringing. It was before 'youth culture' was celebrated musically, targetted by advertisers or investigated by sociologists. Boys like me tried to dress (tweed jackets, grey flannel trousers) and talk like men.

There was no space in between being a boy and becoming a man for any distinctive style or assertion of identity. That is to dwell on appearances, and certainly the school training stressed their import-ance, as the group photos of house and team bear witness – faces earnest, wearing confident smiles or frozen in stiff-lipped determi-

nation, collars and ties and suits departing from the uniform with degrees of casualness as their owners gained the privileges of seniority. Finally, the ultimate in success, the team photo, but here too a sense of precariousness in the pose for this public, eternal moment. For dignity is a fragile thing and can be upset quickly into ridicule. Jack Gold's film *Good and Bad at Games* (1983) captures such a moment when the poise of a prefect trying to impress a girl at a school dance is destroyed by food spilt on his blazer.

What feelings lay under these appearances? Where a system discourages the expression of emotions, they atrophy. This goes back beyond school to the first time the male child's cries are checked with 'Don't be a cry-baby' or 'Boys don't cry' (i.e. girls do). In school, the policing of experience and the competitive dynamic of a hierarchical system fill the emotional vacuum, inviting a boy's commitment to arbitrary constructions like team or house or school as a preparation for the world of work that was to follow. This is what Andrew Tolson has called the 'cultural bribe' – a paradoxical manhood offering 'a dream of fulfilment on the condition that a boy subscribes to authority and convention'.[19]

The extent to which the bribe is accepted depends, as Christine Heward notes in her Ellesmere study, on the 'strength and nature of family and peer-group relations . . . crucial factors in the extent to which boys experienced emotional loss . . . A boy's family and "pals" mediated the pressure to conform, influencing the pattern of conformity and its costs.'[20] My impression was that close 'buddy' relationships were relatively uncommon in my time at Sherborne. Fraser Harrison at Shrewsbury was lucky in finding as a friend a contemporary whom he had known at prep school:

> the development of special friendships was a natural response to the highly unnatural circumstances in which we had all been brought up since the age of eight or so. They were the only available substitute for the relationships that had been cut short, starved or forgotten as a result of our being sent to school. Without either side being more than vaguely aware of it, friends were required to compensate for the absence of parents, brothers and sisters, grandparents, aunts, uncles and the friends who had been left behind.[21]

In my house at Sherborne there were ten new arrivals in my 'term' and I was unlucky in being the youngest, yet the only one placed in a form in the Middle School where School Certificate was taken at the end of

the year. My contemporaries were all, academically, a year behind me and for some years not only did I have no connection with their work concerns, nor they with mine, but I suffered considerable torment from teasing and occasionally physical bullying. Teasing illustrates, and tests, an important feature of masculinity. You push someone till they lose control, break down, cry or lash out in anger. Then *you* have won and *they* have lost. 'If you can keep your head . . .', split off your head from your heart and emotions, pretend you don't care, you're a good sport. You can take a joke – '. . . you'll be a man, my son.' The suppression and splitting involved are reinforced in many ways, not least by the strict enforcement of the rule limiting the range of social acquaintance to one's own 'term'. It is, incidentally, remarkable evidence of the glacial slowness of change in public schools that half a century after Harold Nicolson was irked by similar restrictions at Wellington, I could be making the same complaint in a letter home. 'One chap', I wrote in October 1949, 'fairly high up in the house is only allowed to talk to three people! The rest of his term are prefects . . .' What I did not say was that I was virtually in the same situation.

Rereading *The Loom of Youth* now, I can see the attraction for me at that time of a hero who was clever, idle *and* a successful athlete. If brains and application were needed to climb the academic ladder, sporting success could buy off the unpopularity which the 'swot' inevitably attracted. Among my house contemporaries this strategy served me to some extent, while in the classroom and in the company of those who were 'good at games' I found pleasure in a camaraderie which was lacking in the house. Nevertheless, like Waugh's hero, I began to realize that I often felt 'two separate persons . . . a Jekyll and Hyde business'[22] that left me an outsider in both domains.

In the house, my isolation was not exceptional: the system worked to undermine friendships rather than encourage them, and, as my letter home recalls, the ultimate step of the ladder, becoming a prefect, involved 'cutting dead' any contemporaries not similarly promoted, since any sign of friendship would have compromised discipline. The effect on me, and I suspect on many others, was to put a premium on negotiations for alliances of convenience, on temporary coalitions or balances of power and personality which would neutralize hostile threats. No wonder some lines in Sophocles' *Ajax*, discovered in my second year, became a favourite, secret maxim: 'An enemy should be treated as if he might one day be a friend, and equally I should want to put limits to a friendship in the knowledge that it might not last. For most of us, companionship is not a reliable port in a storm.'[23]

David Cornwell was some years my senior in the house, someone I knew by sight, no more. I like to think that the labyrinths of deceit and betrayal he was later to describe so brilliantly under the pen-name of John Le Carré owed something to this early training in emotional poker. When possibilities for friendship were reduced in this way to an endless calculation of cost and benefit, emotional growth is stunted or warped.

Tolson writes of there being, in the middle-class boarding school, 'no recognised channel by which a boy can either communicate his feelings to others, or discover their possibilities within himself . . . feelings of tenderness, and especially sexuality, remain beyond recognition'.[24]

Sexuality of a kind registered on our consciousness. Sex was safest with yourself, the emotional risks were nil and the only feeling you had to cope with was guilt – especially, it seems, on Sundays. Other feelings, too vague to be articulated at the time, can, on looking back, be detected – displaced as spiritual pursuits, for example, in music or religion. Even the disciplined and competent use of bodily strength and skill in sport provided emotional satisfaction,[25] though it would not have been articulated in those terms. *Mens sana in corpore sano* seemed to account for the whole universe of discourse: spiritual and emotional dimensions were absent. Systematically the feminine was outlawed from our make-up. I recall the anxiety I felt as a fresh-faced treble in the choir when time passed and my voice didn't break. The lack of this obvious sign of manhood meant that I risked sounding like a girl. (My voice never did actually 'break', but inched down the register, with some pushing from me – small incidental proof, perhaps, of the social construction of vocal difference between the sexes.)

We can see here a whole distorted landscape in which a patriarchal ideology assigns arbitrary values to sexuality, emotion and friendship, separates them off from each other, then reassembles them in a unitary coherence from which emotion, a sign of the forbidden feminine, is, not always successfully, excluded. There was no place for women in this pantheon of values and appetites. Heward concludes that at Ellesmere 'The invisibility of women, the low value placed on their caring and nurturing activities and the elimination of feminine characteristics in making boys into men was a sorry preparation for future relationships'.[26]

For a middle-class career, however, it was an excellent preparation. Its shortcomings in a male-dominated world were not apparent. Heavy as were the financial costs to my parents, they did the same for all three sons. In Heward's words, 'they believed they had made a good

investment, valuing their sons' successes and minimising the psychic and social costs'.[27]

ARMY AND OXFORD, 1952-8[28]

National Service was a diversion from the career path that I totally expected and accepted. We were not a generation which burned our draft-cards. If we had enquired we might have found cause enough to protest at the manner of British attempts to retain a colonial hold in, for example, Cyprus, Kenya and Malaya. But that is to use a hindsight and a political understanding that I and few of my contemporaries then possessed. The Korean War was the visible one, the Cold War ideology underpinning the assumptions that justified National Service. The meaning of this interruption for the middle-class, public school conscript, bound for university, was totally different to that for our working-class contemporaries. Most of them had left school at 15 and were earning good wages compared to the Army pittance they at first received. Most, too, had never left home before, and this caused anguish for some in the early weeks – I remember a weeping neighbour my first night in the barrack-room. Those whose boarding school experience made them practised at dealing with alienation had a head start, but in time all learned the truth of the equation: home equals mother equals feminine equals not-a-soldier. Once we reached the officers' mess, normal (public school) banalities were resumed; the equation, though masked, held good.

The continuity of the experience of National Service with public school and university reflects the dominance of a particular class formation in the Officers' Mess and Oxbridge Junior Common Room of the period. This comes through in the regularity and frequency of my letters home. Until I reread them, I had forgotten how un-interrupted a routine it was. It also reminds me of the extent to which I was still under the spell of the family. I had stepped out into the world, yet found structures and values remarkably similar to those I had already experienced; I had escaped the surveillance of parents and teachers, yet remained in debt to home both emotionally and financially. Since Wellington, the family income was precarious. Gone were the maids, but the division of domestic labour, still traditional, went unquestioned: at home we boys were supposed to keep our rooms tidy, do the washing-up and 'help' with shopping for the food my mother planned and cooked.

By contrast the Army made me an expert cleaner and polisher,

literally overnight. I ironed, in the small hours, enough creases to make ironing a chore I never afterwards demanded of anyone, especially not myself. The Army also gave me an item of kit in which a basic needle and thread, darning-wool, buttons etc. could be wrapped, known as a 'housewife', pronounced 'huzzif'. David Morgan remarks on the significance of this 'inert and insignificant' symbol of the feminine role.[29] I simply used it to sew on buttons. I never learned how to darn, and worse, in none of these institutions including home did I ever learn or need to cook.

Cleaning kit and maintaining a perfectly ordered 'bed-space' had, in the barrack-room context, no ostensible connection with a feminine role, unless as part of a pattern of submission in which conscripts might be thought to have been feminized.[30] In my case, certainly, none of the routine transferred to home. It was part of a network of performances – 'bulling' boots, keeping in step and time, standing in the 'correct' (spine-damaging) parade-ground posture, hitting a rifle-butt with a hard, synchronized smack or the ground with your knee as you took up position behind a field-gun, getting through a 'commando-course' in the gym or completing a routine-march without collapsing – the successful performance of which was part of 'having what it takes', a matter of 'inmate pride'.[31] You competed with fellow inmates in the endurance of these chores and hardships, you kept new arrivals in place with 'ranking rituals' designed to show you had done more service than them ('Get some in!') as well as co-operating with your mates in devising schemes to buck the system ('removal activities') of which 'skiving' – avoiding work – was the paramount skill.[32]

These performances were typically masculine, and were accompanied by derogatory comparisons with the world of women – and gays, known in those days as poofs or queers – as a means to rebuke incompetence or failure. I joined the Royal Artillery and in the eight months of basic training and Officer Cadet School our instructors found plenty of scope in the machinery and operation of guns for sexual metaphor and innuendo. So far from being shocking to any of us, this totally fitted an aggressive, competitive male discourse which embraced, as well as soldiering, our entire social life.

Our entire life except home. David Morgan, arriving in the RAF, was told what to expect of basic training: 'The first thing is this: you won't have your mothers there.'[33] Recalling Tom Brown's advice to Arthur, the remark encapsulates the structured presence/absence of women in this world. The ever-present 'fuck' and 'cunt' in language, the sexual metaphor, the derogatory comparisons, ensure a sort of

presence at all times. In the Mess the Queen, the Royal Artillery's new 'Captain-General', looked down from her portrait and was toasted after dinner before the port circulated and the fun began. Among recruits the shortest smoking break brought out the 'dirty story', the talk of sexual exploits, remembered, anticipated or fantasized in imaginations fed by the pages of magazines or tabloids or the glimpses of women serving in canteens or NAAFI. To enjoy them we first have to leave our mothers at home.

> 'Fugg off,' protested Connolly derisively.
> 'How old are you?' Henry asked him.
> 'Eighteen. Why?'
> 'Eighteen, and using language like that,' sighed Henry, shaking his head with every appearance of real concern. 'What would your mother say?'
> 'She don't know anythink about it. I don't swear when I'm at 'ome . . .'[34]

Different from mother and home – and school, down the road, past the guard-room, outside the barracks, there began the world of women, waiting to be picked up, wanting 'it' we had no doubt. Competition extends here, too, in the bravado of a dance-hall pick-up, in 'how far did you get?'[35] Women thus became fodder for male competition.

At least these brief encounters were relatively honest. More damaging was to be the effect of such an attitude within longer relationships. The inevitable conclusion of 'How far can you go?' is penetration which becomes fetishized to the exclusion of all other aspects of a relationship. Worse, as Tony Eardley puts it in a discussion of violence and sexuality,

> For men [sex] becomes heavily charged because of the emotional illiteracy which is part and parcel of male socialisation. So often sex then becomes a bottleneck of pent-up and misdirected yearnings, frustrations and anger. The pressure of this mass of undigested and unexpressed emotion which clusters around sexuality is perhaps what gives the myth of male urgency its subjective power for men.[36]

I recognize the frustration, but violence was never an option for me. The violence of early months in the Army, a violence of language rather than any physical expression, is something I have dwelt on because it points up with clarity the logic of a masculinity that uses women instrumentally. Under that regime women stood for emotions

and feelings that might, unless they were outlawed, impede discipline. In the end, a trigger had to be pulled, a button pressed and it took 'men' to do it because only men were capable of surrendering all compassion.

In my generation at Oxford, a pretentious aspiration to correctness, of class and culture, was common to both sexes. Concealing emotion was important: it was always neater, wittier, *safer* to find in a line of poetry, a reference to an authority, someone to speak for us. In the spirit of that time I will let Elizabeth Wilson, who was, unknown to me, an Oxford contemporary, speak for me.

> We were all crazed with class – trying to merge its privilege and its ritual with its careful decency, that longing to be nice. The cultured cadence, the sharp sweetness of a turn of phrase, the liberal ideas – there was our pre-packaged identity, the identity of the civilised middle class.[37]

The coolness, the ambiguity was studied from cinematic images – the monosyllables of Brando or Dean, the gestures of Marilyn Monroe, the wistfulness of Claire Bloom in *Limelight*, the poise of Grace Kelly. After Rainier stole Kelly away, we fixated on Kim Novak ('half bitch, half baby, a sexy sweetness, a virtuous voluptuousness',[38]) who was promoted by Hitchcock in response to the 'walking, wriggling and giggling embodiments of Dr Kinsey's findings'[39] of rival studios. The expanding universe of the mass media began to be an important source of images which, made by men, were influential in the formation of contemporary male consciousness.

In more serious relationships with women and when it came to dealing with the frustration to which Eardley refers, my tactics were silence, walking away, a refusal to talk which concealed an inability to know *how* to talk. As a last resort it was always possible to break off a relationship, to 'cut dead'. This bred a detachment and alienation in relating to both men and women, and I found some support for such a stance in the anger of Osborne and Braine, Amis and Sillitoe. But the rebellion of *their* heroes came from working-class origins and was directed against the constraints and hypocrisy of the class I inhabited. It was not till later, in America, I read in Riesman's *The Lonely Crowd* a rationale which I thought explained my outsider feeling.

POSTSCRIPT

Sexual intercourse began
In nineteen sixty-three . . .

Between the end of the *Chatterley* ban
And the Beatles' first LP.[40]

In 1959 I came back from North America to teach classics and cricket at
Wellington. I brought with me a copy of *Lady Chatterley's Lover*, still
banned in Britain. It was of added interest because it included the
summings-up of defence and prosecution in the American trial, and I
was sorry when, during the following year as the British High Court
case brought the novel to prominence, my copy disappeared,
'borrowed' no doubt by a boy. A day or so later, the Master, having, I
assume, come upon my copy, promulgated his own ban. I regretted
having unwittingly played a small part in repression. My leaving
present a year or so later from the boys in the dormitory of which I was
'under-tutor' included a Beatles record. By then I had met and married
a woman who found Wellington unbelievable. If I felt the same way
about teaching Latin, a language no one spoke, perhaps the last straw
for her was being asked by the Master's wife to arrange the Chapel
flowers. That was 1963. Twenty years later, contemplating a trail of
broken relationships, including divorce, I began the work of asking the
reason why. More than merely my psychic health was at stake. The
power of public men, I argued about this time,[41] resides largely in an
ability to split head from heart, the personal from the public, to deny
the feminine within and thus half their humanity. Such splitting has
consequences that go far beyond a sad reproduction of proxy fathering.
Mine is the generation that inherited, then institutionalized, the Cold
War, whilst presiding over the pollution of the planet and the
squandering of its resources. To change destructive male behaviour is a
hard, but urgent task. Equally hard is to find a way of encouraging and
celebrating the good in men.

NOTES

1 Thomas Hughes, *Tom Brown's Schooldays* (1857), Harmondsworth, Penguin,
1983).
2 Raymond Williams, *The Long Revolution*, Harmondsworth, Penguin, 1984,
p. 64.
3 See the chapter on 'Male Hysteria', in E. Showalter, *The Female Malady:
Women, Madness and English Culture 1830–1980*, London, Virago, 1985.
4 N. Chodorow, *The Reproduction of Mothering: Psychoanalysis and the Sociology of
Gender*, Berkeley, University of California Press, 1978; T. J. Carrigan and
R. W. Connell, 'Freud and Masculinity', unpublished paper, Macquarie
University, 1984; R. W. Connell, *Which Way is Up: Essays on Class, Sex and
Culture*, London, Allen & Unwin, 1983; R. W. Connell, 'Theorising

Gender', *Sociology*, vol. 19, no. 2, May 1985; A. Metcalf and M. Humphries (eds), *The Sexuality of Men*, London, Pluto, 1985; Jennifer Somerville, 'The Sexuality of Men and the Sociology of Gender', *Sociological Review*, vol. 37, no. 2, May 1989.

5 Carrigan and Connell, 'Freud and Masculinity'.

6 Harold Nicolson, 'Pity the Pedagogue', in G. Greene (ed.), *The Old School: Essays by Divers Hands*, Oxford, Oxford University Press, 1984 (reprint), p. 91; R. St C. Talboys, *A Victorian School*, Oxford, Blackwell, 1943, p. 74.

7 G. and E. Romilly, *Out of Bounds*, London, Hamish Hamilton, 1937, p. 304.

8 T. C. Worsley, *Flannelled Fool* (1967), London, Hogarth Press, 1985, p. 123.

9 My contemporary, John Moat, recalled this regime in 'Good Schooling', *Resurgence*, no. 118, (Sept./Oct. 1986).

10 Thanks to Mike Roper for this insight.

11 See e.g. Anthony Giddens, *Social Theory and Modern Sociology*, Cambridge, Polity Press, 1987.

12 Paul Fussell, *The Great War and Modern Memory*, Oxford, Oxford University Press, 1975, cited in E. Showalter, *Female Malady*.

13 Fraser Harrison, *Trivial Disputes*, London, Collins, 1989, p. 68.

14 I draw in this section on Christine Heward's study of Ellesmere College based on an analysis of correspondence from 1929 to 1950 between parents, boys and the headmaster, *Making a Man of Him: Parents and their Sons' Education at an English Public School 1929–50*, London, Routledge, 1988; on John Wakeford, *The Cloistered Elite: a Sociological Analysis of the English Public Boarding School*, London, Macmillan, 1969, based on his experience in the 'research school' as a pupil in the 1950s, with follow-up fieldwork in 1962–3 (Wakeford draws extensively on Goffman's study of 'total institutions' – Erving Goffman, *Asylums: Essays on the Social Situation of Mental Patients and Other Inmates*, Harmondsworth, Penguin, 1978); on Royston Lambert's study of sixty-six boarding schools seen through the eyes of pupils interviewed in the 1960s, *The Hothouse Society: an Exploration of Boarding-School Life Through the Boys' and Girls' own Writings*, London, Weidenfeld & Nicolson, 1968; and on Fraser Harrison's account of his time at Shrewsbury from 1958, Harrison, *Disputes*.

15 *Flannelled Fool*, p. 123.

16 Lambert, *Hothouse Society*, pp. 329f; Alec Waugh, *The Loom of Youth*, London, Methuen, 1984.

17 Lambert, *Hothouse Society*, p. 313.

18 Dr John Bowlby, *Childcare and the Growth of Love*, (1953), Harmondsworth, Penguin, 1970. For the book's effect on schools and parents in the 1950s, see Heward, p. 90, and for its effect on the general public, my namesake Peter Lewis's *The Fifties*, London, Heinemann, 1978, pp. 45f.

19 A. Tolson, *The Limits of Masculinity*, London, Tavistock, 1977, p. 46.

20 Heward, p. 125.

21 *Disputes*, p. 125.

22 Waugh, *The Loom of Youth*, London, Methuen, 1985, pp. 222–3.

23 Sophocles, *Ajax*, lines 679–83 (my translation).

24 Tolson, p. 39.

25 'Men's Bodies', in Connell, *Which Way Is Up*.

26 Heward, p. 194.

27 Heward, p. 195.
28 For accounts of National Service see B. S. Johnson, *All Bull*, London, Allison & Busby, 1973; D. Lodge, *Ginger, You're Barmy*, London, Secker & Warburg, 1962; D. Morgan, *'It Will Make a Man of You': Notes on National Service, Masculinity and Autobiography*, Studies in Sexual Politics, University of Manchester, 1987; T. Royle, *The Best Years of Their Lives: the National Service Experience 1945–63*, London, Michael Joseph, 1986. For the period generally, see Peter Lewis's *The Fifties*, and L. Segal, 'Look Back in Anger: Men in the 50s', in R. Chapman and J. Rutherford (eds), *Male Order: Unwrapping Masculinity*, London, Lawrence & Wishart, 1988.
29 Morgan, *'It Will Make a Man of You'*, p. 51.
30 Showalter, *Female Malady*, p. 173, cites Sandra Gilbert on the quasi-Victorian confinement of the trenches in the First World War: Sandra M. Gilbert, 'Soldier's Heart: Literary Men, Literary Women, and the Great War', *Signs*, vol. 8 (1983), p. 423.
31 R. Wulbert, 'Inmate Pride in Total Institutions', *American Journal of Sociology*, vol. 71, no. 1 (July 1965), cited in Wakeford, *Cloistered Elite*, p. 249.
32 'Ranking Rituals', 'Removal activities' in Goffman, *Asylums*; 'Get some in!': see Morgan, *'It Will Make a Man of You'*, p. 30.
33 Morgan, *'It Will Make a Man of You'*, p. 30.
34 Lodge, *Ginger, You're Barmy*, p. 126. The novel was published in 1962. In his 1982 introduction Lodge explains the contemporary need to disguise swearwords.
35 Compare Tolson, p. 77.
36 *The Sexuality of Men*, p. 101.
37 Elizabeth Wilson, *Mirror Writing: an Autobiography*, London, Virago, 1982, p. 49.
38 Alfred Hitchcock, cited in Ann Shearer, 'All Shades of Blonde', *Guardian*, 18 February 1985.
39 P. Lewis, *The Fifties*, p. 53.
40 Philip Larkin, 'Annus Mirabilis', in *High Windows*, London, Faber & Faber, 1974.
41 Peter M. Lewis, 'Power and the Public Man', paper in series of Institute for Contemporary Arts discussions, *What Do Men Want*, 14 March 1985.

9

YESTERDAY'S MODEL

Product fetishism and the British company man, 1945–85

Michael Roper[1]

Historians have often discussed material culture in relation to femininity, but the same kind of attention has not been focused on masculinity. Preoccupied with understanding how we arrived at a contemporary dichotomy between production as a male domain and consumption as a female domain, work on gender relations has charted the concentration of men in technical occupations, but has tended to overlook the relationship between men and objects. Yet the process of manufacture and the pleasures it entails are highly gendered. Industrial production is fuelled by a masculine delight in things mechanical.

The manifestation of identity in products is an enduring theme of industrial history. For example, Marx's concept of alienation hinges on a recognition of the intense pleasure which people gain through production. Production as 'human beings' entails the affirmation of selfhood and, through the creation of mutually desired goods, brings membership of a community:

> 1) In my production I would have objectified my individuality, its specific character, and therefore not only have enjoyed an individual manifestation of my life during the activity, by also when looking at the object I would have the individual pleasure of knowing my personality to be objective, visible to the senses and hence a power beyond all doubt.
> 2) In your enjoyment or use of my product I would have the direct enjoyment both of being conscious of having satisfied a human need by my work, that is, of having objectified man's essential nature, and of thus having created an object corresponding to the need of another man's essential nature . . . Our products would be so many mirrors in which we saw reflected our essential nature.[2]

190

Although Marx speaks here of 'man' in the generic sense, he is nevertheless also articulating a link between the male sex and the psychic fulfilments of production. In a capitalist economy the spiritual bond between 'man' and products would gradually be eroded. Alienation strikes at the very roots of masculine identity; Marx argues elsewhere that it is a state in which 'begetting' becomes 'emasculating'.[3] Conversely, an economy which allowed the free play of human production would empower men by providing objective evidence of 'personality' in the form of products. In such an economy the exchange of products would affirm 'our essential nature'.

Labour process theory has drawn attention to the way in which alienation is rooted in the division of labour itself; in the splitting of production into conception and execution, mental and manual labour.[4] However the index of alienation as Marx describes it here is not just the design or content of jobs but also the possibility which work offers for claiming 'ownership' of products. Alienation entails both the creation of increasingly repetitive, meaningless jobs and the symbolic appropriation of products by management. While the possibilities for psychic fulfilment from production have been steadily eroded for workers, the opposite is true for managers. Managers oversee the progress of goods over a much greater physical distance in the production cycle than workers do. Furthermore, managerial work provides scope for influencing the shape, form and presentation of products. Design, production, marketing, sales; these are administrative labels, but also tasks providing control over products, and hence opportunities for creativity and the investment of personality in goods.

Control is not the only source of motivation in managerial work. Job satisfaction for the manager derives not only from the exercise of power over other people but from a privileged access to the creative aspect of 'making things'. Masculinity enters into the very heart of this construction of the manual/managerial divide, differentiating the relationship and extent of autonomy between workers and managers. In his study of northern engineering firms, Paul Willis points out that male shopfloor workers often achieve a sense of empowerment by valorizing their endurance of noisy, uncomfortable, and often unsafe work.[5] They claim masculinity from their daily battles with the machinery of production. For male managers it is not possible to claim status from 'hard' work in this way. At one remove from the physical work of production, they seek masculinity instead from the fruits of manual labour. Control of the manufacturing process as a whole enables managers to 'steal' the psychic delights afforded by products.

While product fetishism is a continuing dynamic of industrial management, its character differs between generations and sectors, and has been influenced in the longer term by shifts in capital. At the end of the Second World War Britain was still dominated by family firms. Of the ninety-two largest British firms in 1950, over half were controlled by one family, but by 1970 that figure had fallen to 30 per cent.[6] The transition to a corporate economy had a dramatic effect on management structures, business education, and the nexus between masculinity and production. For the post-war generation of managers, early career involved the acquisition of 'hands-on' knowledge about production and products. Product fetishism acquired a generational dimension during the 1970s and 1980s, as the company man was gradually overtaken by managers who were business-school educated, and who spurned object-related, experiential knowledge in favour of financial expertise. This conflict between older and younger men centred on products, the older generation feeling that their profit-conscious juniors had tried to take away 'their' toys.

Focusing on the accounts of career managers who entered British industry during the 1940s and 1950s, this chapter explores how the eclipse of family capitalism helped foster a particularly intense bond between men and objects.[7] The first section discusses present manifestations of product fetishism, and the theoretical approaches which can help us illuminate them. From there I turn to the historical context in which the post-war generation pursued their careers. Finally, more recent conflicts over business strategy are examined, for the debate over whether managerial authority should reside in formal skills or in product fetishism not only illustrates generational differences but also reveals two competing versions of masculinity.

It was the physical setting and drama of fieldwork which initially raised my curiosity about the nexus between managers and products.[8] I would often emerge from interviews puzzled and slightly dismayed by the fact that while I knew a great deal about what managers did, had indeed often seen them 'at work', their life-histories remained obscure. What managers *did* seemed embodied in products, which were shown to me by way of confidences, revealing enthusiasms and desires which had not been articulated in words. The currency between me and them was thus objects, perhaps timing belts for car engines, landing gear for aircraft, welding equipment, or in the case of production managers, process equipment. Reminiscences about products brought them to life, posing questions about the historical dialectic between masculinity and products.

Taking the process of what happened in interviews as my cue, it soon became apparent that there were two dominant manifestations of product fetishism. Products seemed to act as landmarks in memory, orienting managers in relation to their career history, and so bringing their past to life for the interviewer. Post-war boom, takeovers during the 1960s, and recession in the early 1980s, were recalled in the context of how they forced a realignment between company loyalties and products. At another level products helped engender a sense of selfhood, and anchored male friendships. They were thus mediums of both economic and social exchange.

Product fetishism was often apparent immediately on entering a place of interview. Surrounding the boardroom walls of a brazing company for example were a series of spectacular framed photographs of welds, in which tinted steel formed the backdrop for brilliantly coloured sparks and flame. During our interview the founder-owner Mr Trilling used them to illustrate changing techniques and technology during his career. The sequence included arc welds, brazing, MIG welds, and concluded with the latest plasma technology. The pictures provided decoration and offered Mr Trilling a means of dovetailing his life history and that of the industry, at the same time conveying very vividly the power and potential of technology.

The interweaving of self and product in this way is equally apparent with retired managers, who on leaving work often took objects of production with them. In such cases the original function of the article might become entirely subordinated to its symbolic and aesthetic function. The image serves as a memento of the company and expressed loyalty to it. Perhaps the most startling example of this was Mr Wright, a retired refinery manager with Swan Oil. A glance around his home revealed the company logo emblazoned like a coat of arms on lounge and dining room furniture, and even on the bathroom soapholder, towel rail and basin. Wright's fidelity to his past employer knew few bounds.

Equally revealing were the retirement gifts which he showed me after the interview. Dominating the hallway was a grandfather clock, its face and cabinet engraved with the company symbol. Wright explained that all the components, from the mechanism to the cabinet, had been handcrafted by 'his boys', the apprentices at Swan. Some two years prior to his retirement they had secretly begun work on this testament to their time-keeper and 'grandfather' of the workshop. In the lounge was Mr Wright's favourite gift, a whisky dispenser which had been presented by his fellow managers. The oak cabinet (Mr Wright's favourite wood) took up a whole coffee table and was

surmounted by a large brass pipe and stopcock. Just like a refinery it was designed to regulate liquid flow; an electric pump could dispense a single, double or triple whisky. Like a refinery it had built in fail-safe mechanisms, and would not operate unless a heavy bottomed whisky tumbler was placed beneath the nozzle. Affixed to the side of the cabinet was a brass plaque with a tribute to Mr Wright on it, inscribed with the names of his colleagues. The dispenser brought together the diverse elements which had constituted Wright's enjoyment of work, at one level commemorating his departure from the world of production while at another level bringing the machinery of production into his home. Wright had gained possession of his own little refinery, complete with working components. A working model of his career past, it expressed a deeply felt link between aesthetic beauty and the machinery of production.

From another perspective we might view the gift as a celebration of male companionship. Where the grandfather clock expressed vertical hierarchies between men, based on class (apprentice/scientist) and age ('boy'/'grandfather'), the whisky dispenser represented fraternity. It worked the managerial prerogatives of control over labour and process machinery into a shrine to virility. From the source of their shared pleasure, that magnificent shiny phallus, flowed whisky, the corporate man's medium for socializing. The gift from his fellow managers offered the promise of continued potency despite Mr Wright's retirement, while at the same time elevating the product as an object of shared male desire.

In general I was struck by the number of models which adorned offices. Sometimes these were full-scale, enabling visitors to view, *in situ*, components manufactured by the firm. Blurring the distinction between toys and machines, managers also often displayed miniature images of products. Business commentators during the 1960s often remarked on similar phenomena. For example in his portrait of Lord Stokes, Anthony Sampson noted that the ex-engineer and Managing Director of British Leyland had a collection of model buses and trucks on his desk.[9] Similarly, the desks of managers in my sample featured cars, trucks and aeroplanes on stands.

In comparison to the way my attention was drawn to products, it is striking that I could only vaguely remember what the men themselves looked like. Facial details were recalled easily enough, and I retained a general impression of size and height. While I registered that men invariably wore 'correct' attire, in other words a suit, I rarely left interviews with a strong image of their bodies.[10] Perhaps as a student I

was simply insensitive to the nuances of middle-age male office dress. At the same time however, there seemed here a kind of conspiracy to hide the male body, to neutralize and rob it of objectivity. As Rosabeth Kanter has observed, the suit and tie facilitate the sublimation of individual needs and desires to bureaucratic procedures and loyalties.[11] On a visual level the suit helped to deflect my attention from the male manager and his personality to the firm and its products.

The neutrality of the suit exploits a masculine ability to objectify others but keep its own sexuality out of view. There is a direct relationship between sex and dress here, since the ability to show off the body is regarded by this generation – particularly those in heavy industry – as a feminine privilege. The managing director of a Midlands automotive firm revealed this in his comment that while our interview had been interesting and enjoyable, I had 'overdressed'.[12] Throughout our session Mr Dowell had praised the heroism and ingenuity of engineers like his father and grandfather, contrasting them to financiers, civil servants or academics. While engineers 'actually produced' wealth, the latter groups merely provided services, and were lesser men by implication. As a non-worker I fell completely outside the pale of masculinity. My attention to dress confirmed this gender order, for it made me into an object of aesthetic attention, and indicated that I was a consumer; both attributes signifying femininity in this man's mind.

Like many other managers, Dowell was surrounded by table-top models and photographs of his company's products. His views, personal appearance and the work environment he had created, reflect those of his brothers. While the businessman's uniform of this generation understated and de-sexualized the male body, products were 'dressed up' and colourful.[13] Products rather than men formed the visual and symbolic focus of the office landscape. Making products desirable is of course essential in an economy based on creation of demand, for if goods are to sell they must excite the consumer's passions. The manager's regard for the technical and aesthetic merits of products should not be dismissed as mere marketing, however. Products occupy a special place in the managerial psyche because they embody commonality with others, proprietorship and fruitful labour. While the nexus between pleasure and product is of course not exclusive to post-war managerial entrants, or to men, it was accentuated by economic changes which this generation witnessed during their careers.

This symbiosis between men and 'man-made' goods informs both the manager's individual identity and management cultures as a whole.

Marx suggested this above in his perception that psychic and social identities are forged through relationships to products. Products may 'mirror' man's personality, reflecting selfhood and confirming individual identity, but equally they may be *objects* of his pleasure, providing evidence of man's 'essential nature' by drawing attention to the creativity and humanity of others. Products occupy a grey space between the self and others, internal life and the environment. They are sometimes represented as extensions of the self, and at other times represent the 'not me'. In this respect they have the ambiguous but highly significant quality which D. W. Winnicott ascribes to the transformational objects of infancy.[14] Symbolizing the interdependence of self and others, at the same time they engender a realization of individuality and separateness. Hence as we saw in the case of Mr Wright, sometimes representations of the product may be phallic, and sometimes, as in the tradition of naming machinery 'she', they may invoke images of femininity. The diversity of these illustrations reveals that at a psychic level products are polymorphous. They may represent women, fellow managers or 'issue'. Sometimes they express potency and sometimes they are objects of desire.

Diversity and contradiction are the hallmarks of product fetishism, and this should make us wary of drawing simple conclusions about the relationship between men's fantasies and their social power in the workplace. But the link is absolutely critical, since the joy of making things for this generation derived partly from the way it enabled them to appropriate 'feminine' qualities, rendering women themselves superfluous. Women's servicing labours in the home and at work freed male managers to experiment through objects with the panoply of gender identities. Placing goods at the centre of their emotional and work life, the post-war generation expressed masculinity through sophisticated play. Today the wheels of industry are still driven by a power structure in which, through their intimacy with products, male managers reap rich psychic and financial rewards.

An explanation of why the post-war generation placed such emphasis on their intimacy with goods as a source of social power and psychic well-being requires that we explore the historical context in which they spent their careers. Two interwoven themes were particularly important in shaping their responses to work. First was the relationship between economic and career cycles. Feelings of youth/empowerment and old age/decline were reinforced by the fact that interviewees began their careers during the post-war boom, and entered late career

during the slump of the early 1980s.[15] Nostalgia for youth sometimes took the form of lamentations about the decline of products. Second, the advent of a corporate economy, in particular the frequency of takeovers during the 1960s, forced a realignment of the nexus between company loyalties, masculinity and products.

The remainder of this chapter explores in more detail how the post-war generation narrated their life histories. It begins with early career in the 1950s, moves then to the 1960s, and ends with the early 1980s recession. From their accounts emerges a complex picture about the historical conditions governing product fetishism. Past merges with present however since, as we have seen, products also acted as metaphors for the telling of life history. Products may be both the subject and agent of career narratives.

In the family firms which dominated Britain's economy until the 1960s, products were often treasured as embodiments of the founding father's wisdom and vision. Associated with this was a disdain for formal management training, in favour of a lifetime's involvement in the business. As D. C. Coleman has pointed out, the 'gentleman amateur' tradition celebrated hands-on invention and experiential knowledge.[16] Skill was codified in products, which also represented the company history and family lineage. For the ex-managing-director of a sugar refining firm, maintaining product quality was a vaunted family ritual:

> I tasted the golden syrup every day, like my uncle before me. And if the flavour was off, 'Why?' During the war we had to change the process because of a shortage of something or other. And my cousin came back from the war and said 'The flavour has altered. You've altered it'. And we said 'Yes'. And he said 'Don't F. . . about! Bloody well go back to the original process.' 'It'll cost more.' 'It doesn't matter. Go back to the original recipe.' And he was right; only way to maintain the standard.

This conception of the manager's role as guarantor of products and company traditions grew out of family capitalism but was adopted by career managers in both public and family firms during the post-war period. Product-related knowledge provided them with a source of pride and authority, bridging their status between owners and workers. Such knowledge depended on life service, the expectation of which was fostered from the moment graduates began their careers. New recruits usually underwent a 'Cook's tour' where they worked in various manufacturing divisions gaining knowledge about their own

capacities and the firm's product range.[17] Lasting up to two years, the Cook's tour was a substantial investment in future service. It succeeded in its aim, for even today the most vivid, exciting memory of all remains that first introduction to colleagues and the plant. The Cook's tour soldered ties between the firm, its wares and its future managers.

The economic climate of the 1950s reinforced such links. Boom conditions meant that companies were working to capacity and that new products and plant were constantly under development.[18] Managers recalled the excitement of being thrown straight into jobs on the frontiers of new technology. They were often sent to distant and exotic locations like the Middle East, Far East, South Africa or Australia, where they helped set up new plant and markets. Expansion, youthful camaraderie and the feeling of being in on something new, combined to generate a heady sense of the fulfilment production could provide. The young graduate Mr Greenwood was part of a team at Swan Oil which had been sent in to rebuild a refinery after an explosion. The company 'crashed' resources on the plant:

> Because this was a crash programme, we were building without designs; they were designing behind us. It really was a major exercise. You were demolishing, building . . . You wanted to be back on stream, and we would break every rule that existed, but not doing it without thought. We had a whole, whole massive team of fellows we'd got there. Very very good fun.

By providing opportunities for empowering, creative employment with other men, post-war boom intensified the affection which managers felt for their firm and its products. The sheer, manic pace of production; the work of 'demolishing, building', was extremely seductive.

The traditional dominance of engineering over finance or marketing in British manufacturing provided a further basis for the expression of masculinity in products. Business historians have often attributed the poor performance of manufacturing firms during the 1960s to this preference for technical excellence, and disdain for modern management techniques. Graham Turner remarks that the engineer's 'dominance' meant that products 'were often developed for their own sake rather than because they were going to be profitable'.[19] The tension between finance and engineering has remained a constant theme in management literature over the past two decades, but its gender dimension has been overlooked.[20] Through his long association with

engineering functions, the post-war company man acquired a rough but manly status which he asserted over his social superiors and trained 'boy' managers. Management in heavy industry, particularly, was imbued with a masculine ethos which championed technology, and regarded 'accountants and salesmen . . . as lesser breeds of men'.[21]

During the 1960s, 'merger mania' hastened the shift towards a corporate economy, threatening the nexus between masculinity and products. There were on average 564 mergers per year in this decade, many of them in industries like textiles, electronics and construction which had previously been dominated by family firms.[22] The takeover boom went hand in hand with the introduction of more sophisticated financial management techniques, and resulted in considerable 'rationalization' of product lines. As the management consultant John Tyzack remarked at the time, 'once again . . . profit has not only become respectable but desirable'.[23] The effect of takeovers on the post-war generation was equally far reaching. It could generate job insecurity if a manager belonged to a firm being taken over, but equally created opportunities for those in acquisitive companies.[24] Either way it increased job mobility and placed the tenets of family capitalism – in particular the notion of life-service – under strain.

Because they opened senior management up to talent, one might have expected career managers in family firms to view takeovers as a liberating force. They often seem to have had the *reverse* effect however, bringing owners and career managers together in an assertion of the firm's traditional goals and values. Displeasure may have centred on fears about job security, but career managers expressed it by becoming protective of 'their' products. This is illustrated by the cases of Mr Baker and Mr Higgs, both of whom were career managers at Jennings Windows. In 1965 Jennings had merged with another family firm, but, typically of such mergers, there was no divisional re-structuring and in some markets the two companies continued to compete. The merger had been a way of beating off hostile takeovers while maintaining a strong family presence in each firm. Then in 1968 the newly merged company was taken over by a 'corporate raider' who proceeded to sack staff and sell off parts of the business.

Neither Baker or Higgs was sacked; in fact Mr Baker felt he had benefited from the reorganization of promotion and pension schemes which the new owners instituted. But both perceived the takeover as a threat to job security and a long-standing 'affinity' between family and employees. Profound attachment to the family culture went alongside recognition that the firm had in many respects been archaic; its senior

management closed to non-family members and ignorant of modern accounting techniques. This affection, and more directly, the hostile character of the takeover, is indicated by the sexual metaphors which they employed to describe it. While these are by no means consistent, there is an underlying conception of family capitalism as a union between employer parents. While the father represented ownership, productive capacity was associated with femininity. Takeover represented a breaking-up of the family in which the fruits of union, the products, were threatened.

The first merger in 1966 did not alter the partnership which had previously existed between the two sets of employer parents. Mr Higgs explained that it was a 'top merger. We didn't get into bed at all'. Mr Baker's explanation confirmed the metaphor: 'It was like a marriage and the couple never got into bed together, never consummated the marriage.' The point emphasized by both men is the absence of passion. Whilst the two firms had embraced each other from the 'top', there had been no intercourse and no 'issue' in the form of products. It was a marriage of convenience whose sole purpose was to assist the survival of separate regimes.

Managers at Jennings described the second, hostile takeover in precisely the opposite terms to those generally employed by business historians. Instead of bringing a backward looking, paternalistic firm into the age of corporate capitalism, the takeover was retrograde. 'Cruel' young 'hatchet men' were called in to reorganize Jennings, which they did by metaphorically murdering the 'father' and violating his 'assets'. Mr Baker explained that the 'marauder' had 'married this rich widow, and it was like going back to feudal property rights; that the wife had no rights at all. And so he married this rich widow and stripped her of all her assets, and said "Well, I've done the best for you my dear, you're on your own now." Which is what happened. He creamed it, didn't he?' The memory provoked a more hurt reaction from Mr Higgs: 'They raped Jennings and then chucked them out into the cold again, eventually after raping them, taking all their assets. Yes, it was a classical asset–stripping exercise.' Again and again here, metaphors of rape and despoliation reappear. Concern focused on the stripping of 'assets'; that is, the violation of creative capacity. The removal of capital in turn discouraged product development. Under the new regime 'products suffered badly, there's no doubt about that'. Asset stripping struck at the very roots of creativity in work:

One of the hardest things in my career has been to adapt from a

man who makes good windows to a man who is selling
profitably. And they're two different things. I mean Jennings
were proud of the fact that they managed to make good
windows. The fact that they managed to make damn good profits
as well was . . . I suppose it was good management but it was
[also] good luck in a way I suppose. They thought of themselves
first of all as makers of good windows, not as makers of money.
They did make money.

One's whole upbringing was that Jennings made a good
window. Anyone could make a window cheaper than us if they
wanted to, but we sold a good one at a good price. It's been a
hard lesson to learn that you're not in business to make a beautiful
product, you're in business to make money for your shareholders
. . . I find it rather hard to reconcile myself to the Mammon
aspect of it. I'd far rather be making a good window . . . I'm not
so naive as not to realize that you've got to make a decent profit
on your product, but I'd still be happier making a good window
than making a lot of money.

It is tempting to interpret this passage as yet another example of the
necessary trauma involved in dragging the British economy into the
twentieth century. Martin Wiener would doubtless see in Higgs's
statement a further confirmation of the 'English disease': implicit
distaste for making money and a preference for aesthetic consider-
ations.[25] But to adopt such a stance ignores, first, the deep-seated
connection between masculinity and technical creativity among career
managers of this generation, and, second, the extent of psychic scars
inflicted by their successors.

A desire to produce beautiful windows pushed career managers at
Jennings to new heights of technical endeavour. The traditional
management culture successfully exploited the relationship between
innovation and masculine delight in things mechanical. 'One's whole
upbringing' in the firm taught post-war entrants the value of in-house
knowledge about how to make and appreciate a 'beautiful product'.
Takeovers helped push to the fore a new generation of men and
managers, who attempted to destroy the ethos of family capitalism by
severing ties between products and managers. The older generation
narrate this story in terms of fantasies about domination. Accountants
and economists are 'hatchet men' who have castrated the older
generation by denying them the pleasures of invention. Lacking the
capital to influence the course of change, and coerced into 'making a

lot of money for other people', men like Higgs and Baker lost a source of beauty and well-being.

Far from shaking the older generation's faith in products, financial uncertainties in the 1960s sometimes intensified it. Managers like Baker and Higgs subverted the new order by perpetuating pre-takeover traditions of pride in the product. Higgs has reacted to the takeover by manoeuvring himself into a position where he can once again exercise aesthetic control. While the actual standard of goods might be beyond his grasp, he can at least guard the company's reputation and traditions:

> I regard myself also now as the keeper of the company's external image; its guardian . . . Making sure that its livery looks right, that any output from the company is in keeping with our standards. You can't catch it all, but you try and make sure. Without ever making much fuss about it I've managed to grasp most of that to myself now, so that I can see that the company's logo is used properly, and is used where it should be, and the company's products are described by their right names and not by some fancy code name. All those things where it is important that the company is seen to be expressing itself and is visible in the right way.

Higgs has carried forward the family company 'livery', its traditions of quality and workmanship, and in a finance-dominated environment has transformed them into saleable assets. By appropriating *images* of the product, he has succeeded in reconciling the 'Mammon aspect' of managership with creative satisfaction. Trading on icons and traditions, Higgs has achieved liberation from the whims of ownership.

We have seen that management cultures which celebrated technical excellence were often also those in which there was an expectation of life-service. This kind of product fetishism not only survived the increase in job mobility during the 1960s, but could be a decisive factor for managers who chose or were forced into changing employers. Mr Gidley is one example. He wanted to stay in the firm where he began his career in 1961, but after it was taken over in 1967 he became increasingly disaffected with the management. In 1973 he moved to Plastex, a newly established plastics moulding firm. They offered him only a slight salary increase, but, drawn in by the 'technical merits' of the product, he took the job.[26]

Where Mr Higgs depicted the product as a vulnerable child in need of protection, Mr Gidley viewed it as a kind of temptress. It seemed to

beckon him over, banishing financial and other considerations from his mind:

> Every salesman dreams of having a product which is unique. Nobody else has it, or if they do they can't compete technically. It gives no pleasure to a salesman to sell anything on price. That's not real selling in my book, particularly if you're selling a technical, semi-technical product. So the challenge was to sell on technical merits. And by doing so, of course, to achieve a much higher profit margin. So that was the fascination . . .[27]

In his preference for products over profit margins, Gidley here voices the sentiments of his generation. Making money is not the aim of managerial work, it is simply the outcome of enjoyment in technical wizardry. Such accounts seemingly confirm Wiener's comment that British businessmen were disdainful of salesmanship.[28] More than mere snobbery is intimated in this passage however. We also see an echo of Marx's comments about the satisfaction of psychic drives through production. Gidley draws constantly on a language of romance and eroticism. The perfect product is a 'dream' which provides 'satisfaction', 'challenge', 'fascination' and 'pleasure'.

Gidley's comments reveal a close link between status and an attractive product. In an obvious sense this is because a 'unique' product enables its seller to dominate the market and so better his or her career. However such an interpretation does not explain the psychically charged language of the passage. A further interpretation would be that a beautiful object also transforms its possessor in the eyes of other men. Gidley points out that '*every* salesman dreams' of the perfect product. Dreams turn the salesman himself into an object of shared male pleasure. Akin to the Hollywood tradition of fights between men for possession of women, business celebrates the undercurrent of competition between men in the search for unique beauty.[29] Satisfying desires for the 'other', products also satisfy homoerotic desires by joining men in their quest for objects of mutual regard.

In the longer term the nexus between masculinity and products was eroded by economic uncertainties and the accountants' drive for profitability. Recession in the 1970s affected the competitiveness if not the continued existence of products, and further undermined the possibility of long-term service. Managers of this generation sometimes responded by continuing to pursue the 'unique product' as, one by one, companies fell victim to the vicissitudes of the market. After three years with the plastics moulding division of Plastex for example, Mr

Gidley was forced to accept a promotion to a division which was not selling 'a prestige product quite the same way that I had been before'. He was unhappy there and soon afterwards determined to leave. His next job was again chosen on the basis of technical merit. Gidley expressed a sense of having been seduced, the attractions of the product leading him to ignore questions of financial security or managerial competence in the new firm:

> It was the Rolls Royce of plastic packaging . . . It commanded the cream of the market but the market could no longer afford such packaging. It came from an expensive raw material, imported largely from the States . . . The upshot of that was that the company went into receivership only a year after I'd joined. And very shortly before that I was made redundant. That was in 1980, and at that time it was practically impossible to find a job.

Sixteen per cent of the sample were made redundant in the early 1980s.[30] For this group, memories of the recession could not easily be separated from personal depression. Injury at being cast aside, or 'put out to grass' as one called it, was expressed in lamentations about Britain's failure to maintain its technological lead. The 'cream of the market' had soured and they had become old men, impotent to introduce new lines or defend yesterday's models.

With decline of the product went decline of the nation, a particularly poignant fact for this generation because of the incursions which foreign producers – especially those whom they defeated in the war – had made into British markets. Their advances placed those conscious of 'technical merit' in a paradoxical situation. They resented the dominance of foreign goods but could only admire the quality of design and workmanship. One man remarked that he wished his firm could attain the kind of quality control which the Japanese had been able to achieve by building up production volume. Similarly, the managing director of a truck distributorship who had remained loyal to British firms was angry about their tardiness in keeping up with overseas advances. The British manufacturers

> didn't change much after the war . . . Gave them a heater in the cab and such luxuries as that, and said to the driver 'Think yourself lucky'. Out came the Scandinavian vehicles with sprung seats, heated mirrors, *comfort*, tilted cabs, all manner of things. And industry in this country looked at it and literally pooh poohed it.

Mr Lloyd's loyalty to the local truck industry did not extend to his personal transport however, a realm in which he allowed his product fetishism free reign. He had gone for a French vehicle because the combination of features he desired – automatic transmission and a turbocharged diesel engine – was unavailable in British vehicles.

Today the post-war managerial entrants retain their keen sensitivity to technical aesthetics. It has survived declining competitiveness, the vagaries of company ownership and even redundancy. This struck me most forcibly in the case of Mr Gidley. After a traumatic eight years involving two redundancies, it appeared that he was about to be made redundant yet again. The division of the British company for which he worked had been sold to an American firm and it was probable that headquarters would be relocated there. Gidley resented having put so much into the company without a promise of job security, yet continued to work inordinately long hours. An entire wall of his office was lined from floor to ceiling with tins of paint, all neatly stacked with the labels facing forwards. I puzzled over this until Gidley explained proudly that the logo had been his own design. In the face of yet another corporate betrayal of his old-fashioned loyalty, it had been important to demonstrate intimacy with the product. Mr Gidley seemed to view the logo as a kind of signature, a personal claim inscribed on the product.

Whilst managers such as Gidley continue to hold the product close to their hearts, the epoch of the technical man is undoubtedly over. The product provides small solace in an era where as one explained, older managers are sometimes forced into playing second fiddle to 'younger chaps from the business school', who wished to 'sweep them out of the way'. The younger generation are blamed for severing the nexus between national pride, company loyalty and product worship. Traditional morality combined patriotism and paternalistic work traditions such as life-long service, and expressed them through shared affection for products. Goods formed the basis for moral precepts and a community of men. Motivated by private gain alone, today's managers prostitute themselves. They are loyal to neither nation nor 'governor'. Worse still, they feign their fathers' passion for the product:

> Reps . . . they've got no allegiance to a company or a product. If you were a rep and came to me and said 'I'd like to sell Seddon Atkinson trucks', and I said 'Alright. I'll give you £5,000 a year, Michael, and I'll train you to sell Seddon Atkinson trucks', you'd say, 'Yep, Seddon Atkinson's the best thing since sliced bread.'

Out you go, and six months later you come in and say 'Sorry governor, I'm going off to sell Volvos.' 'Why is that?', I'd say. 'Well, they're going to pay me £6,000 a year' . . . And I say to myself 'how the hell can that man go in to a customer and say 'Seddon Atkinson's the best thing since sliced bread'. Six months later he says 'Seddon Atkinson's terrible. Volvos are the greatest.' Six months after he's back in there again, 'Volvos, Seddons, terrible things. Scanias, great!'

How can a man do that? There's no *faith* in the man that's buying the truck, in the guy that's selling it to him! Don't like that. I feel that the man who sells a Seddon Atkinson truck, he's a die-hard Seddon man. He'll sell Seddons till the cows come home.

The erosion of product loyalty threatened the roots of the company man's creativity. The young wimps of my age gain no inherent pleasure from the toys they make, but adopt a feminine stance by offering up body and soul for money. Instead of dressing up the product they model themselves. At least their fathers refuse to be bought and sold, and so will go out like men, will 'die hard' dreaming of the perfect product.[31]

Among career managers who entered industry in the 1950s, masculinity is today represented in images of experience and 'hands-on' knowledge, which are in turn objectified in 'man-made' goods. In their firmly amateur status, the emergent generation of career managers adhered to the traditions of family capitalism, in which invention hinged on a partnership between 'practical men' and 'gentlemen amateurs'. Interposed between owners and workers, they borrowed guises from both. They prided themselves on their practical knowledge, but in common with inheritors they enjoyed a privileged access to the fruits of production.

But while the masculinity of the company man was reactive to changes in capital, gender hierarchies also helped to shape management. The reluctance among business historians to adopt a gender perspective – even among those who champion a cultural approach – has resulted in a one-dimensional understanding of British business. For example, Martin Wiener attributes the decline of the British economy in the twentieth century to a hegemony of upper-class traditions, arguing that the pursuit of wealth was never socially legitimate and that business merely provided the means to a gentrified, leisured life. Entrepreneurial drive was sapped by a national culture which celebrated civilized, 'clean' (and by implication effeminate) pursuits.[32]

Wiener extends his thesis to the industrial manager, claiming that the desire for social recognition explains the dominance of engineering related functions in post-war British manufacturing firms. The cult of technical know-how was merely a 'transitional ideology, for managers not yet become gentlemen'.[33] We cannot view the heroism of engineering simply in terms of an emulation thesis. Industrial managers did wish that technical knowledge had more status, but did not aspire to become gentlemen and instead subordinated class to masculine status. They despised gentlemen, preferring a masculine stereotype bound up with the drama of production, technical competence and product fetishism. Wiener ignores the gender dimension of the gentleman/player dichotomy, and the way it cut across ideologies of class.

In post-war manufacturing industry, managers of all social backgrounds revelled in technical excellence. None of the men quoted in this essay was an engineer, while the two most fervent product worshippers were public school educated. The acquisition of practical knowledge and experience liberated them from the more tenuous, 'soft' masculinity of the public school. Invoking class as his only social category, Wiener describes an unproblematic monopoly by gentlemen over the industrial spirit, while in fact the history of business involves a much more complex dynamic between competing masculine and class identities in which gentlemen might also become players, and players might dominate gentlemen.

The past decade has seen a resurgence of the 'gentleman', in line with the growing importance of the financial sector in Britain's economy. But just as the identity of player took on an ambiguous class connotation during the post-war period, so too now the identity of gentleman has been fractured – at least in the popular imgination – so that the ex-East-End barrow boy now sports the pin-stripe suit alongside his Oxbridge-educated brothers (and sisters) in the City. Product fetishism persists but is more likely to fix on information technology than the 'white-hot' industrial products of heavy industry. While technology grows more and more divorced from physical strength, material and ideological gender divisions remain. The new technology has spawned a generation of 'computer widows' whose menfolk have surrendered family life for the fascinations of computing, with its fetishizing of power in terms of processing speed and memory, and its gendered language of 'hardware' and 'software', 'motherboards' and 'RAM'.[34]

Historically, technical knowhow has been closely associated with male domination, not only in industry but in society at large. Cynthia

Cockburn has vividly described the ways in which technological change and shifting skill requirements in the print industry during the early 1980s resulted in a sense of disempowerment among male printers, and in efforts to prevent women's access to the new machinery.[35] At the managerial level a similar pattern emerges: control over the creation of products provided male career managers with a closely guarded source of power and pleasure. The creation of a technical aesthetics rested on dichotomies between producer and consumer, subject and object, masculine and feminine. Product fetishism thus reflects the power of male career managers over women and over men on the shopfloor. For the post-war generation it also provided a bulwark against threats from above in the form of economic change and the growth of new requirements for managerial skill. The masculinity of the post-war company man resided in his appreciation and knowledge of yesterday's model.

NOTES

1 I would particularly like to thank Guy Boanas, Romano Dyerson, David Goodman, Gareth Jones, Yasmin Lakhi, Lyndal Roper, and members of the Masculinity Study Group for their comments.
2 K. Marx, 'Comments on James Mill, Elements D'Economie Politique', *Collected Works*, vol. 3, 1843–4, London, Lawrence & Wishart, 1975, p. 227.
3 'Economic and Philosophic Manuscripts of 1844', *Collected Works*, vol. 3, p. 277. It has been argued on the basis of Marx's comments that through technology, men seek immortality. Production compensates for men's inability to reproduce Lydia Sargent (ed.), *Woman and Revolution: a Discussion of the Unhappy Marriage of Marxism and Feminism. A Debate on Class and Patriarchy*, London, Pluto, 1981, pp. 170–82. Whilst this insight is thought-provoking, it runs the risk of returning us to explanations rooted in biology.
4 H. Braverman, *Labour and Monopoly Capital*, New York, Monthly Review Press, 1974. See chapter 1, 'Labor and Labor Power', esp. pp. 47–50.
5 P. Willis, 'Shop Floor Culture, Masculinity and the Wage Form', in J. Clarke, C. Critcher and R. Johnson (eds), *Working-Class Culture: Studies in History and Theory*, London, Hutchinson 1979, p. 190.
6 L. Hannah, *The Rise of the Corporate Economy*, London, Methuen, 1976, p. 166; S. Pollard, *The Development of the British Economy 1914–1980*, 3rd edn, London, Edward Arnold, 1983, p. 302.
7 The chapter is based on the accounts of thirty middle to senior managers, twenty-five men and five women, who entered manufacturing industry between 1945 and 1955. Now aged between 55 and 65, this generation oversaw the rise of the corporate economy. While the majority had some form of tertiary education, they lacked the formal management training of their juniors: 83 per cent had a further degree, but only 13 per cent in commerce; 23 per cent were apprenticeship trained engineers, 20 per cent

had done arts, 17 per cent science, 7 per cent secretarial, and 3 per cent law. The solidly middle-class character of the sample is indicated by the fact that 67 per cent were grammar school educated, 23 per cent (mainly the inheritors) attended a public school, while 10 per cent (mainly ex-engineers) attended a secondary modern school.

8 During the fieldwork I kept a journal which I filled in immediately after each session. It was an account of what happened, particularly my visual impressions, and was a means of scratching away at events or conversations which had seemed particularly puzzling or curious.

9 According to Anthony Sampson, through the models Stokes exhibited his 'passion' for cars (*The New Anatomy of Britain*, London, Hodder & Stoughton, 1971, p. 606).

10 This was not the case in interviews with women, or with men when they were interviewed in casual clothes at home.

11 R. Kanter, *Men and Women of the Corporation*, New York, Basic Books, 1977, p. 48.

12 I had tried to indicate conformity by wearing a plain tie, feintly striped white shirt, sports jacket and wool trousers, but it seems that my efforts in fact rendered me visible!

13 This 'invisibility' does not hold for the younger generation of male managers. 'City fashion', embodied by the Next look in particular, accompanied 'big bang' and the growth of London's financial sector during 1987. Wide, colourful ties, braces and waistcoats have since become the stock-in-trade of high street male fashion (see Frank Mort, 'Boy's Own? Masculinity, Style and Popular Culture', in R. Chapman and J. Rutherford, (ed.), *Male Order: Unwrapping Masculinity*, London, Lawrence & Wishart, 1988, p. 204). Self-conscious play with dress codes by the younger generation of financiers has also been captured in Hollywood films, notably *Wall Street* and *Working Girl*. Suit and tie fashion is most often associated with the financial sector. The gentleman financier is considered effeminate by managers in manufacturing industry, who show profound distaste for dressing up, as Mr Dowell's comments above indicate.

14 D. W. Winnicott, *Playing and Reality* (1971), London, Penguin, 1988. See esp. chapter 1: 'Transitional Objects and Transitional Phenomena'.

15 This theme is explored by Daniel J. Levinson in *The Seasons of a Man's Life*, New York, Knopf, 1978.

16 D. C. Coleman, 'Gentlemen and Players', *Economic History Review*, 2nd ser., vol. 36, no. 1 (1973), esp. pp. 92–103.

17 Having decided to join Faith windows for example, Mr Higgs went 'round to all the departments . . . learning the various products and how the company handled them and how it did its business, straight from the estimating and pricing, costing of windows, right through to the design, the ordering of them, the manufacture of them in the shops, and the fixing of them on site'.

18 An example of diversification in product range and markets is NGT, which extended its operations during this period to South Africa, Australia and France, and branched out from the supply of brakes and clutches to cover steering and suspension, rubber pressings, hydraulics and aircraft parts.

19 G. Turner, *Business in Britain*, London, Eyre & Spottiswoode, 1969, p. 302.

20 For example Turner's comments are echoed by D. F. Channon, who writes that in engineering companies 'the goal of engineering excellence was too often allowed to override commercial sense. Companies had been, and in some cases still were, managed by men thinking as engineers rather than as managers; marketing skills were often neglected, and products had frequently not been designed to fulfil market needs' (*The Strategy and Structure of British Enterprise*, London, Macmillan, 1973, p. 149). From a somewhat different perspective, Martin Wiener argues that the engineer's desperate efforts to gain social acceptability led to excessive emphasis on 'technical perfection'. *English Culture and the Decline of the Industrial Spirit, 1850–1980* (1981), London, Penguin 1985, p. 141. I argue precisely the reverse; that the obsession with technical merit was a means of refuting the claims of gentlemen rather than emulating them.

21 Turner, *Business in Britain*, p. 301.

22 For further information on economic change in the 1960s see Hannah, *Rise of the Corporate Economy*, p. 94; Pollard, *Development of the British Economy*, pp. 302–5; and chapter 1 of my Ph.D. thesis, 'Masculinity and the Evolution of Management Cultures in British Industry, 1945–85', University of Essex, 1989.

23 Quoted in A. Sampson, *Anatomy of Britain Today*, London, Hodder & Stoughton, 1965, p. 511.

24 Of the thirty managers in the sample, fourteen mentioned that mergers or takeovers during the 1960s were a decisive factor in career moves. Four (all employed in predator firms) felt that mergers had been beneficial, while a further seven felt their careers had been disrupted by mergers. In four cases a takeover led directly to a change of employer.

25 Wiener, *Decline of the Industrial Spirit*, p. 3.

26 Writing in 1970, Cyril Sofer noted that 'the general area of plastics has glamour' among technical specialists (*Men in Mid-career: a Study of British Managers and Technical Specialists*, Cambridge, Cambridge University Press, 1970, p. 297). Another example of the same general phenomenon is Mr Sorrell. His first career move, from STC to a small family company which manufactured electronic components, was partially predicated on admiration for their product line. The owner 'kept his ear to the ground' for technical developments in Germany, and had 'a very good eye' for new and exciting products.

27 A further aspect of Mr Gidley's fascination is the way the firm reintegrates the production process: 'They did a complete turn key operation. They produced the raw material, they produced the machinery to process the raw material, they sold the technology to go with it. And they also took customers' metal articles and coated them themselves. So they did the whole process, which of course gave the company a unique experience.' In his new firm the whole of the production process was visible. Confirming Marx's observations about the division of labour, involvement in such an operation was empowering.

28 Wiener, *Decline of the Industrial Spirit*, p. 141.

29 The representation of masculinity in film is treated – rather flippantly and unsuccessfully – in Antony Easthope's *What a Man's Gotta Do: the Masculine Myth in Popular Culture*, London, Paladin, 1986.

30 All were men, the majority of whom had an engineering background.

31 Although I have drawn a clear line here between older, technically trained, and younger, financially trained managers, the distinction is of course blurred. The career histories of managers who remained close to manufacturing functions differs from those in the sample who, at the forefront in the drive for professionalization, moved in to personnel, management consultancy, or other management services. It has been easier for the latter group to ride out the recession in late career. They have been in greater demand than production or sales managers, and their expertise has been more easily deployed across companies.

32 Wiener, *Decline of the Industrial Spirit*. See esp. chapter 7, 'The Gentrification of the Industrialist', pp. 127–55. For a more complete critique of Wiener, see Roper *Masculinity and the Evolution of Management*, conclusion.

33 Wiener, *Decline of the Industrial Spirit*, p. 139.

34 See Margaret A. Shotton, *Computer Addiction? A Study of Computer Dependency*, London, Taylor & Francis, 1989.

35 Cynthia Cockburn, *Brothers: Male Dominance and Technological Change*, London, Pluto, 1983. For a more detailed description of the pleasures which men gain through their control over technology, and the difficulties which they experience in moving from 'hands-on' technical tasks to management, see Cockburn's *Machinery of Dominance: Women, Men, and Technical Know-how*, London, Pluto, 1985.

SELECT BIBLIOGRAPHY

This list is offered as a short guide to further reading. While we are not necessarily in sympathy with the approaches adopted by all these writers, they do nevertheless represent a cross-section of recent work in the history of masculinity.

Bell, Donald, 'Up From Patriarchy: Men's Role in Historical Perspective', in Robert A. Lewis (ed.), *Men in Difficult Times*, Englewood Cliffs, Prentice Hall, 1981.

Davidoff, Leonore, 'Class and Gender in Victorian England', in Judith L. Newton *et al.* (eds), *Sex and Class in Women's History*, London, Routledge, 1983.

Davidoff, Leonore, ' "Adam Spoke First and Named the Orders of the World": Masculine and Feminine Domains in History and Sociology', in H. Corr and L. Jamieson (eds), *The Politics of Everyday Life: Continuity and Change in Work, Labour and the Family*, London, Macmillan, 1990.

Davidoff, Leonore and Catherine Hall, *Family Fortunes: Men and Women of the English Middle Class, 1780–1850*, London, Hutchinson, 1987.

Gillis, John, *Youth and History: Tradition and Change in European Age Relations, 1770–Present*, 2nd edition, New York, Academic Press, 1981.

Gillis, John, *For Better, For Worse: British Marriages since 1600*, New York, Oxford University Press, 1986.

Haley, Bruce, *The Healthy Body and Victorian Culture*, Cambridge, Harvard University Press, 1978.

Hall, Catherine, 'The Economy of Intellectual Prestige: Thomas Carlyle, John Stuart Mill, and the Case of Governor Eyre', *Cultural Critique*, vol. 12 (1989), pp. 167–96.

Mangan, J. A. and James Walvin (eds), *Manliness and Morality: Middle-Class Masculinity in Britain and America, 1800–1940*, Manchester, Manchester University Press, 1987.

Mort, Frank, *Dangerous Sexualities: Medico-Moral Politics in England since 1830*, London, Routledge, 1987.

Mosse, George L. *Nationalism and Sexuality: Respectability and Abnormal Sexuality in Modern Europe*, New York, Howard Fertig, 1985.

Newsome, David, *Godliness and Good Learning: Four Studies on a Victorian Ideal,*

London, John Murray, 1961.

Roberts, David, 'The Paterfamilias and the Victorian Governing Classes', in Anthony S. Wohl (ed.), *The Victorian Family*, London, Croom Helm, 1977.

Stearns, Peter N., *Be A Man! Males in Modern Society*, New York, Holmes & Meier, 1979.

Vance, Norman, *The Sinews of the Spirit: the Ideal of Christian Manliness in Victorian Literature and Religious Thought*, Cambridge, Cambridge University Press, 1985.

Weeks, Jeffrey, *Coming Out: Homosexual Politics in Britain from the Nineteenth Century to the Present*, London, Quartet, 1977.

In addition, the following books' approach to theory is particularly helpful to historians:

Brod, Harry (ed.), *The Making of Masculinities: the New Men's Studies*, London, Allen & Unwin, 1987.

Carrigan, Tim, Bob Connell and John Lee, 'Hard and Heavy: Toward a New Sociology of Masculinity', in Michael Kaufman (ed.), *Beyond Patriarchy: Essays by Men on Pleasure, Power, and Change,* Toronto, Oxford University Press, 1987; and in Brod, *Making of Masculinities*.

Chapman, Rowena and Jonathan Rutherford (eds), *Male Order; Unwrapping Masculinity*, London, Lawrence & Wishart, 1988.

Cockburn, Cynthia, *Brothers: Male Dominance and Technological Change*, London, Pluto, 1983.

Cockburn, Cynthia, *Machinery of Dominance, Women, Men and Technical Know-How*, London, Pluto, 1985.

Connell, R. W. *Gender and Power*, Cambridge, Polity, 1987.

Kimmel, Michael S. (ed.), *Changing Men: New Directions in Research in Men and Masculinity*, London, Sage, 1987.

Segal, Lynne, *Slow Motion: Changing Masculinities, Changing Men*, London, Virago, 1990.

Swidler, Victor J. *Rediscovering Masculinity: Reason, Language and Sexuality*, London, Routledge, 1989.

Tolson, Andrew, *The Limits of Masculinity*, London, Tavistock, 1977.

INDEX